TRADITION AND AVANT-GARDE:
THE ARTS IN SERBIAN CULTURE
BETWEEN THE TWO WORLD WARS

JELENA MILOJKOVIĆ-DJURIĆ

EAST EUROPEAN MONOGRAPHS, BOULDER
DISTRIBUTED BY COLUMBIA UNIVERSITY PRESS, NEW YORK

1984

EAST EUROPEAN MONOGRAPHS, NO. CLX

Copyright © 1984 by Jelena Milojković-Djurić
Library of Congress Card Catalog Number 83-83005
ISBN 0-88033-052-X

Printed in the United States of America

To memory of my parents:
Judge Borislav A. Milojković
and Zora Vujović Milojković.

CONTENTS

ACKNOWLEDGEMENTS

Since this volume presents a revised form of my doctoral dissertation, I would like to express my appreciation to the doctoral committee at the University of Belgrade, Yugoslavia, Professors: Radovan Samardžić, Dejan Medaković, Dragan M. Jeremić, Andrej Mitrović and Lazar Trifunović. The dissertation research was funded by the Committee for Music History of the Serbian Academy of Sciences and Arts chaired by Professor Stanojlo Rajičić in 1978, and subsequently by Dr. Dimitrije Stefanović in 1979. Clara Huggett, former instructor in the Department of English at Texas A&M University read the English version of the manuscript and offered valuable suggestions.

INTRODUCTION

The period of multifaceted artistic and cultural development between the two world wars was marked by a dichotomy of thoughts and ideologies, reflecting beside avantgarde tendencies a visible presence of tradition. The creative output of Yugoslav and in particular Serbian writers, composers, painters and sculptors, who at that time started or further developed their professional activities, was characterized by the fluctuations between adherence to tradition and the acceptance of contemporary innovations. Although the wish for participation in the contemporary development of artistic creation was clearly established, at the same time there persisted an awareness of the artistic heritage in the creation of an autochthonous contribution.

A very significant parallel could be drawn between the literary and the musical development in Serbia. Due to the historical circumstances and general social conditions, music very much like literature was created under a considerable influence of national folk tradition perpetuated orally from one generation to another. In the creation of literature an important element was the literary folk tradition, while in the creation of artistic music an equally important element was the spiritual and the secular folk song.

In his study of Serbian literature of the eighteenth and nineteenth centuries Dragiša Živković pointed out that in the contemporary literary historiography there prevailed the thesis about the discontinuity and accelerated development of certain national literatures.[1] In such instances the more recent literary development started slowly with a certain degree of delay due to the general social, political and economic conditions. Živković stressed that the literature of Serbia was influenced by the late national unfoldment caused by the centuries long Turkish occupation. Therefore Serbian literature of the eight-

1

eenth and nineteenth centuries has the characteristics of the discontinued literary development. The connections with the earlier Serbian or Croatian literary tradition were broken or anachronistic, while a meaningful tie with the oral folk tradition was established only in the first half of the nineteenth century. Consequently the Serbian literature achieved an accelerated development, becoming part of the contemporary European literature around the turn of the century: "The so-called 'catching with Europe' that during all this development pursued the generations of Serbian writers as an incentive for growth as well as a nightmare that instilled a feeling of inferiority, was thus—observed in historical relations—quickly resolved."[2]

In the musical development a similar phenomenon was to be observed. The gradual growth suffered delays and interruptions caused by the general social circumstances. The specific and discontinued development of Serbian music included in its course many postponements. The influence of folk music tradition both secular and spiritual was consistently felt. At the same time there existed the desire for an accelerated growth in joining the mainstream of musical development elsewhere, in order to end the isolation experienced through centuries as well as the resulting backwardness.

Vojislav Vučković described the consequences of this regression in an article addressed to the education of the young composers:

"The cultural history of our land, taken as a whole—and especially the part that corresponds to the period between the eighteenth and nineteenth century, as a spiritual expression of the specific conditions of the economic and political development and of the formation of our national emancipation, this development alone explains the level and orientation of our present spiritual culture. We have, unfortunately, to admit that this level although historically observed presented a necessity; it is not in international terms high enough. We have travelled at the beginning of this century through the waterlogged and muddy roads over which Europe passed in the last century . . . But we were not only late then and thus excluded from almost any competition with the West—but we are, generally speaking, regressing even today which is even more difficult and tragic than the one before."[3]

In this context tradition as contained in the national music idiom was perceived as an obstacle for further development. The gradual approach to the level of the general development in Europe was achieved somewhat later than in the literature, in the late 1920's and during the 1930's. It was the generation of composers born in the 1880's and 1890's comprising Milenko Paunović, Petar Konjović, Miloje Milojević, Stevan Hristić and Kosta P. Manojlović that brought the Serbian music to the artistic level already attained by the fine arts and literature. Due to the strength of their talents and theoretical

knowledge their works reflected an advancement of musical technique and expression as well as preserving a link with the immediate past. Their contribution in the compositional field was complemented by their endeavors in building different aspects of the musical culture. This generation of composers participated in the foundation of all major musical bodies and institutions.[4]

Around the time of economic depression in the late 1920's and at the beginning of the 1930's a new generation of composers started their professional careers. This group of composers often referred to as the Prague Generation, was so named after the town where they accomplished their musical studies. The group included, among others, Mihailo Vukdragović, Mihovil Logar, Predrag Milosević, Dragutin Colić, Ljubica Marić, Vojislav Vučković, Stanojlo Rajičić and Milan Ristić.

These composers contributed to different musical fields, foremost as composers, but acting also as teachers, conductors and music writers with the wish to enhance and broaden the musical culture in their native land. Their compositions, although individually different, point to the adherence of the contemporary sound, close to the expressionistic style of the European avantgarde. However in the course of time they became aware of the discrepancy that existed between their musical compositions and cultural needs of a broader and musically inexperienced public. The altogether negative reception of the new compositions by the public and critics alike led to a gradual search for a more accessible musical language. In the hope that their music may reach and enrich the lives of many, and fearing the isolation of the luxury of writing for the selected few, they slowly approached a change in their musical style.

A similar trend was observed on the European scene. It was common knowledge that the athematic and atonal compositions were rarely performed. This phenomenon was discussed at the conference of the International Society for Contemporary Music, held in Venice in 1937. It was concluded that the dodecaphonic way of writing was being abandoned, and even considered by some composers as "unrealistic."[5]

This change of attitude towards avantgarde tendencies in music as well as the casting off of innovations in many fields of artistic thought, introduced in the earlier part of the century, was also strongly influenced by the economic, social and political crisis that permeated many aspects of life and national existence.[6]

The artists were hesitant to continue to follow the atonal, athematic or dodecaphonic manner of composing. Since the tradition of musical folklore in Yugoslavia was still alive and especially rich, one of the possible solutions was the creation of a musical language based upon the folk idiom. The new works allied with tradition, yet with an essentially new approach, could achieve an

autochthonous artistic expression, independent from foreign influences. This solution was often suggested in reviews and essays dealing with the music of this period.[7]

An example of a conscious effort to create a work that would be accepted and understood was the opera *Sacrilege in Saint-Florijan's Valley* by Mihovil Logar, composed in 1938. The basis for the libretto, by the composer, was the novel by the well known Slovenian author Ivan Cankar. In order to establish the atmosphere of his native Slovenia, Logar used Slovenian folk songs interwoven and fragmented to suit his purpose.

Motivated by the wish to create a more truthful and accessible artistic language, a group of artists in Belgrade organized meetings with discussion focused on realistic trends in modern art. Along with the painters Djordje Andrejević-Kun, Mirko Kujačić, Vinko Grdan and others, the writers Jovan Popović, Radovan Zogović and Dušan Matić, as well as the composer and musicologist Vojislav Vučković attended the meetings.[8]

These meetings of progressive artists with a leftist orientation took place during 1937 and 1938. During that time Vučković came to the conclusion that the contemporary realism in the arts was the expression of the current moving forces of social progress.[9]

This assertion points to the metamorphosis of Vučković's previous views, expressed at the beginning of the 1930's in his musicological and compositional works. At that time Vučković maintained that the achievements of the athematic, twelve-tone and quarter-tone music were a progressive result of the social development, stressing that the avantgarde music would enable a wide range of public to gain the understanding of the musical art. Since the contemporary development of music is the result of a historical process, the contemporary means of musical expression are neither progressive nor regressive in themselves, since their character is conditioned by their application.[10]

Vučković's pleading for a socially engaged art should be understood in the framework of existing dissuasions brought about by the changed attitudes of the avantgarde artists and prevailing predicaments in the social, political and economic upheavals. Thus Vučković asserted that the new art should reflect the aspirations of many in order to gain significance and a progressive, revolutionary value.

Another document of these changes, on the literary field, presented the essay of Marko Ristić entitled: "The Moral and Social Meaning of Poetry." Ristić realized that a poet cannot avoid the questions that are imposed by the social chaos, since his personal life exists only within the scope of the human community. Therefore Ristić contended that the contemporary poet must approach the progressive ranks, as well as the real poetry, as a moral activity,

should present with its latent content the revolutionary, that is useful value.[11] This concept manifested certain similarities with the viewpoints of Vučković: both artists perceived the socially useful role of the arts.

Similar objectives guided the group of graphic artists in arranging the first joint exhibit that took place in 1934 in the arts gallery *Cvijeta Zuzorić* in Belgrade. On this occasion Mihailo Petrov wrote that the majority of exhibited works showed "a much closer and direct connection between the artistic aspirations and the realities of life, than it was ever achieved before the exhibit."[12]

Among the works in this exhibit was a very explicit message of new tendencies in the woodcuts of the painter Djordje Andrejević-Kun: *The Street, Harmonica-Player, Woodcutter.*

In the course of the same year of 1934 Mirko Kujačić presented his graphic collection entitled *Fishermen.* In the preface Kujačić stated that the contemporary artist should stand against individualism, pure art and eternal beauty, but actively support "the poetry of progress, working men, the proletarian thought and immense collective discipline."[13]

Such active support was depicted once again in a collection of woodcuts by Djordje Andrejević-Kun, commemorating the mishap that occurred in the shafts of the mines of Bor, in East Serbia in 1937. Kun, a member of the group *Život* (Life), shared the strain of socially oriented esthetic thought, present at the time in different art fields. In the wish to bring improvements to many in forgotten avenues of life, these works often testified to a deep humanitarian concern.

One of the first compositions with an expressed social tendency in Serbian music presented the symphonic poem *Under the Ground* by Stanojlo Rajičić. It was originally conceived as ballet music, based on a literary rendition by the writer Petar Petrović-Pecija of another tragic event in the mines of Kakanj. Because of its sombre and therefore accusing impact, the work was never staged. The first performance of this work, in the form of a symphonic poem, took place in May of 1940.[14] The musical language of Rajičić has achieved in this composition a new found clarity and moderation indicating the stylistic change of compositional and artistic concepts, approaching in spirit the folk music idiom.

The interest in inflections of the folk music idiom, coupled with a modified compositional technique, is noticeable in some other newly composed works of the avantgarde music. This change of attitudes is present in the critiques, essays and studies published in this period. Therefore it should be concluded that the stylistic change in Serbian music was sufficiently anticipated during

the 1930's, to attain a more defined development at the eve of the Second World War.

Up till present it was assumed that the young generation of composers, the members of the so called *Prague School,* completely rejected the folk music idiom.[15] The basis and the musical language of their works were eventually declared worthless and therefore abandoned after the end of the Second World War. The young composers at that time became aware of their illusions and approached a transformation of their beliefs.[16] Some authors claimed that only Vučković managed to approach a new synthesis before the outbreak of the Second World War. This change in his artistic beliefs, as an engaged social and political activist, was regarded as an isolated effort.[17] Interestingly enough, it was even asserted that Vučković could not completely free himself from the negative influence and create a musical language in accordance with his theoretical and esthetic ideologies.[18]

In essence, Vučković as well as other representatives of the *Prague School*: Mihovil Logar, Dragutin Čolić, Stanojlo Rajičić and Milan Ristić have approached a stylistic change, in the course of the 1930's, although each of them did so individually and to a different degree.

These changes in artistic and esthetic attitude appeared in different art fields. Thus the works created in this period are united as testimonies of human thought reflective of the multiple changes in the social, political and economic development of this time.

In writing this work the wish was to depict the development of music in the context of the general cultural growth, based on the research of art works, essays, articles, studies and critiques published by contemporaries who by the virtue of active participation helped to shape this period. The recollections in form of oral communications to this author were used to a lesser degree since very often the recounting of past events contained a form of conscious or unconscious modification or correction of former statements, presenting in itself the inexorable nature of the evolutionary flow of human thought. The interdependence of development in different artistic fields within a given time period was especially stressed. Art works that expressed some commonly conceived thoughts and ideas were in the center of attention.

In particular the influence of Bogdan Popović in the formation of Milojević's value judgments was traced and acknowledged, for the first time, in a number of articles and studies that established Milojević as a leading personality in the musical life of Belgrade. Milojević a former student of Popović at the College of Philosophy in Belgrade, as well as a long time collaborator of the journal *Srpski Književni Glasnik* which was founded by Popović, must have been intimately informed about Popović's views.

Milojević's criteria were very likely influenced by a similar attitude of Bogdan Popović, one of the outstanding personalities of the cultural life of Belgrade, as is reflected in Milojević's musicological and journalistic works.

Special attention was given to Vučković's contribution to the musical life in the course of the 1930's. Vučković influenced through his active participation not only the consequent development in his homeland but his contribution was appreciated in Prague where he was acclaimed as the founder of the *Prague School of Music Sociology*.[19] Interestingly enough Vučković's role in the musical life of Prague has not been sufficiently known and documented in Yugoslavia.

Thus this work points to the similarities and parallels in the development of literature, music and fine arts stressing the spiritual exchange with leading cultural centers elsewhere, while evaluating the Serbian esthetic and artistic thought within the contemporaneity of European achievements.

THE ARTISTIC AND CULTURAL LIFE IN BELGRADE AFTER THE END OF THE FIRST WORLD WAR

After the end of the First World War, Belgrade as the capital of the newly found state of Yugoslavia became the center of an intense development in all artistic fields. Although many buildings were destroyed and the whole city reflected the impression of devastation and want, there existed a widespread desire for collaboration in the organization of a new cultural and artistic life. According to Marko Ristić, Belgrade seemed: "Cold and deserted, without lights, without water, full of holes and ruins and weeds . . ."[1]

Another testimony about the situation in Belgrade at that time was left by Rastko Petrović. Petrović came to Belgrade after the conclusion of the war, travelling by train from Paris. No travel fare was charged, but the journey lasted for six days. Upon his arrival Belgrade seemed to him as a little and sorrowful city. In spite of that uncared and neglected appearance, Petrović noticed a new spirit that prevailed. Even the casual meetings and encounters pointed to similar interests, the same need for communication and for the organization of a new cultural life. Everyday meetings with men and women that were also poets rendered exaltation that one is not alone, opening possible avenues for collaboration.[2] The poets were not the only ones to meet; there existed a broader context of spiritual kinship between the artists and musicians alike, although the influence of young writers was decisive. The influence of literary criticism and of literary and theoretical studies and essays took a leading place in the shaping of the artistic development of this period.[3]

The spirit of solidarity, collaboration and spontaneity, the belief in unbound possibilities of growth and of progress, a prospect of equalization within the cultural achievements of Europe, all these aspects contributed to an openness

striving to an unifying artistic expression, in all artistic fields. There was no tendency of closing within one particular artistic discipline, or of exploring only the indigenous questions pertinent to one artistic language.[4]

These tendencies for collaboration led to the formation of associations and artistic unions and societies, as well as several professional bodies. As one of the first the *Group of Artists* was formed. The writer and critic Marko Ristić wrote about the founding of this society that took place in the Café Moskow, a favorite meeting place of the artists:

> "The Café Moskow, illuminated then with candles was the first meeting place of writers and artists who represented at that time *Modern*. There at the table under the big round mirror, on the ground floor of Moskow that remained, by the way, for years the headquarters of the *Modern*, the founding of the, in many ways pioneering, *Group of Artists* took place, comprised of artists, musicians and writers."[5]

The first literary-musical presentation took place November 17, 1919, in the auditorium of the music school *Stanković*. Ristić stated that at that occasion the following writers and poets read their poems; Sibe Miličić, Sima Pandurović, Josip Kosor, Danica Marković, Mirko Korolija, Ivo Andrić and Todor Manojlović.[6]

This first joint manifestation was greeted with an appropriate review that was published in the journal *Misao*, in December of 1919.[7] The author of the review V. Živojinović in presenting the members of the group tried to determine the reasons and motives for the formation of this association. At the same time Živojinović was trying to project the goals that these artists could accomplish and fulfill. Živojinović believed that the *Group of Artists* was formed out of the wish for collaboration and the need for organizing and strengthening the artistic and literary work:

> "This is probably the first effort in our midst of joint propaganda and a planned cultivation of the arts, the first effort in which the pictorial art, literature and music are united in a joint work. That is not only the introduction of our milieu to the contemporary movements in our artistic life, nor only the disssemination of understanding for the arts in general for the arts in our midst, but also the stressing of productive work, the awakening of the action among the artists themselves."[8]

Živojinović points to the fact that this action has shown the diversity and multitude of artistic conceptions that prevailed in literature. There was a similar situation in pictorial art. Živojinović stated his opinion that the painters

gathered around the *Group of Artists* presented as many art directions as there were represented artists by their exhibited art works.[9]

Živojinović stressed in particular that these literary-musical evenings revealed a valuable link that existed between the younger and the older generation. This fact was enabling a gradual development instead of a sudden production of creative growth. Therefore Živojinović is observing that the new appears to be branching out, from the very beginning since every offspring has its own physiognomy, life and expression. "*The Group of Artists* has gathered the young and the youngest artists. These are exactly the artists that stand at the crossroads of the old and the new, or these ones that have finished with the old intentionally or by an inner instinct, and search for the new road."[10] As participants at these presentations Živojinović mentioned the following writers: Danica Marković, Sima Pandurović. Sibe Miličić, Ivo Andrić, Todor Manojlović, Mirko Korolija and Josip Kosor. The achievements in the visual arts were presented by the works of Branko Popović, Sibe Miličić, Milan Nedeljković, Becić and Marinković. The musical arts were represented by Stevan Hristić, Miloje Milojević and Kosta P. Manojlović. Živojinović wrote furthermore:

"Although different in artistic temperament and expression, they are akin in the belief that they are standing in front of a new era and that for their new feelings and new views they have to find new means of expression, because of the belief in the new and of the cult of the new. Therefore this group, although free and not tied with any kind of prepared program, presents nevertheless one whole with a defined physiognomy, and it is not at least accidental in its composition as it may seem on the first glance."[11]

Živojinović pointed out that the common trait of these artists is their interdependence with the new era. Therefore their sensitivities are new, as well as their efforts in finding new means of expression, while noticing their belief in the new and the cult for the new. Therefore followed the conclusion that it was necessary and useful to learn about these newest achievements, since the new artistic development depended on the knowledge of the old traditions:

"Finally it was necessary and useful to acquaint ourselves in a concise fashion with the situation of the literary work today, with the new tendencies and new directions, with all that has crystalized . . . and emerged on the ground of old traditions or in the atmosphere of the new worlds. It was useful to see this all one next to each other, at the same time . . . to determine in the old the new and in the new the old and to perceive, perhaps, the perspectives of our literary tomorrow."[12]

Furthermore Živojinović noticed that this important tie between the old and the new in literature is represented in the poems of Danica Marković and Sima Pandurović: "Mrs. Marković by carefully preserving all the achievements of the formal aspects inherited from the epoch of Dučić-Rakić, fills her poems with new feelings . . . and Mr. Pandurović stands at the turning point as a guard of the old and a vanguard of the new."[13] Živojinović considered that the further development ought to have an evolutionary character, although he is welcoming the new tendencies in the arts, since a sudden jump or a sudden transition could destroy this valuable tie with the past: "And it was especially stimulating to see on this literary-musical evenings this nice transition, this distinguished tie between the two generations . . . that is enabling an evolutionary progression even there where apparently a sudden jump was threatening."[14]

In considering the development of music, Živojinović pointed out that the wish for the cultivation of the new and modern is prevailing, although parallel to it there is the desire for the implementation of the folk music idiom. The composers Milojević, Hristić and Manojlović, according to Živojinović, are trying to create a contemporary musical language, safeguarding at the same time the characteristics of the national musical language. In order to accomplish these goals, these artists wished to present the national musical expression into a contemporary, European form, so that Serbian music may reach the achievements of the general artistic development. Živojinović concluded: ". . . and it cannot be denied that this work (no matter that we are evaluating it in details) will be the starting point of a new movement: new although resulting basically from the one that preceeded it with Marinković, Mokranjac, Krstić and others."[15]

From Živojinović's explication it follows that his position was closest to the points of view expressed by the musicians gathered around the *Group of Artists*. Very much like Hristić, Milojević and Manojlović, Živojinović believed that the new artistic growth should not sever its ties with the old, but continue in a gradual evolutionary flow. Thus Živojinović's attitude was obviously similar to the one held by the majority of the members of the *Group of Artists*, pointing to the dichotomy in the opinion of the role and importance of artistic tradition. Although a new era has started that conditions a contemporary and novel understanding, the newly created art works should not be without the support of the tradition of the past. However the aspiration in establishing a link with the European development was also clearly expressed as one of the main traits.

About the first literary-artistic evenings wrote also the composer Steven Hristić.[16] It was Hristić's opinion that the musical life in Belgrade had started

to gain a more defined profile. Therefore even the evenings of the *Group of Artists* represent a positive result, but more in their aspirations than by the positive results. Hristić considered that the musical programs of this kind required a special genre of compositions, and only one among the three composers that belonged to this group had a considerable amount of such compositions. Hristić was alluding to Milojević, although not mentioning his name. That is why there was insufficient material for the recitals dedicated to the works of native composers. Besides, Hristić thought that there is still an insufficient number of performing artists, but that the future development will depend on the performing skills and excellence of their craft. "Until this is true not one theatre is going to be able to compose an orchestra and engage singers out of the local artists."[17] The reason for this occurrence Hristić observed the lack of educational possibilities for young musicians due to the absence of music academies or conservatories. In Belgrade at that time existed two music schools, established already before the First World War. Although these schools increased the number of the teaching staff, and the number of enrolled students, thus evidently serving an important role in the musical life of Belgrade, Hristić nevertheless stressed repeatedly the importance of the founding of the academy of music. Only such a musical institution can safeguard the higher professional education needed for the establishment of the symphonic and operatic orchestras, singers for operatic productions and teachers for middle schools. Until such an academy is established the composers will impassionately wait for the performance of the works that they composed in their youth having in mind large orchestras, eight-part choir ensembles and singers with a large vocal register. Hristić very likely knew from personal experience that the composers, in due time, simplified and rewrote their compositions. Thus often a large orchestra was substituted by a smaller instrumental ensemble; eight-part choirs were adapted for four-part choral compositions, while in the vocal parts written for soloists the attention was shifted to the diction, since developed and schooled voices were rare and present in an insufficient number.[18]

In another article, "About the National Repertory," written somewhat earlier during the same year, 1919, Hristić pointed to the existence of a specific dramatic form accompanied with music. Hristić stated that the writers of the plays based on folk life often inserted authentic folk songs. That was the case in the plays *Djido* and *Koštana* or with the songs composed in the folk idiom like the ones used by Milorad Petrović-Seljančica in the play *Čučuk-Stana*. Hristić thought that it is hard to define these plays in which there is no real dramatic action and pointed to a number of stereotypes in portraying the

leading characters. These plays always presented a rich but stupid peasant son, a patriarchal father figure, a meek daughter and an ideal youth.[19]

In these plays the composition of the dramatic development and inserted songs was only loosely completed. Hristić depicted the musical interlude, that usually leads to a slow down in the dramatic action in the following fashion:

> "For the most part one person will say: "Come on, sing." Another one will reply: "Sing the one, you know." The third one: "Yes, indeed, sing this one." Everybody: "All right, sing."

Hristić noted that after such a dialogue a sign from the prompter box will follow and the conductor will start with the orchestra the introductory measures. This procedure is common for almost all plays with singing. Therefore Hristić rightfully contended that the value of this dramatic and musical variety is only historical, since these musical scores were written at a time when the artists had to adapt themselves to the conditions and circumstances that were more than modest. The orchestra was incomplete: only one instrument performed for the woodwinds, the bassoon was usually omitted, the french horns were mostly represented with two instruments, and commonly there was only one trombone. The melody was usually given to the first violins, with the participation of the choir and soloists, by doubling in the octave, or even in unison. The musical value of the score was very modest: "All that was learned in the very first lessons of a harmony course was here applied. The basic chord and its dominant replace each other endlessly."[20]

In addition, while perusing the scores of these plays from the folk life, Hristić found the notes and technical instructions in the German language, as for example: Vorhang, Kommt Chor, Eingang, Einleitung. This led to the conclusion that in the National Theatre many foreigners were employed and probably discussed "in a Viennese vernacular with the musicians during the rehearsal."[21]

Hristić deduced that like the music even the dramatic form was outdated and unsuitable, especially because this genre was already forgotten in other literary traditions. However, since these *plays from the folk life* have established a certain reputation and a wide spread rapport with the public, Hristić thought that the creation of a new and contemporary dramatic stage form, related to the folk opera, could better comply to this requirement. Hristić concluded that this would be the possible area of work where writers and musicians can join in a communal effort: "The solution will depend on the initial work of the writers—the creation of a text-libretto—and from the final

work of the musicians—from the composer and the musical arrangement of these libretti."[22]

Hristić even tried, as composer, to introduce the new musical content and in such a manner to renew the old form of the play with singing. In this way Hristić composed as early as in 1907 the music arrangement for the popular play of Milorad Petrović-Seljančica: *Čučuk-Stana*. The overture composed in a rhapsodic form, under the title *The Serbian Slaves,* was written in the vein of the lofty romantic style, while including in the consequent scenes elaborate choral parts and solo numbers based on the folk idiom.

However the music for *Čučuk-Stana* remained an isolated effort. Hristić did not continue composing in this style, although he showed the possibility of creating a new dramatic and music form, more developed and complete in comparison with the former plays with singing. The reason for this may have been the lack of a suitable libretto. Therefore his emphasis was on the need of collaboration between the musicians and writers, many years later, in the mentioned essay: "About the National Repertory."[23] This essay points to his further interest in the composition of music-dramatic works, that will be close to the wishes of the public, continuing and prolonging the tradition of plays with singing.

Hristić's activities as composer and conductor were in the first place tied with the operatic and ballet repertoire. The compositions that he left had as the main source of inspiration foreign sources, with roots in European tradition. The influence of folklore is visible in his first more extensive work, in the stage music for *Čučuk Stana,* and afterwards many years later in his last and most profound work, the ballet *The Legend from Ohrid.*[24]

One exceptionally interesting attempt of collaboration between the artists in different art fields presented a contemporary stage work: *Le Balai du Valet* in the course of 1923. The libretto written by Marko Ristić presented an original attempt as an anticipation of the automatic writing that was later to be established as a characteristic of surrealistic texts. The scenography as well as the program cover were designed by the architect Aleksandar Deroko. The choreography of dance numbers was in the hands of the ballerina and dance pedagogue Jelena Poljakova. Composer Miloje Milojević supplied a witty and sparkling score that closely followed and underlined the often burlesque and free flowing happenings on the stage. The cast included in the leading part the painter Mirko Kujačić. However *Le Balai du Valet* was never staged on the scene of the National Theatre.[25] Instead it was presented under the auspices of the newly founded *Association of the Friends of Fine Arts Cvijeta Zuzorić.* The ballet became part of a fund raising event: *The Thousand and Second Night,* that was arranged to benefit needy artists. It was staged by a

free and voluntary contribution of time and talent pointing to the kinship of artistic preoccupations, thus acquiring a form of an artistic manifesto.

The compositions of Miloje Milojević were at that time performed often, notably at the concerts of the *Group of Artists.* Hristić stated this fact in his essay: *The Present Musical Work.* Although he is not directly mentioning Milojević's name, Hristić is obviously referring to Milojević as the member of the *Group of Artists* whose numerous compositions were repeatedly performed.[26] Petar Konjović, a steady supporter and faithful visitor of recitals arranged by the Group wrote in retrospect that Milojević participated in all presentations of the *Group of Artists* either as composer, performer or lecturer.[27]

The programs of the presentations of the *Group of Artists* were varied and composed with care. Thus one concert was dedicated to French music, and was perceived as a tribute to the French influence still present. The introductory lecture under the title: *Coserie sur la musique francaise,* was given by Milojević in the French language due to the presence of a number of French officers in the public.[28]

Milojević's numerous public lectures delivered on many occasions, notably ones prepared for the academic society *Collegium musicum* as well as for the *Public Conservatory,* mark the beginning of a versatile professional career led by the wish to enlighten and educate the public. Milojević himself wrote on the occasion of the foundation of the *Collegium musicum* at the University of Belgrade: ". . . the highest obligation of an artist is to work towards the education and development of the public, and to work with all the force and on every occasion and with all the means available."[29]

At that time Belgrade did not have a permanent concert hall or professional organizers that could coordinate all the necessary preparations for a concert performance. Kosta P. Manojlović wrote about this problem in his article: "A Letter from Belgrade."[30] Manojlović wanted to turn attention to the backwardness of the musical mileu in Belgrade, at that time, hoping that his criticism might spur the work for the betterment of the situation: "The main trouble that causes difficulties in the musical life of Belgrade is the lack of concert halls. In want of a concert agency and agents, it became customary that all the obligations be carried out by musicians. Many artists and musical societies that have expressed the wish to give a concert never even think what difficulties have to be faced by the people they have asked to make reservation of the concert hall, print the posters and tickets, and prepare everything that is necessary for a recital."[31]

Manojlović realized correctly that there are many reasons preventing further growth of the musical life in Belgrade. Therefore he stressed that there

is not enough understanding and support for the development of music education and fine arts in general. At the same time Manojlović was aware that the artists themselves under such circumstances were not able to fulfill all expectations: "The result did not always correspond to the amount of invested energy. Half of the guilt may be of the artists, but the other half is due to the social order of the whole society . . . The political and material shortcomings of Belgrade as the center of Serbia caused the music to remain within national boundaries and mostly vocal."[32]

These conditions have contributed to a great extent to the decision of Kosta P. Manojlović to direct his professional activities as composer and conductor of the *First Singing Society of Belgrade* in the footsteps of his teacher Steven Stojanović Mokranjac. Manojlović as composer and music writer remained throughout his life true to his youthful aspirations. His creative output presented a development of ideas that originated in the early part of his life. The most significant work Manojlović accomplished as music writer represents the monograph about his teacher: *The Remembrance of St. Mokranjac.*[33] Since Mokranjac's life and work were closely connected with the *First Singing Society of Belgrade,* Manojlović also elucidated the role of this deserving society in cultivating the musical culture at the time when musical occupations were not in esteem. Manojlović even recalled incidents where rocks were thrown at the students of music schools while walking the streets with their instruments, declaring them to belong to the Gypsies.[34] Manojlović tried to depict the social circumstances and the influence of many known and unknown contemporaries that influenced the make-up of Mokranjac's artistic physiognomy. Manojlović paid special attention to the compositional work of Mokranjac pointing to Mokranjac's credo: ". . . the Serbian art music could be only elevated if based on the fundamentals of Serbian folk music . . ."[35]

While interpreting Mokranjac's *Rukoveti* as the work central in importance, Manojlović pointed out that the composers before Mokranjac did not fully perceive the psychological basis of folk melodies. Therefore, they did not comprehend the hidden, latent harmony that is contained in the melodic and textual base. Manojlović concluded: "Therefore the historical and artistic value of St. Mokranjac, although he was not a great and strong original composer lies in *the psychological treatment of the tonality and not in a penal submissiveness to it.*"[36] (Italics by KPM).

Manojlović also pointed out, very much like Vojislav Vučković many years later, that Mokranjac's work presented a point of departure for future generations of composers that should continue in Mokranjac's footsteps.[37] Manojlović clearly counted himself in this group, since his compositional and ethno-musicological work developed under Mokranjac's influence. Mano-

jlović thought that Mokranjac's compositions *Rukoveti* showed: ". . . the right road that our musical art should take and develop: aiming towards national characteristics rhythmical, melodic and harmonic, and most of all-psychological."[38]

Similar to Milojević, Manojlović also participated in organizing many music organizations. After the founding of *The Association of Friends of Fine Arts Cvijeta Zuzoric* at the beginning of 1922, Manojlović became a member of the Music Section. The establishment of this association was a wish of many, but the highest credit for the founding was due to the efforts of the writer Branislav Nušić, as the secretary of the Fine Arts Department.[39]

The Association Cvijeta Zuzurić strove to help the development of the fine arts. On the occasion of the festive founding Milojević made a speech pointing among other matters to the difficult conditions that prevailed in the cultural life: "All forces in our midst are disrupted and overexerted, that is why there is so little orientation in our public life and in general but most of all in our cultural life."[40]

In order to remedy the situation, Milojević is pleading for a betterment of artistic and social conditions: "The cultural circumstances should bring about more tolerable artistic and social conditions in our midst: these conditions are today in the circles of our artists and writers absolutely unbearable, which is since several decades a public secret."[41]

While discussing the contemporary musical scene Milojević was aware of the disparity of opinions and perspectives about the future development in music:

> "In the historical context of the development of our cultural life there was never as much motion and that many currents, so many confrontations and opposite aspirations as today, and utmost extremes. On one side fires are being lit on the sacrificing stones for the idols of past generations, the admiration of the past is preached and the future is negated; on the other hand the eyes are turned towards lofty distances where a new life is barely visible, yet different from the present, immeasurably different from the life of our fathers, grandfathers or forefathers."[42]

Milojević had a critical attitude towards the *traditionalists,* but at the same time also towards the one oriented in a progressive fashion; the *progressives*:

> "The offense of the traditionalists is due to the fact that they languidly sit in the armchairs of their forefathers . . . doubtless they remain seated in these armchairs contending that this *pose* will appeal to the wide public—while the young, vital, lively and temperamental progressives have their tresspassings . . . In the wish to express their individualities they created their gods . . . They deny the past . . . and

believe that they came from somewhere else, from a distant world, new and never seen before."[43]

Milojević's writing described to a great extent the spiritual climate after the end of the First World War. The wish for merging with the contemporary development was a strong impetus for many, although the persistence of tradition was still alive in the multifaceted artistic and cultural scene. However, the yearning for tradition was sometimes presented as obsolete and even worthless.

Sibe Miličić in his essay: "One Summary That Could Be a Program," written in 1920, noted that already before the First World War a search for new avenues took place. Miličić quoted names of poets that announced the forthcoming changes. In America it was Whitman, in France Verhaeren, in Germany Rilke and Mombert. Comparing the achievements of these writers with the "older generation" of Yugoslav poets, Miličić stated that there is hardly room for comparison. Yugoslav poets remained within national boundaries while European poets depicted general aspirations of mankind.[44] The more recent contributions of poets managed to transfer only the formal aspects of foreign poetry, but could not identify with the new horizons, remaining followers and not truly becoming contemporaneous. However the youngest generation of poets differs in this aspect very much. These poets, declared by the critics as less talented, have instilled their poetic work with new messages, very much like their European counterparts: "They may be, in comparison with the refined older poets disheveled, but they walk in step with the whole of the European literary youth. In truth they give themselves, open up new horizons, being in the first ranks."[45]

Furthermore in this article, Miličić while referring to the duality of the spiritual and material world maintained that the spiritual world is the basis of poetic creations. Thereafter followed the conclusion that new poetic heights will be achieved when mankind is liberated from all material aims. A new and never heard before poetry will spread around the world. This will be the poetry of cosmic love. It is noteworthy that the poets who gathered around the *Group of Artists* often sang about the cosmos.[46]

The feeling that the Serbian literature is at the crossroads, and that after the war an accelerated development took place, has caused speculation about the further directions of development. Thus Svetislav Stefanović pointed in the introductory article in the journal *Putevi* under the title "Towards Wider Horizons," that twenty years before he had posed a question to himself and to the Serbian writers, that is again pertinent: "Because today we are again at the crossroads . . . and we are asking ourselves: which road and in what

manner."[47] Stefanović considered that at the beginning of the century the first extensive spreading of boundaries of Serbian literature took place, although the central problem was at that time the liberation of the Turkish occupation. After the war a great leap forwards resulted, by entering in the area of more open and wider horizons.[48]

About this period of sudden growth wrote also Rastko Petrović in his autobiographical essay: "The General Data and the Life of a Poet."[49] Petrović wrote that he lived through the war, but did not kill a single man: the society did not consider him a sufficiently grown-up man for that. Later he grew, together with his homeland:

"His spirit was racing to conquer and pass all known boundaries at present, he was totally taken by this rhythm of speed. He made gigantic gestures that were funny for the one that calmly observed it. He encountered myriads of secrets that his spirit could not embrace and it seemed to him that his power of comprehension was leaving him . . . He was falling in incurable melancholy and dispair."[50]

Petrović as a poet and writer deeply felt the negative judgments about his poetic work. Marko Ristić tried to explain the reasons that led to the crises in the artistic and human conditions of Rastko Petrović:

"One has all this to comprehend, perhaps love, in order to understand what all that meant to the poet, what all that could and must have meant when at home, while returning first temporarily in the winter of 1921–1922 and then permanently in 1922, and bringing with him all that he considered his poetical and essential message, when he only found misunderstanding and mockery, stupid journalistic mockery, a total misunderstanding of a tough provincial environment, malice and stupid jokes, idiotic wittiness and malicious imputations, when he has hit against the wall of rationalism and narrow mindness, pettiness and envy."[51]

The lack of understanding and rejection as well as the knowledge that changes cannot be accomplished concerning the narrow-minded artistic and poetic values brought Petrović to a deep depression and thoughts about suicide. That is why Petrović's poem: "The Time of Renewal," according to his friend the writer Marko Ristić, was born in the shadow of suicidal thought.

Petrović tried to adjust to given conditions and possibilities. Therefore he wrote himself: "He reconciled with everything and sometimes tries to understand. He holds nothing against anybody. *He is not asking that things should be surpassed, in all of it there is life, and it depends entirely from his attitude how is he going to accept all this.*" (Italics R.P.).[52] In this effort for adjustment

Petrović was very much helped by his belief and hope in the preparation of the future life, that will begin only with tomorrow.

The existing reviews of Petrović's books written by his contemporaries describe in greater details the negative reception of his poetic contributions. Thus the review of Miloš Crnjanski can serve as an example, written on the occasion of the publication of Petrović's book *Otkrovenje-Revelation*. Crnjanski wrote:

> "It was amusing to observe the false worry for the society, morals and traditions in connection with this book . . . It is even more futile, because of different interests to proclaim this book as a proclamation of an anarchistic group. This group—in fact a remainder of the simple, not to say banal, need of the literary evenings—is not existing. There are others in existence . . . *Revelation* without all this has a very natural place in our newest literature, and its date. Very much like our countries that are at the end of a historical period, our literature has started a new period. This will be hard to prevent by those who are disturbed by it."[53]

Perhaps one of the most impressive literary reviews was written by Isidora Sekulić, soon after the publication of the book by Rastko Petrović. In this review Isidora Sekulić expresses admiration for the young people that have "written, designed and bound in large covers the booklet of youth, joy, pride and folly and the booklet of poetic glory." So is the following paragraph from the review of Isidora Sekulić because of its imaginative and picturesque metaphors and its rhythmical phrases flow into a poetically transformed prose:

> "Rastko Petrović is a powerful young ship that has set its sails, and lowered its oars, and wound up its winches and flies like a seagull, and cuts like an arrow . . . And still Rastko Petrović is like a dragon, he beats with his tail so that the earth shakes, he is fiery and vigorous, around him is magic and fairy tales . . . And still Rastko Petrović is a real poet, who deserves all large lettering in the beautiful edition . . . And still Rastko Petrović is the strongest temperament of our whole poetry, a temperament that can burn to a handful of ashes his foolish teachers that are persecuting him because of his blasphemies of all that is responsible to God and Beauty for a general human import."[54]

Both Isidora Sekulić and Miloš Crnjanski mentioned in their reviews the inappropriate criticism of the poetic work of Rastko Petrović. In a similar fashion were judged other young poets, members of the modernistic movement. That is why the review of Milan Dedinac published in 1922 in the journal *Putevi,* as an attempt of interpretation of these rejections has acquired

a special importance as an artistic declaration. While discussing the book by Miloš Crnjanski *The Diary About Čarnojević,* Dedinac is re-emphasizing his reflections in the wish to explain the position of young writers. Members of this generation, including Crnjanski, were very much influenced by the historical and social development, as well as by a distinctive sensibility for the rhythm and spirit of the new time.

Dedinac considered the listless affectation of Cupid with his arrow as being at the present without relevance to this generation of poets. It would be very necessary to remember that the forefathers of this generation of poets walked under arms in the woods and waited for the Turcs on the roads. Sometime it was necessary to plow the fields early. Their grandfathers lived all their lives in provinces and heard little about happenings elsewhere or about big cities like Paris, not comprehending fully what Paris as a city looked like. That is why "the stories from the villages" were possible at the time, or the poetry of Jovan Jovanović-Zmaj and Vojislav Ilić. The young generation is told to support these literary achievements and even the poetry of Jovan Dučić who truly was a poet. But Dučić could not feel in his office all the haste of the trains on the bridges, nor the agitations and uneasiness of the present. The poets of the young generation sing in the rhythm of waterfalls, or the noise of the airplane propellers, or steamboat engines. The conventional forms did not correspond to their emotional state and disturbances; they depicted in their poems whirlwind cities, unreal landscapes, movie theatres, daybreak at sea, snowed in distances.[55]

Marko Ristić gave another interpretation of the division that existed in Serbian literature after the end of the First World War. Ristić stated that all that had been written at that time was scrutinized using mainly one criterion. Thus the literary works that did not comply with a certain educational and nationalistic system, although obsolete, according to Ristić, were neglected, even suppressed. Due to such simplified evaluation the critics and the public saw only in the newly written works "modernism, lack of understanding, triviality and disorder."[56]

Because of this confrontation the young writers felt united not only by the wish for collaboration in building a new artistic and social reality, but also by the almost generally negative reception of their work, in spite of the fact that their works presented a varied and versatile spectrum of literary achievements.[57]

Ristić defended the newly written works maintaining that they do not represent a fashionable whim, or a wish for originality, but rather present a necessity. The new poetry constitutes an entity, although it never was harmonious singing in one accord of similar motives of unified voices in a choir. This

poetry opposed arbitrary limitations not only concerning the form but also the content of literary works.[58]

There is a distinctive similarity in the artistic conceptions between literature and fine arts, especially while observing from a vantage point, in retrospect.[59] As in literature so in visual arts there is an exceptional development. The critics and essays published in the dailies and professional journals depict vividly this period. Thus Mihailo Petrov reviewing the exhibit of Petar Dobrović voiced his opinion that the post-war period brought in a powerful sweep the victory of the contemporary artistic ideologies.[60]

Petrov thought that the time segment from the end of the war until 1922 is expressed as vigorous flourish of the artistic life, its most prominent feature being the confrontation of the old and the new. The main reason for this division were idealogical differences. The final result was a new strain of artistic and esthetic thought, contemporary in spirit and outlook. The Fifth Yugoslav Exhibit in 1922 proved the dominance of the younger generation of artists, pointing to their kinship with the artistic development of Western Europe.[61]

One of the most important manifestations of the visual arts in Yugoslavia was the organization of the Fifth Yugoslav Exhibit in the hall of the Second High School in 1922 in Belgrade. The writer Todor Manojlović, who also often acted as an art critic, left an interesting report of this exhibit. Manojlović wrote that there were a hundred and fifty participants from the older, younger and youngest generation, members of all better known groups and associations. Over 800 works were exhibited and therefore a more detailed overview of artistic achievements was possible. Manojlović stated that in the relatively short time period of about some twenty years remarkable results were achieved. In this evolution the first stage is marked by the creation of the so-called "national style." This style developed under the influence of the artistic achievements of Ivan Meštrović. But Manojlović feared that Meštrović's archaism and pathos could change in the works of lesser artists into a lifeless and dried up mannerism. Therefore the question is raised as to the direction of further growth. However Manojlović thought that a positive and affirmative answer was the Fifth Exhibit itself. Manojlović felt that this exhibit presented a new generation of artists and a new artistic ideal.[62]

Manojlović believed that the youngest participants, painters and sculptors had reached in their work the mainstream of the artistic development elsewhere. The concurrence of their aspirations with the achievements of European artists showed even more the strength of their talents and artistic insight:

"While inspecting the works from these different groups in a condensed manner, we have experienced yet still very clear our art history of this last twenty years ... a historical exhibit in our midst, projecting the old and the new in their historical interdependence and resolved continuity, directing us to observe the necessity of their origin and existence objectively, and to judge the people and things not according to the movements that they belong to, but only according to their internal individual value."[63]

The complexity of artistic achievements in literature as well as in the visual arts and music, in the course of the 1920's and 1930's is also reflected in the essays and critical reviews from this period. Thus the reviews of pictorial art written by Rastko Petrović reveal many accurate and valuable observations. Therefore the contributions of Rastko Petrović in addition to his literary achievements extended to the field of fine arts. His thorough knowledge of the criteria of art criticism, comprehension of perceiving similar problems in different art fields, capability of grasping fundamental values of single artists, made him one of the most influential art critics in the period between the two world wars.[64] It was the opinion of Lazar Trifunović that Petrović's work in this field helped to found and establish the synthetic art criticism.

Petrović as art critic maintained that the period of nationalism had passed, especially if based on a false presumption of folk temperament. Therefore while reviewing the exhibit of a group of painters from Belgrade in 1921 Petrović stressed that the national trend did not create works of value, nor impress the public abroad. Until the artists have learned the language of European artists, they are not going to be able to find what is important for themselves or to be able to express it so that it becomes valuable for the rest of the world. Presently a group of artists that included Bijelić, Dobrović, Miličić, Popović, Šumanović and Milunović can very well represent Yugoslav art in Europe.[65]

In the critical review of the exhibit of Milo Milunović and Sreten Stojanović, Petrović stated that this occasion was a very pleasant one, since it gave him an opportunity to write about artists that he first met in Europe a few years earlier. While realizing that their works presented an exceptional artistic value, Petrović expressed doubts about the future work and working conditions in their native land. Petrović correctly anticipated the difficulties that these artists had eventually to face. It was only six years later that Sreten Stojanović in the capacity of art critic for the journal *Misao,* addressed a similar message to Dragan Beraković and Momčilo Stefanović. Stojanović in fact advised the artists to return to Paris, since he did not believe that they would sufficiently progress by staying in Belgrade. Stojanović stressed that the

local milieu would not provide encouragement nor preserve valuable achievements.[66]

The pressure of the artistically undeveloped environment was so strong that many artists became decorators and portrait painters of the bourgeois-class. Besides Belgrade did not have an exhibit hall, so the exhibitions took place in school assembly rooms or even corridors. It was only in 1922 that thanks to the initiative of Branislav Nušić the founding of the *Association of Friends of Fine Arts Cvijeta Zuzorić* took place and with it the planning of the exhibit pavillion in Mali Kalemegdan.[67]

It was a frequent occurrence that the exhibited art works were not sold. Thus Milan Kašanin stated with discontent, that after such an important manifestation of the achievements in the fine arts field like the Sixth Yugoslav Exhibit nobody was interested enough to negotiate an offer for any of the exhibited works—not even a city, association or any individual.[68]

At the beginning of the 1930's the situation did not improve. This fact was discussed in a review by Milan Kašanin of the exhibit of Milan Konjović. Kašanin pointed first to the exceptional progress of fine arts in general especially when compared with the situation before the war. The difference is obvious in the quality of the works but also in the quantity of the produced art works.

Kašanin considered it important to stress that this artistic upsurge did not find adequate reflection in the society. There are no possibilities for founding and maintaining a journal dedicated to the important issues and topics of fine arts, or for a dispersion of information about art by the help of books and monographs, he noted

"There is no due attention given to schools of art or museums. The consequences of such policies are very noticeable. Not only do young artists have to live abroad because of the lack of support, since their surroundings were not conducive to their artistic growth and further development, but even mature artists never found sufficient moral and material gratification. That is why there is always a steady emigration of artists living abroad, especially painters, even among the best of them."[69]

Miloš Crnjanski wrote also about the neglect of young artists. While reviewing the exhibit of Miloš Golubović, Crnjanski pointed out that it is somewhat humiliating to be a young artist in Yugoslavia. Since Golubović is young and not inclined to paint nude posers or "Kosovo suppers" he will remain unknown. However, knowledgeable visitors will stand long before his portraits. This is lamentable, not so much for the artists as for everybody else. There is a custom of taking care of the artists only at the time before their death.[70]

Crnjanski expressed in 1922 a similar discontent in the review mentioned earlier of the newly-published book by Rastko Petrović *Revelation*. Crnjanski advocated the acceptance of new artistic values pointing to the falsehood and backwardness of the habitual and established criteria.

Due to such conditions there existed a "voluntary artistic emigration," in the words of Milan Kašanin. Lazar Trifunović provided another explanation of these migrations many years later. While writing about Moša Pijade, Trifunović reflected about the confrontation that existed between the old and the new artistic ideology. It was basically a conflict of the formulation of nationalism as expressed in operatic literature of a lighter genre and of the art forms with unassuming themes. It was also a clash of two worlds: one that was fading away and that was inclined towards folklore and national romanticism, and the new facing nature and light. This dichotomy at the very beginning of the Modern Movement made it necessary for the sons of rural Serbia to disperse to different European cities and centres.[71]

Another more general explanation of this phenomenon was left by Isidora Sekulić in her chronicle *Ambitions, Smoke*. The work presented an artistic transposition of real life lived by many, observed by a keen eye of a writer and consequently acquiring a deeper insight. In this work, very much like that of the *Chronicle of the Provincial Graveyard,* Isidora Sekulić described the departure of the young from their parochial nests, in the wish for fulfillment of their ideals. Unfortunately their creative ambitions are halted by a web of circumstances. In the end, these exceptional people are lost to their homeland. In the chronicle *Ambitions, Smoke* Isidora Sekulić tried to explain the destiny of the young poeple, reaching the conclusion that in part the culprit for this exodus is the ancestral land.

These are the reasons for the advancement of education and the building of a new appreciative public, capable of understanding and supporting the development of fine arts. Therefore the trend increased toward association within several journals, literary editions and groups espousing different artistic ideologies. Thus in 1919, at the time when the *Group of Artists* was formed, the journal *Misao* (The Thought) was founded. This journal, described in its subtitle as a literary and political journal, projected a wider scope of interests, covered in addition to the literary events the political and economic scene. The journal lasted for two decades, a fact noteworthy in itself. In the period between 1922 and 1923, at the time when Ranko Mladenović acted as its chief editor the journal *Misao,* according to Marko Ristić, played an exceptional role, by publishing a number of articles which helped to establish a new poetic ideology.[72]

The publication *Albatros,* with editors Stanislav Vinaver and Todor Manojlović; attracted writers belonging to the Modern movement. In this series were published the works of Crnjanski, Vinaver, R. Petrović and Kujundžić. Marko Ristić has singled out three books from this series: *The Dairy of Čarnojević* by Miloš Crnjanski, *The Lightning-Rod of the Cosmos,* by Stanislav Vinaver, and *The Burlesque of Mister Perun, the God of Thunder* by Rastko Petrović. Marko Ristić believed that the books published in this series could serve as an evidence that the period at the beginning of the 1920's was rich with ideas and originality.[73]

The members of the literary association *Alpha,* located in Belgrade, considered that the root of their poetic explorations was contained in the poetics of the nineteenth century. Their artistic credo was according to Todor Manojlović: a revival of poetry by breaking with any indoctrination, and a liberation from outside criteria. It meant a return to individual sensibilities or intuition, as the only source all true poetry. Members of this group considered the poet Laza Kostić as their spiritual father and Charles Baudelaire as their predecessor. The only joint treatise of the group, *Alpha,* was published in the journal *Kritika* that appeared in 1921. Another attempt of collaboration was accomplished with the founding of the journal *Zenit.* The first issue of the journal was published in February of 1922. The journal wanted to help in creating a new art doctrine that would contain a new social and humanistic message. *Zenit* published the contributions of Rastko Petrović, Miloš Crnjanski, Stanislav Vinaver, Marko Ristić, Milan Dedinac. The journal attracted the attention also of foreign writers and artists such as Anatolij Lunačarskij, Vladimir Majakovskij, Vasilij Kandinskij, Ivan and Clair Gol, Marcel Sauvage, Jean Epstein and F. R. Berens. The vignettes and drawings were supplied by Mihailo S. Petrov, Sibe Miličić, Jovan Bijelić, Fran Kralj, J. Havliček, L. Suss, K. Teige, A. Hofmeister, A. Wachsmann. The pictorial contributions enhanced the content and appeal of the journal. In the eleventh number of the revue that appeared in 1922, on the front page the editor Ljubomir Micić published his *Zenithism Manifesto.* Micić argued that zenithism was a new art form from the Balkans and at the same time a manifestation of the freedom of the spirit. The journal *Zenit* is the first Balkan revue in Europe, and at the same time the first European revue on Balkan. This statement referred to the comparison with European examples although further explication pointed to an aspiration for an original and unique expression. Micić believed that the first task was the creation of a Balkan art and culture and then only the "balkanization of Europe." The creations of poets belonging to this movement represent a departure into the life, into the new time, reaching new heights. Micić further stated that Zenithism presents the

revival of the original man-hero in the spiritual incarnation of the Barbaro-
Genius: "We do not want to be European. We are of the Balkans—Easterners
... We want the balkanization of Europe ... The Balkan art is not an utopia.
Zenithism is a new art of the rebellious Balkans and or a liberated
Barbaro-Genius."[74]

At the beginning of 1923, in the issue that appeared in February of that
year Micić stated that the journal had acquired an international reputation for
Zenithism and the New Art. Since the journal had been in existence already
for two years it had attracted the attention of artists from abroad. Micić
quoted that until then twelve countries and over sixty journals had showed
interest about Zenithism as a movement, as well as to the ideological profile of
the publication itself. However Micić noted with regret that the journal is
neglected and boycotted in the moral and material sense in his own land. The
country, the society and the press are treating the journal and its editors in an
unfair and unjust manner. That all was happening in spite of the fact that the
zenithists have won an honorable position on the international field fighting
for the victory of the New Art and a unifying all embracing human culture.[75]

In a further effort for gaining recognition, the editors of Zenith arranged
an international fine arts exhibit. For this occasion more than one hundred
works from well known artists were solicited. Among others the works of
Archipenko, Delaunay, Moholy-Nagy, Zadkin, Kandinskij and Lissitsky
were featured. In the text of the catalogue of the exhibit Micić wrote:

> "It should not be forgotten that the zenithists have marked the recent history of our
> cultural youth the first epoch of the Serbian artistic progress and of the first poetic
> revolution that leads to the Balkan culture, to the Balkan civilization, to the first
> cultural manifestation away from Europe. Stay away from Europe. Europe is not
> original and has committed in the past most cruel offenses that history remembers.
> More within ourselves. Balkan. Slavs. The harder to reach the goal, the more
> strength in the thrust, in order to achieve the creation of new and newer works."[76]

A very interesting testimony about the influence and importance of
Zenithism was left by Slavko Batušić. Batušić pointed out that a considera-
ble number of European writers had gathered around Zenit and their
contributions were published in the original language. Batušić also wrote
about the friendly ties that existed between the composer Josip Slavenski and
Branimir Poljanski, an active participant of the Zenith movement. Poljanski, a
co-editor of the journals shared the views of his brother, founder of the journal
Ljubomir Micić.[77]

Josip Slavenski was also obsessed with the Balkan idea, Balkan music and
general Balkanization. Batušić thought that the interest of Slavenski for the

Balkan was spurred by a similar outlook of the brothers Micić who considered the Balkan and the Balkans as an exceptional autochthonous power leading to a cultural revival. Therefore it is interesting to mention that in the journal Zenith published in 1925 the composition *Danse Balkanique,* with the subtitle *The Tambourica Players* was included. The date of the composition, as printed, appeared to be 1912, proving that Slavenski's interest in the native folklore stemmed from the early days of his youth.

According to Batušić's recollections Slavenski came to Paris in 1925 together with his friend Poljanski. While living there Slavenski was engaged in composing his symphonic suite *Balkanophony.* Batušić thought that this composition was an indication of Slavenski's obsession with the existence of the genuine, unbridled Balkan antithesis to the Western decadence and the musical and esthetic speculations about the dodecaphony. Slavenski considered even as Balkan the archaic tunes of Medjimurje with their acrid rhythm and melancholy melody.[78] The composing of *Balkanophony* was finished in 1927. Slavenski wanted that this work present a manifestation of the sounds of Balkan, the country of exuberance, strength, versatility, the country of courageous joy, slavic mysticism, oriental nostalgia and archaic songs.[79]

The chamber music of Josip Slavenski has achieved international recognition. Among his compositions, sometimes the titles refer to the essential qualities of their musical content pointing to the persisting attraction to the folk idiom of Slavenski's homeland in a broader context. Among these works the *First String Quartet* op. 3 composed in Prague in 1923 deserves special attention. At the prestigious International Festival of Modern Music in Donaueschingen in 1924 the composer received an exceptionally favorable reception of his work. The laudatory reviews opened for him the doors of European concert halls and of the publishing house Schott in Mainz, where his works from then on were published. *The First String Quartet* is comprised of two movements: Singing—Largo molto intensivo, and Dancing—Andante deciso—Allegro Balcanico. The second movement, with the subtitle Allegro Balcanico, develops into a dance-like movement, its rhythmical pattern and accelerated tempo projecting a likeness to the national dance *kolo.* The critics acclaimed this work as "the most valuable musical content on the program," and as "the music with a folk soul."[80] Among the piano miniatures a special place should be reserved for *The Balkan Songs and Dances* in two volumes, published in the Schott's edition.

Four piano pieces composed between 1910 and 1917 Slavenski later arranged as a suite under the title *From the Balkans.* Later on Slavenski arranged the suite as an orchestral piece. The second movement of this suite

From the Balkans under the title *The Tamburica Players from Zagorje* was published in the journal *Zenit* in 1925, as was mentioned earlier.

Thus the period between the two world wars was marked by an exceptional richness and variety of artistic conceptions and creations. Besides the clearly expressed desire for joining the mainstream of European development, there existed at the same time a wish for the preservation of tradition and of an original expression. This dichotomy was expressed not only in the works of the artists but also in the essays and critiques addressed to single performances and creations, in literature, visual arts and in music. However in the course of time even the avantgarde artists changed eventually their outlook, due to the greater involvement and participation in the many functions and capacities of the cultural life; as teachers, critics, collaborators, editors in varied journals and schools administrative functionaries of professional bodies and associations. Answering to the needs and demands of the society, that was reflected in the reception of the newly composed works, they took over the didactic functions of educators and builders of culture, that they had previously rejected. Consequently they have consciously diminished the volume of their own contributions, considering as their duty the consolidation of a new cultural and artistic environment.

THE BUILDING OF MUSICAL CULTURE AND
THE POSITION OF MUSICAL ARTS
IN THE CONTEXT OF GENERAL ARTISTIC MOVEMENTS

Besides the *Group of Artists,* one of the first associations of representatives of different branches of the fine arts, there came into existence in Belgrade during the 1920's and 1930's a number of professional bodies uniting writers, artists and musicians. Very important to such development was the role of already existing journals as well as newly established ones that served as expressions of different groups of varied profiles. Therefore this period presented a reexamination of the present positions as well as the corroboration of the new artistic viewpoints.

Next to the founding of the *Group of Artists,* the year 1919 marked the announcement of preparation for the continuation of publication of the most prestigious literary journal: *Srpski Književni glasnik* (The Serbian Literary Herald). The new series of this journal started again in 1920 under the editorship of Bogdan Popović and Slobodan Jovanović. It was the wish of the editors to publish the old contributors and also to attract the representatives of the *Moderns,* as the young writers were then called. The editors wanted to achieve a closer contact and collaboration with the young authors who were at the beginning of their literary careers in order to obtain authentic explanations of their positions, and a more clear formulation of their views.

In the introductory article of the new series of *The Serbian Literary Herald,* Bogdan Popović addressed the readers with an invitation for collaboration. Popović stated that people do not agree with each other often because of a lack of understanding, or even because they do not know the outlook of a particular individual whom they have declared to be their enemy. In order to

31

remedy such a plausible confrontation Popović advocated the need and importance of knowledge and information about different positions and outlooks. Popović believed himself to be of an open mind willing to understand what is new. Recently he noticed that he sometimes was not comprehending the output of the youngest generation of poets. Should he then judge negatively their products or would it be more prudent to address himself to the poets themselves and ask about their goals and aspirations, to give explanation for what is not understood. In other words, the policy of the *Herald* would be to point to the high position that the poets have in relation to the critiques, and thus to avoid the misunderstandings.[1]

In his invitation for collaboration, Popović showed readiness for the revision of his concepts about the youngest generation of poets. Popović wanted to stress that the poets rank higher than critics since poets are always vanguards even when they wander in the mist.[2]

It should be remembered that Popović at that time had already an established position as the acknowledged and authoritative critic, professor and literary historian, as well as the editor of the best literary journal. This invitation drew the responses hoped for—the writing of many texts that otherwise would not have been written. The young poets were in the process induced by this invitation to clarify their positions themselves.

Due to this invitation of Bogdan Popović, Miloš Crnjanski wrote for his poem *Sumatra* a commentary: "The Explanation of Sumatra." This "Explanation" due to the acuity of perception of the post-war situation, where the experienced terrors of war were still vivid, presented a wider poetic and human context. Crnjanski captured the feelings that prevailed among the young writers around the world.

In the "Explanation" Crnjanski wrote:

"The world has yet not heard the terrible storm above our heads. While down there it has shaken, not the political relations, or literary dogmas but the life itself. These are the dead that are extending their hands. They must be paid. While the art meant distraction, after so much time we, as a sect, bring unrest and revulsion in words, in feelings, in thinking. If we have not yet expressed it, we have it undoubtedly in ourselves. From the masses, out of earth, out of time it passed into us. And it can not be suppressed."[3]

Furthermore Crnjanski tried to explain the new content and form of art works:

"The newest art, especially the lyric poetry prefers new sensibilities. Without crude quadruples and drummed up music of the former metrics, we give the pure form of

an ectasy . . . We try to express the changing rhythm of the dispositions that was discovered long before us. To give an exact, the most spiritual picture of thoughts! To use all the colors, swaying colors of our dreams and foreboding, the sound and whispering of things, until now despised and dead . . . Once again we are letting our form be influenced by cosmic forms: clouds, flowers, rivers, brooks . . . That is why our metrics are personal, spiritual, nebulous like the melody."[4]

Crnjanski felt that everything in the world is connected and interdependent. Even if we are distressed by the death of a friend, this loss will be somewhat beneficial. Crnjanski stated that he did not fear death any more, discovering the soothing presence of the surrounding: "I lost the fear of death. The link with the environment. Like in a wild hallucination, I rose in the infinite morning mists, to stretch out my hands and caress the far away Ural mountains, the Indian sea, where also the rosy color of my face went. To caress the islands, love, those in love, pale figures." Crnjanski felt deep down, although he resisted admitting so, a great love for the far away hills, snowed-in mountains all the way to the icy seas. This discovery and exaltation helped him to transcend the immediate human sufferings in the chaos created by the First World War. These feelings are reflected in the first two verses of his poem *Sumatra,* in particular with the above mentioned added comments of the author.

Now that we are without worry, light and tender,
Think: how quiet and white are
the peaks of Ural.
If we are saddened by a pale face
that we lost one evening,
we know that somewhere a stream
flows in his place in a pink hue![5]

A special importance for the development of Serbian music prompted Popović's invitation for collaboration addressed to the younger composer and music writer Miloje Milojević. Milojević became a steady contributor to the *Glasnik* already in 1910, after his graduation from musical studies at the Music Academy in Munich.

This was a great honor for the young composer, since Popović managed to attract to his journal the most prominent personalities of the literary and artistic life. Before Milojević's departure for Munich, as a student of the College of Philosophy, Milojević attended lectures of Bogdan Popović and Jovan Skerlić during the school year of 1904–1905.

In this respect it is interesting to note that Bogdan Popović in his lectures when discussing the arts devoted much attention to music. Popović, musically educated, an accomplished violinist, was well informed about musical art. It was his opinion that music occupied the first place among the arts and within the spiritual culture. However, the invitation handed to Milojević was not incidental as it may seem. According to Petar Konjović, *Glasnik* did honor Milojević by extending him the invitation for collaboration, but at the same time, Milojević with his contributions raised the importance of the journal.[6] It is a fact that Milojević's participation steadily increased in the period between the two world wars. He eventually became one of the leading personalities of the musical scene in Belgrade.

The formative influence of Bogdan Popović on Milojević as a music critic was very decisive, although it has not yet been acknowledged. The proof for this statement is contained in studies, critiques and articles that Milojević wrote for *Glasnik* and other professional journals. The interest and confidence that Popović showed towards his former student gave the impetus and direction to Milojević's efforts in writing some of his best theoretical works.

The invitation of Bogdan Popović and his willingness to publish music articles points to his readiness to further the development of music. Popović's support should be more appreciated since music did not have at that time an equal standing when compared with other art disciplines. Miloje Milojević and Kosta P. Manojlović among others wrote several articles exploring the subordinated role of music.

The prominent role that Bogdan Popović played in the foundation of the University Chamber Music Society *Collegium Musicum* also pointed to his conviction that music should be part of the general culture. Popović became the first president of this society while Milojević exercised the secretarial duty. The Dean's Report from the school year 1924–1925 stated that on May 11th of 1925 the members of the faculty of the University in Belgrade had founded the *Collegium Musicum.* The society had the task to cultivate chamber music and to educate the musical taste of the student body. The first concert took place on April the 21st, 1926. For this occasion Popović had prepared an introductory lecture. Popović wanted to establish the position of music among other arts, as well as the position of music at the University and its educational value. Popović said: ". . . the University should be some kind of centre for all spiritual manifestations of a people. Music is part of general culture, and not a subject that should be studied by a group of professionals . . . All colleges are represented in our Collegium Musicum." Therefore Popović concluded: "It is our wish that the University should help in the best fashion the musical art, one of the greatest and noblest among the arts.[7]

This conclusion presented the essence of Popović's belief about the importance of musical art, and at the same time it manifested his continuous support for its further development.

After Popović's introduction, Milojević presented a commentary with a brief analysis of the featured compositions. These concerts, held on a regular basis, helped to promote the interest in musical art. Milojević was in charge of the selection of the compositions, the study and preparation for the concert performances, in addition to his role of conductor. His commentaries facilitated the comprehension of performed music, thereby increasing the appreciation and enjoyment of the public.[8]

The carefully selected concert programs deserve to be preserved as examples of systematic and methodic work on musical education of the university students and interested public. Therefore the concert appearances of the University Chamber music society *Collegium musicum* constituted an important development of the musical and general culture. The concerts contained works of significant composers that influenced the consequent development of different periods of musical art.

In the period between 1926 to the beginning of the Second World War, seventy concerts took place in arrangements of *Collegium musicum.* These concerts drew the public to fill the concert hall of the University year after year.[9] The success of these performances as well as of the Association *Collegium musicum* had justified the hopes of Bogdan Popović. Music finally obtained the position at the University in Belgrade that was habitually reserved for it in the curricula of all the better known universities in Europe.

Within the activities of the society *Collegium musicum* Milojević undertook the publication of about ten volumes of compositions of Yugoslav composers. Milojević's selection, editing, and technical appearance of the composition showed the application of contemporary and highly professional standards. Peter Konjović, the biographer of Milojević considered that this edition presented: "a major step in the Europeanization of Serbian and Yugoslav musical culture."[10]

In spite of many successes in his work at the University, MIlojević's professional standing was marked by difficulties. Recorded in the minutes of the meeting of the faculty of the College of Philosophy on 31 May 1926 was the fact that a proposition read and signed by Bogdan Popović, Vlada R. Petković and Viktor Novak recommended that the former assistant Miloje Milojević be promoted to the position of associate professor of Music History in the Department of Art History. The minutes read furthermore: "On this occasion it is suggested that the Department of Art History be divided in two sections: the chair for the History of Plastic Art and the chair for Musical Art."[11]

However, Milojević was not elected and the founding of a new chair for music did not take place. The discussion about the election of Miloje Milojević continued in the meeting of March 5, 1927. The minutes of this meeting stated: "In connection with the motion of Messrs. Bogdan Popović and V. Novak that Mil. Milojević be elected as associate professor of history of music a long discussion was held. It was ended by the decision of the Board that Milojević be elected to the position of docent of history of music. On consequent meetings of March 14 and 17 of 1927 the discussion continued. Thanks to the persistence of Bogdan Popović, Milojević was finally elected to the position of docent. The fact remains that the motion filed by one of the most influential authorities of the University stirred a lengthy discussion and revealed lack of support of the majority.

It should be stressed that Milojević at that time had already four published books. In the edition of Geca Kon the first and second volume of *The Basics of Musical Art* had previously appeared. The first volume at the time of his election was published in a third edition.[12] Milojević also wrote a study: *Smetana his Life and Work* in 1924 that was published by S. B. Cvijanović. Privately he published his doctoral dissertation: *The Harmonic Style of Smetana* which he had defended in Prague in 1924. The first volume of collected works, under the title: *Studies and Articles on Music* was published by Geca Kon in 1926.

Although Milojević's difficulties were of personal nature, they were caused mostly by his insistence that music did not have an equal status among other art disciplines. Therefore even more recognition should be given to the unselfish and zealous efforts of Milojević and his contemporaries in building the musical culture. Among their achievements was the founding of the journal *Muzika*. With Milojević in the venture were associates Kosta P. Manojlović and Rikard Švarc. The editors jointly prepared a circular dated October 1927 with the invitation for collaboration. This letter identified their editorial policy as the wish to serve as a forum of opposite ideologies; it would publish the contributions of representatives both of traditional movements and the new trends in the arts: "*Muzika* will be a professional journal interested in all questions of musical art and culture. Therefore it will present articles, essays and scientific studies about the musical past and about the problems of the traditional area of thought, as well as it will follow with special interest the questions of modern and latest trends."[13]

This openness and wish for collaboration was similar to the invitation of Bogdan Popović in the publication of the New Series of the *Srpski kniiževni glasnik*. Popović wanted to bridge the gap that existed among poets and writers belonging to different schools of thought, but especially he strove to

attract the members of the "Modern." Milojević, as an associate of the *Glasnik* must have been well informed about Popović's editorial policies. Hoping to establish a similar exchange of ideas among the music writers, composers and musicians, Milojević started the journal *Muzika.* Like Popović, Milojević considered too that it was important to be informed about different opinions and viewpoints. The journal also was to be informative about the musical life and further development of musical art. He wrote: "*Muzika* will devote special space to the musical life in all of our country, as well as about the musical life in large musical centres in the world, but principally in the Slavic countries. As a professional voice in our midst it will gladly offer its special column to the institutions that work for the development of musical culture."[14]

The journal *Muzika* started appearing at the beginning of 1928, as the first periodical after the First World War with a European profile, according to the judgment of contemporaries.[15] Milojević managed to attract the younger generation of composer and music writer. By so doing, *Muzika* was able to add a complementary view to the previously established *Muzički glasnik* (Musical Courier). The editor Petar Krstić had started the journal in 1922 with the support of musicians sharing his views. Thus *Muzički glasnik* acquired basically a nationally oriented profile, nurtured with ideas reminiscent of romanticism.[16] Like many other journals *Muzika* did not last long; it ceased publication within its first year. At the end of 1929 the last issue appeared. The wish for the continuation of similar editorial policies as established in *Muzika* was fulfilled in the journal *Zvuk* (Sound). The founder and editor of the journal was Stana Ribnikar, who founded it in 1932 and managed to attract the largest number of Yugoslav musicians and music writers espousing generally a more progressive social attitude.[17] *Zvuk* was published until 1936.

The music society *Stanoković* started in 1928 the publication of the journal *Muzički glasnik* (Musical Courier) mainly as the bulletin of the society. However, after 1933 up to the beginning of the Second World War in 1941, the journal increased the number of its staff, expanding the scope of its contributions.[18]

Vesnik južnoslovenskog pevačkog društva (The Courier of the South-Slavic Singing Society) served as an official publication of the United Singing Societies from 1935 until 1936.[19] The tradition of choral societies was very much alive in the period between the two world wars. One of the oldest was *Prvo Beogradsko Pevačko Društvo (The First Singing Society of Belgrade)* established in 1853 as the first and only musical association of its kind in Belgrade. The society was successful in fulfilling the needs for a richer cultural life of a

newly established bourgeois society. Following hundreds of years of Turkish domination, this new social class evolved slowly from a predominantly rural population. The Society often performed in political and national manifestations highlighting the events with patriotic and artistic zeal.

The Society achieved remarkable artistic affirmation under the baton of Stevan Stojanović Mokranjac. Mokranjac was the chief conductor and "artistic leader" of the Society starting from 1887 until his death in 1914, in Skopje, after his retreat from Belgrade on the eve of the First World War.

After the end of the First World War the board of the society decided to engage as the chief conductor a former student of Mokranjac, Kosta P. Manojlović. Manojlović, at that time still a student in Oxford, England, accepted the invitation. He returned to Belgrade in September of 1919, shortly after the completion of requirements for his graduation. In his new capacity Manojlović strove to accomplish some of the unfinished tasks that were started while Mokranjac was alive. Thus Manojlović remembered how much Mokranjac tried to stimulate varied activities of the Serbian Singing Union. The Union was organized in 1903 with the help of the First Singing Society on the occasion of the celebration of its fifty years of artistic activities. Mokranjac composed and wrote the rules for the Union, which were later accepted. During this period the Croatian Singing Society wanted to establish closer contacts: "Since only through mutual acquaintance and togetherness it will be possible to accomplish that for which we are all striving, that is the cultural unity of all Slavs."[20]

All these efforts for collaboration remained mainly sporadic and accidental. Negotiations toward consolidation started only in 1923, at the time of Mokranjac's entombment in Belgrade, a public event which brought together artists of all viewpoints.

In the same year at a meeting of the board members of the First Singing Society a motion was made about the creation of the South-Slavic Singing Union. The rules were prepared and talks were initiated with the Croatian Singing Union and Slovenian Union of Singing Societies. At the congress in Ljubljana in April of 1924 a formal unification was accomplished, and Manojlović was chosen as the executive secretary of the Union. In this position Manojlović stayed until 1931 demonstrating, in a number of different positions, great industry and dedication. Manojlović especially labored to implement a lasting link to unite the cultural activities of the Serbian, Croatian and Slovene singing societies. He wanted even more than that—the foundation of the Pan-Slavic Singing Union. With these objectives in mind he attended the congress in Prague and Poznanj.[21] While in the capacity of the secretary Manojlović started the publication of works of

Yugoslav composers: of which project a total of 39 compositions were edited and published.[22]

As the conductor of the First Singing Society Manojlović tried to preserve the live tradition of the original interpretation of Mokranjac's choral compositions. He accepted the performance practice established by the composer himself. Manojlović, a former student of Mokranjac, sang in the same choir. Therefore he wanted to preserve with special care the true and unchanged interpretation of these works.

Among the numerous performances that Manojlović prepared with the members of the Society, a few deserve special mention. For example, the concert in September of 1923 in the National Theatre in Belgrade commemorated Mokrnjac's contributions.

The Yugoslav Concert that took place in 1926 in the same theatre should be mentioned. The seventy-fifth anniversary of the founding of the Society in February of 1929 was marked by a festive program. The Society organized concert tours in many cities throughout the country: in Sarajevo, Mostar, Prijedor, Banjaluka, Dubrovnik, Šibenik, Prizren and Skopje.[23]

As the conductor, but also as the "artistic leader", Manjlović selected and prepared with the members of the Society many masterpieces of polyphonic music, like the Mass for Pope Marcellus by Palestrina, and the concert dedicated to the works of Orlando di Lasso and Monteverdi. Manojlović performed also the works of English madrigalists. All these concerts are the true testimony to Manojlović's dedicated work in building the musical culture, introducing the public to the important works of choral literature. The choral repertoire also testifies to the enhancement of the members of the Society's music education.

These achievements were accomplished inspite of many unfavorable working conditions. The rehearsals were held in small rooms that were not sufficiently heated in winter, even occasionally not heated at all. Delays and difficulties resulted when the members of the choir were not regular in attendance. Manojlović noted all these obstacles in a written resignation addressed to the Society in November of 1931. He reminded the members of the board that the very same problems were cited in the resignation of Mokranjac in January of 1889: "I refer to this resignation in order to remind you what difficulties Mokranjac had to overcome and how he was criticized, similar to all that I was reproached for until yesterday. This as a restatement of the reasons as to where lies the reason for the poor progress of the Society."[24]

In spite of all these difficulties, *The First Singing Society of Belgrade* gave 41 concerts in the period between 1919 and 1931, under Manojlović as conductor of the choir.[25]

His resignation as conductor of the Society ended Manojlović's collaboration although many members of the choir appreciated his pedagogical and artistic qualities. True to their conductor and protesting the unjust and offensive criticism, forty members of the choir left together with Manojlović. This division of the Society was observed in the daily press. The paper *Poltika* commented on this breaking up within the Society in an article under the title: "Forty dissidents are going to perform tomorrow." These singers served as a nucleus of a new choral group *Mokranjac* named after Manojlović's teacher. In his autobiographical sketches Manojlović wrote that he was the ideological creator of the new society and its conductor. He commissioned and unveiled the first sculpted bust of Stevan Stojanović Mokranjac in the headquarters of the choral society *Mokranjac*.[26]

The Choral Society *Mokranjac* made many concert appearances. Among the highlights of their repertoire were the cantata *John of Damascus* by Tanjaev and the *Christmas Oratorium* by J. S. Bach.

Very much like Milojević, Manojlović contributed to the development and progress of many professional organizations. He persistently advocated the necessity of building and strengthening of the musical culture with all available means. Manojlović worked for many years in the music section of the *Association of the Friends of Arts Cvijeta Zuzorić*. Starting from 1924 to the beginning of the Second World War Manojlović participated in organizing many concert performances with a selected repertoire representing different periods of music. Due to his suggestion these concerts were designated as the *Public Conservatory*.

In the wish to stimulate the creation of new compositions of Yugoslav artists the *Association Cvijeta Zuzorić* sponsored open competitions. Submitted compositions were judged by a professional selection jury and if deserving awarded prizes. The competitions received favorable publicity and helped to establish the reputation of young composers, contributing new compositions to the repertoire and facilitating their first performances. Kosta Manojlović, in an introductory lecture for the concert dedicated to modern Yugoslav music in February of 1940 explained the criteria and the position of the Association in the support of contemporary trends in music.[27]

The founding of the Belgrade Philharmonic in 1923 became an important event in the cultural life of Belgrade. The formation of a professional instrumental body for the cultivation of symphonic music pointed to the fact that the musical life in Belgrade was improving in quality and distinction. Such growth was especially remarkable in view of the fact that there had not existed a tradition of instrumental musicianship. In Serbia up to the First World War the only transmitter of musical culture were the singing societies and middle

schools for music. An operatic society did not exist nor permanent symphonic or chamber music associations.[28]

It was only after the end of the First World War, when the situation in the country started improving in general that serious steps were taken for building necessary professional institutions to insure further development of music.[29] In the beginning, the same members of the philharmonic were also the members of the operatic orchestra. Such dedication and willingness to help were evidence of the common desire of many for enrichment and betterment of the national musical life. This spirit of solidarity and collaboration was vividly present not only in the musical art, but in other art fields as well.[30]

On the occasion of celebration of the tenth anniversary of the foundation of the Phiharmonic, Vojislav Vučković voiced his concern for the deserving members of the orchestra. Since the foundation of the Philharmonic, the diligent members of this orchestra had supported the ballet and opera repertoire by playing for all these performances. Vučković was concerned that this huge task imposed on capable players was not rewarded accordingly. He advocated the recognition of a higher social position of these musicians since they were not employed on a permanent basis. The musicians had become proletarians, performing under a life threatening situation, without adequate pay. Vučković suggested that it should be necessary to make the division between the operatic and philharmonic orchestra, so that the players could perform under less pressure.[31]

In another later article devoted to the beginning of the seventeenth season of the concert series, Vučković stressed the importance of the role that the Philharmonic had played so far. As the oldest institution devoted to the cultivation of symphonic music, the orchestra had rivals in this area of performance.

It had been only three years ago, he noted, that a radio-orchestra was established. Up until that moment the Philharmonic performed the entire symphonic production.[32]

Scrutinizing the policy of the repertoire, especially the conceptions of single concert performances, Vučković thought that the basic questions had not been solved in a satisfactory manner. The first obligation of the Philharmonic should be the performance of compositions of Yugoslav composers. Vučković considered this objective to be also the most important since it would help to awaken the interest of the public in the works of Yugoslav composers. The composers would benefit from such performances and the level of symphonic production would be raised. However the Belgrade Philharmonic did not fulfill such expectations.[33]

As a secondary task Vučković considered the importance of having an established criteria in the artistic policy and long ranging program planning. Only in such a manner would it be possible to present through selected works the most important stylistic periods in the development of music. Special attention should be paid to the needs and requirements of the musical milieu. Since the program policy is of general importance in governing the artistic policy of any outstanding musical bodies, it should not be left to the discretion of a single individual. Vučković argued that it would be hard to imagine that only one man, even an expert and well educated one could make all such decisions. In reality, this is the usual procedure of the institution: very often it is the conductor who makes all of the judgments.[34]

It is obvious that Vučković's criticism was based on a thorough knowledge of the working atmosphere of the Belgrade Philharmonic. Vučković performed in the course of 1936 the function of the general secretary of the organization. During his association with the orchestra Vučković planned serious but less conventional concert programs. He repeatedly insisted on furthering the musical education of the members of the orchestra. Vučković was also occasionally invited to conduct some of the concerts arranged by the Belgrade Philharmonic.[35]

Among other conductors deserving special mention is Stevan Hristić, who was very influential during the foundation of the Philharmonic. In the period between 1923 and 1934 Hristić led the orchestra as the chief conductor. During the 1930's his guest conductors included Mihailo Vukdragović, Predrag Milošević and some well known foreign orchestral leaders.[36]

Of special importance was the founding of the Opera in 1920 in Belgrade, in an atmosphere that reflected the recently ended war. Since the opera society had no building, the performances took place, on a sporadic basis, in the halls of Kasina or Manjež. Since this music institution presented a novelty without extensive tradition in the cultural life of Belgrade, so the managerial positions were assigned to equally inexperienced individuals, without professional authority.[37]

Miloje Milojević as critic of the *Srpski književni glasnik* and of the leading daily newspaper *Politika* followed with great interest the development of the newly established opera company. His writing about the first operatic performances, the repertoire policy and many other questions of importance enhanced his position as an informed critic, as well as informing and influencing his contemporaries. Observed from a vantage point and removed in time, Milojević's critiques present important documents enabling a better understanding of the not so distant past.

Stanislav Binički became the first director and conductor of the Opera. Since Binički until then had acted as the conductor of the Music of the Royal Guard, whose founder he was, so the formation of the operatic orchestra drew many former members of the Royal Guard. The operatic choir was made up of actors participating in popular theatrical plays with singing. Some of the actors with a naturally endowed singing voice became operatic soloists for supporting roles. The lead singers were foreigners, in the majority of cases of Russian origin. Although there were a number of talented younger beginners the functionaries leading the administration did not take notice of their potential possibilities. The education of the fledgling artists was not supported, in spite of the need of young talents for the future growth of the Opera company. Even in the case of a talented soloist like Pisarević, little was done to promote him as it had been expected, and no advanced studies were available to him.[38]

Milojević's review: "The Russians and the 'Operatic Singing' in our Midst," that was published in the daily paper *Politka* sheds considerable light on the situation in the Belgrade Opera. According to Milojević an operatic production, as a mainly vocal form, depends largely on good singers. However, a very important part of singing is correct diction and pronunciation. With this statement Milojević wanted to stress that the textual and dramatic component should not be subordinated at the expense of purely vocal effects, exhibiting the beauty of the voice alone. Opera should be a synthesis of music, drama, dance, stage scenography. From the unknown technician in charge of lighting up to the first foremost singer, in Milojević's opinion, all participants play an important role. Milojević thought that even each word should be clearly and lively pronounced, with a logical accentuation within the sentence itself. One unifying artistic feeling and emotion should prevail be it in the operas of Verdi, Thomas, Puccini or Čajkovskij. If this is not the case, then it is possible to speak about single singing roles or about the occasionally successful interaction of the ensemble. In such situations it would be impossible to speak about the ideal architecture of an opera, inspite of its fragmentation, about a profile of an opera, no matter how variegated, or about the impression of the whole.[39]

Milojević pointed to a negative trait that prevailed from the beginning of the existence of the opera company: the presence of exaggerated personal ambitions and interests. Milojević thought that an opera should present an entity, even if it required personal sacrifices. Instead of reinforcing the supremacy of single soloists, there should be a collaboration of all participants. Milojević also pointed out that there is a relatively insufficient number of native artists as compared to a disproportionate number of Russian singers, ballet dancers, members of the orchestra and choir as well as conductors and composers:

". . . this is a whole sea of Russian melofluence, of Russian warmth and soul, that we Serbes like so much—but still—it seems to me that it would have been better if they all have not lost their fatherland. We, who have to thank them for many purely artistic experiences, would have had by now without them our people in the opera, and if necessary one or two international greats, as it is customary elsewhere in the world. Besides the respect that I have for some Russian artists, there are some that I admire those who pay them, I still dare to say, that our opera, and we should remember the operas in Zagreb and especially in Ljubljana, for this amount of money would not be worse than this Russian that we are applauding today . . . We have our powerful and expressive Pisarević . . . and a number of young beginners that nobody thinks about or only by the way and superficially, so that they still wait for the opportunity to be educated and ready for the true artistic work. And this is our greatest sin . . . the administration of the opera has forgotten its first duty: to send our beginning singing youth to schools, for professional training."[40]

The argument that Milojević had made pointed to the lack of an operatic policy, leaving thus the uncertainty about the opera unresolved: "There does not exist the style of an entity, since the scene is not dominated with a single artistic spirit, but envy and a clique and a linguistic conglomerate that has no known name."[41]

Petar Konjović, a somewhat older contemporary of Miloje Milojević, stated that Milojević in his articles about the Belgrade opera had shown courage, almost at the beginning of his career as critic. Konjović thought that Milojević rightfully noticed the shortcomings and weaknesses in the decision-making of the Opera. Konjović shared the view that a repertoire policy did not exist, and that performances were chosen according to the wishes of the soloists: "since in a theatre led by principles a repertoire implies an entirely artistic, or artistic-educational, or artistic-fighting idea."[42]

The first operatic performances, according to Konjovic, were closer to being singing competitions, stressing the vocal volume and neglecting the idea of an entity. In spite of all shortcomings the public came. A period of relative prosperity and peaceful development encouraged the wish for novelty:

"The public wanting sensation, hears young, inexperienced ones whose noble instinct cries out for most careful methods of education, and is satisfied that Traviata succeeded Rigoletto, Werther followed Tosca, etc., and nobody asked whether this performance had a certain style and therefore sense? Whether this public can be ennobled by the musical artistic sensations, impressions that widen spiritual horizons."[43]

The founding of the Opera and Belgrade Philharmonic imposed again the question of professional training of young musicians. In Belgrade the Music

Academy did not exist: only two middle schools existed. In 1899 the Serbian Music School was founded on the basis of a proposition made by Mokranjac. This first middle school operated under the roof of the First Singing Society of Belgrade.

On the occasion of the 25th anniversary of existence of the Serbian Music School in 1924, Kosta P. Manojlović as professor and secretary of the school wrote a report in which he pointed out that the school was started due to the efforts of the founder and the devoted work of teachers. The school although not supported by a long-standing tradition managed to trace the path to the present musical education and offer directions to those who attended it. This school through its devoted work was preparing the foundation of the Music Academy or Conservatory.[44]

Before the beginning of the Balkan War in 1911 the Music School *Stanković* had opened its doors. These two schools, Serbian Music School and Music School *Stanković*, in many ways laid the groundwork of a more profound development of musical culture.

The official plan for Music Academy was announced in 1921, but the founding did not occur. The allocated budget was spent for other purposes. In 1929 a new commission was formed for the preparation of a new decree. Manojlović was among the members of the committee. A very favorable decree was worked out, yet the proposition did not materialize.[45]

Thus Petar Konjović wrote:

"As a rule, ministers of education and their secretaries were people, that in spite of their other qualities, did not have understanding of art and artists. They saw artists as bohemes, as some *gypsies* that presented a nuisance in the office of the minister, whose only responsibility should be education and culture. That culture comprises art, and constitutes a very important part, that the arts require their own space, they did not realize. Although they did not want to be burdened with such worries, there were few exceptions."[46]

The disregard for the function of the arts in society has caused many difficulties. At the beginning of this century, and even after the end of the First World War, many artists who sought employment, after the accomplishment of the higher education abroad were placed as fine arts teachers in middle schools. Moša Pijade wrote in 1912 about the fate of "Only Serbian artists are the unfortunate ones who throw away half or even more of their time on the barren work of a high school teacher of drawing."[47]

This was the fate of the sculptor Sima Roksandić. After his return from Munich, he could not find a position in Belgrade. About one-half of the

middle schools had been closed by the decree of Andrva Djordjević who was at that time the minister of education. After a hard search the sculptor was placed as the teacher of art in Kragujevac. He was employed full time substituting, in addition, for two teachers. Sreten Stojanović wrote about this period of Roksandić's life: "For full eight years this artist whose splendid career was prophesied in Munich had only on holidays and Thursday afternoons the free time to devote to art and individual work. It is no wonder that for this eight years, although in his prime, he could finish only eight works."[48]

Along the same road passed also Miloje Milojević after his return from Munich. He started his professional career in Belgrade as teacher of music in the Fourth, then in the Third and finally in the Second High School in Belgrade.[49] A testimony about the quality of musical education was left by Petar Konjović:

> "In High Schools then . . . music was taught only in the two lowest classes, where some meagre basics about music theory was presented. Occasionally in some schools, violin was taught as an elective subject and the older students had choir singing, with the only purpose to arrange an annual festivity where the student choir would be presented to the public. About a pedagogical method of music education there could be no mention."[50]

The organization of the Department for Arts spearheaded by Branislav Nušić meant a favorable change. The Fine Arts had been finally acknowledged to have an equal rank in the Office of Education.[51] From October of 1920 until June 1922, Milojević worked in the Department for Arts. During this period Milojević worked to inform the leading personalities about the importance of the founding of the Music Academy, as the highest institution devoted to music education.[52] Milojević also tried to establish a public awareness of this important issue and supplied pertinent information in many articles. He published a lengthy article under the title: *For the State Conservatory* in the journal *Srpski muzički glasnik* in 1923. Milojević pointed out that after difficult war years: "the cultural wave from Europe passed also over our soil . . . our cultural society, agitated and stirred by noble ambitions and actions of conscientious culture-fighters clearly showed the tendency to rise to heights of West-European culture."[53] Milojević thought that the upsurge of cultural growth dictated the foundation of this advanced music school. At the Middle School for Music in Belgrade in the period after the war the number of students had grown to eight hundred. Besides, the Music School *Stanković* had two hundred students. The total number of students taking music lessons, including those studying with private music teachers, must have

been at least two thousand. The Conservatory could accept these students and offer a chance for specialization of young professionals so much needed in the musical life. Milojević predicted that the Conservatory would produce a host of young artists that could take part in different areas of public life. The composers would create new works, the performers would present these works as well as compositions of the famous music literature. All these aspects of a richer musical life are now missing, a lamentable fact that is known.[54]

Milojević concluded that with the foundation of the Conservatory, the Philharmony as well as the Opera Orchestra would gain educated artists thereby enhancing the quality of performances. The Conservatory would include the department for ballet and acting studio contributing to the development of theatrical art and dance. The building that should house the Conservatory could serve many functions. Since there is an appreciative public, many concerts and cultural events could take place in this structure. Milojević stated with regret that many cultural manifestations did not take place because of lack of available facilities. Even the performances that take place lose the quality due to the inadequacies of available space. He concluded: "Our education has lost a focal point and our culture has suffered a setback for decades."[55]

Finally in the course of 1936 a new decree about the foundation of the Music Academy was announced. The writing of the decree involved Milojević, Konjovic, Manojlović and Krstić. The final redcaction of the decree became official in March of 1937. Kosta P. Manojlović, Stevan Hristić and Petar Stojanović became first professors, while Manojlović in addition served as the first rector of the new school.

The placement of new teachers and the purchase of necessary music instruments were temporarily halted when the Main Comptroller office filed a complaint.

Manojlović wrote in his autobiography:

"It seemed as if an unknown hand was constantly holding back. While I was forcefully working, trying to form the divisions so that nothing would be missing, and losing my nerves since I had many sleepless nights, waking at 3 a.m. and already at 5 a.m. at day break starting the business in the Academy—things in the Office of Education did not move. Salaries were stopped due to the complaint of the Main Comptroller so I took a loan from Sveta Rajkovic, the book store owner."[56]

Thanks to such devoted attention, the work in the new Music Academy started successfully. The following recollection of Manojlović shows how hard

was the beginning: "When the registration started for the Middle School, attached to the Academy, and we did not have the furniture, I borrowed from the National Theatre several tables, chairs and benches in order to hold the registration. In such an improvised office myself and Pera Stojanović were sitting, while I personally did the registering."[57]

In the course of the next two not fully completed years, until September 1939, while heading the Academy as its rector, Manojlović collected twenty thousand books and different music materials for the newly established library at the Academy. Manojlović wrote: "I knew that the musicians need the music literature as the daily bread . . . and that out of their means they personally cannot afford it. In my dreams I was envisaging a great Library of the Music Academy of national importance with people working in it, utilizing the results of past generations and I was happy as a child for each new volume that we received or bought."[58] The selfless and devoted efforts of Kosta P. Manojlović as the first rector of the Music Academy established the solid foundation for further growth of this institution.

The founding of the Music Academy almost coincided with the establishment of the Fine Arts Academy. Thus the year 1937 marked an important date in the cultural history: the long awaited founding of two educational institutions of higher learning, dedicated to the cultivation of the arts. The consequent favorable results have justified the expectations. Both academies produced highly specialized professionals and young teaching staff for different positions in schools and professional bodies. Creative work was stimulated since there were more favorable possibilities for performances of newly composed works, exhibitions of artwork and publications, as well as for the critical evaluation of new works. All these activities influenced the spiritual climate of the whole society which in turn was reflected in the output of composers, writers and painters. The artistic life of Belgrade has reached a higher level of accomplishment thanks to the existence of these institutions.

THE CONTRIBUTION OF MILOJE MILOJEVIĆ
IN THE ROLE OF A CRITIC, MUSIC WRITER AND
ORGANIZER OF THE MUSICAL LIFE

Miloje Milojević as composer, music writer and pedagogue believed, as did many of his contemporaries, that the building of the musical culture was a task of greatest importance. Motivated by this goal he wrote articles, studies, critiques and on a variety of occasions, delivered many public lectures and appropriate introductory commentaries discussing different musical and cultural issues and topics. Milojević's numerous essays, studies and critiques were published in professional journals and dailies. The extent of his interests and his awareness of the spiritual quests and yearnings of his time lends to his writing a documental value. His collected works had been published in three volumes: the first volume appeared in 1922, the second in 1933 and the third in 1953, posthumously.[1] Of particular interest are the articles reflecting the musical circumstances in the country during his life time, and especially in the period between the two world wars.

The introduction for the first book of *Musical Studies and Articles* was written by Bogdan Popović, whose name appeared on the book cover, along with the title. The attention and mutual respect that existed in the relations between Popović, as a former teacher and mentor, and Milojević, as his former student, are revealed in the general concept and tone of the introduction. Popović noted that Milojević who was known in the musical world as writer and as the composer, did not need a recommendation for the readers. Popović even thought that Milojević would receive later his place "as one of the founders of music criticism in our midst."[2]

Popović contended that Milojević will eventually earn this place not because of a mere passing of time, but because of his great erudition and diligence. Popović then proceeds to present his view about the function of the critic, limiting his exposition to the place of theory in criticism. Popović stated that the role of theory in esthetic criticism is twofold. One aspect, a purely scientific character, is engaged only in observing and explaining. This critical concept is not primarily concerned with the composer or the public, since it is not educational in its scope, nor does it seek to increase the appreciation of the friends of the musical art.

On the other hand the public is free to reciprocate this attitude: even without knowing the theoretical postulates of scientific theory, the public can learn to enjoy the compositions of Beethoven, Wagner or Franck. The educational aspect of the theory contributes to a more thorough knowledge of musical art and consequently to enhancement of esthetic enjoyment. Popović thought that the theory

"analyzes an art work in all its details, separately dividing all its components. Thus details are discovered that the usual, empirical method of observing cannot detect: since it is too summarized and intuitive. However, the details contribute to the complete impression, the way an artist has imagined it; to totally comprehend a work, and therefore to be able to appreciate it entirely, is possible only if all the details are seen, heard and understood."[3]

As an example Popović has cited other art forms such as architecture and literature that are easier described in a verbal discourse than music, which demonstrate his opinion. Popović considered that the literary theory prepared the readers for more precise and accurate perceptions. Even the elementary theory of literature that pays attention to elements of the style, the use of correct and pure language, to the correct and refined use of figures, to the construction of sentences, the word order, the rhythm of the sentence, alliterations and assonances and such devices—is preparing the readers to notice these things and to start learning to appreciate and find artistic enjoyment in a work.

"Without extensive explanation, without more thorough examination of the theory of effects, already the fact that the attention of the reader is directed to the details discovered by the theoretical analyses is sufficient to elevate the taste of the reader and to encourage a graduate progress to higher levels. This elementary 'Theory of literature,' this theory without the real theory, can teach *what one should pay attention to.*"[4] (Italics by BP)

Therefore Popović thought that Milojević's book had an educational character since it contains: "a series of theoretical remarks of the kind that we speak about, about rhythm, melody, harmony, and so on."[5] Popović therefore concluded that this book will be welcomed by everyone "who by the help of theory desires to obtain a complete knowledge of the musical art."[6]

The introduction of Bogdan Popović is valuable for several reasons. In the first place it pointed out the consistency of applying "the line-by-line" method which Popović advocated with great zeal in literature. Popović explained this method of analyzing literature in a study published in 1910 in the journal *Srpski Knniževni glasnik*. A year later Popović applied this method in the compilation of selected poems for the *Anthology of the Newer Serbian Lyrical Poems*. The method corresponded to his criteria about the required qualities of art works that included the presence of emotions, harmony, clarity and beauty of the whole, as well as absence of mistakes. By selecting poems according to this criteria Popović created, in his own words, a new and very personal work similar to the way a mosaic is composed. Popović's Anthology still remains one of the best books of the Serbian literature.[7]

The line-by-line method when it was introduced by Bogdan Popović was not new or entirely original. In 1893 Alexander Baine, professor of logic, in the second part of his enlarged edition of his book: *English Composition and Rhetoric,* noted that this method had been used by many rhetoricians from the time of Aristotle, Samuel Johnson rediscovered this method and introduced it in his *Lives of the Poets.*[8]

Popović enlarged the method as an analysis of details pertinent to other art disciplines, as a general microesthetic method. Popović wrote about the method thus:

"The line-by-line method, as the name already expresses it denotes a method of research inquiry and criticism of a literary work, but not in general traits, or according to its broadest, one could say *abstract* characteristics, but thorough, and expanding in details, in concrete and small details, which constitute the broad characteristics and the last effects of literary works."[9]

Popović advocated this approach also in other arts, fully convinced that this is the only method to enable a thorough knowledge and comprehension of art works. In addition Popović had explained in this introduction what should be considered as "the important details," arguing the possibility of such analyses in music.

Popović's contention about the two fold role of theory in esthetic critique was later criticized by Petar Konjović. Konjović believed that if the public has

developed an awareness of the musical art then so the critique should be on a higher level. But the expertise should not be obtrusive in displaying erudition that will "threaten the intellectual and emotional space of the listeners, but should only help to elucidate and clarify this space."[10]

However it is interesting to note that Popović's supposition about the role and character of the art critic was corroborated almost fifty years after the publication of his *"Introduction"* for the first volume of Milojević's articles and studies. Thus Leonard B. Meyer in his book *Explaining Music* stated that the primary goal of criticism is explanation of the art work. The educational aspect is not its primary goal. Experienced listeners respond for its own sake to music without studying the theory or history of music. The understanding of music does not depend upon knowledge of theory or information about means and techniques: "understanding and enjoying a Bach's fugue or a Brahms sonata does not involve knowing about-conceptualizing cadences, contrapuntal devices." Meyer even states that this is true of all arts and audiences. As an example Meyer quotes Albert B. Lord's account of the singing of epics in Yugoslavia where conceptualization or classificatory knowledge are not necessary for the composition of oral poetry. However, it is Meyer's opinion very much like Popović's that understanding and therefore the appreciation and consequently the enjoyment can be increased and enhanced by education.[11] Meyer believed that although knowledge about the theory and history is not a prerequisite for sensitive understanding it is a necessary basis for explanation. Today the explanation of music, as for example, of compositions by Bach, would be in terms of syntactic processes and formal organization, and not in terms of doctrine of affections.[12]

Milojević's adherence to the *line-by-line* method is apparent already in the first essay of his first volume of collected works under the symbolical title; *The Paths that lead to Musical Art.*[13] Milojević pointed out that the musical art, in its essence, is very complex and therefore requires a careful and gradual study. The path that leads to the comprehension of this art or discipline leads to the analyses of details, starting from the single tone. Later the comprehension of the role and use of motives and melodies will result from a thorough study of the best works of music. The inherent expression of a musical composition is underlined by its rhythmical structure and supported by harmonic progressions and instrumental tone colors. Milojević stresses the importance of delineating the specific relations of all these elements within a particular composition determining in the process the framework of stylistic characteristics. However, each work of art is a reflection of the intellectual and spiritual preoccupations of its creator. Furthermore these preoccupations are, as it were, stipulated by the point of view shared by the members of his generation

as well as by a live tradition passed from one generation to another. Therefore, it is important to study the historical development of the musical art focusing on stylistic traits, starting from the Renaissance to the present. The study of style involves not only the analyses of the numerous details and technical requirements which account for the specific qualities of a composition but also the comprehension of the relationship between the given work and others of the same period.[14] This essay confirms the supposition that Milojević adopted the *line-by-line* analyses, enriching this method with the historical development of music and stylistic periods. Like Popović, Milojević acknowledged the importance of employing techniques, but not exclusively or as the most important criterion. Milojević believed that an art work is a synthesis of objective or technical elements and the subjective or ideological. Therefore he considered important the knowledge of a composer's personality and the tradition from which he grew. He stressed the importance of the historical development of music and music styles quoting in addition the thought of Guido Adler that the style is a basic measuring device in the evaluation of an art work.[15]

The most consistent application of the line-by-line method was presented in Milojević's doctoral dissertation: *The Harmonic Style of Smetana.* Milojević defended his dissertation at the Charl's University in Prague where he spent three semesters, starting with the summer semester of 1924 until the summer of 1925. Having in view the extensive and rich literature that already existed in the country of Smetana's birth, Milojević's work, as an original contribution presents exceptional accomplishment. Smetana, as one of the leading Czech composers, has inspired many monographs about his compositional heritage; Milojević was familiar with many of these musicological works already before his departure for Prague. As a result of this interest in Smetana and his work Milojević wrote a well documented book under the title: *Smetana, Life and Work.*

It is possible to assume that this research of Smetana's compositions, as a possible example for the creation of a contemporary national style, eventually led to the decision to further his studies at Charl's University. A thorough bibliography appended to his book on Smetana testifies to his extensive research of the area. Milojević's biographer Petar Konjović stated that this concise book of only 124 pages may be considered as one of the most accomplished books about music in Serbian literature.[16]

In his dissertation Milojević aimed to analyze the harmonic language of Bedřih Smetana; "measure after measure, chord after chord." In the process Milojević noted next the simple and well known harmonic configurations some that, in his opinion, present the peculiarity of Smetana's harmonic

language. Milojević concluded that artists like Smetana remain unique even if they assimilate different influences due to capacity for growth and enrichment of their own individuality. Milojević stressed that Smetana had a thorough knowledge of techniques of composing. Again, this statement reaffirms similar beliefs of Popović who consistently advocated the importance of the command of craftsmanship that enables the creation of valuable art works. Milojević thought that Smetana's knowledge of the compositional techniques facilitated his search for new harmonic possibilities.

In this collection of Milojević's writing, of central importance is the study; "The Artistic Personality of Stevan St. Mokranjac."[17] The study is dedicated to Bogdan Popović as a gesture of homage and gratitude for his steady support and trust. The study presents Milojević's attempt of a reevaluation of the position and role of Stevan Stojanović Mokranjac. Milojević believed that his interpretation of Mokranjac's musical heritage presents a more truthful and just account of his contribution to the musical history of his homeland.

Milojević as a former student of St. Mokranjac considered the national music idiom, that resulted from the vocal folk tradition, as a valuable contribution to the musical culture. The compositions of Mokranjac were a suitable answer to the needs and requirements of the public. Milojević thought that Mokranjac did not create his compositions with the wish to link the future development. He did not show interest for the events in the contemporary musical life abroad. Milojević wrote: "His interest did not follow the powerful waves of the "music of the future" . . . for the expression inaugurated by Liszt and his followers of the free instrumental symphonic poem . . . The borders of his homeland were enough for his inspiration and for the expression of this inspiration."[18] However, Milojević thought that under present conditions it was more important to be interested in contemporary achievements. Milojević stressed that Mokranjac, it seems, did not want or wish, even did not feel a need for, the study and analysis of musical development elsewhere. It would have been useful to implement the basic principles of the new development: to adapt it to the comprehension and needs at home. A direct transplantation of such novelties would not accomplish the desired results.[19]

Milojević's conclusion reflects similar aspirations of Bogdan Popović, at the time when he was starting the preparations for the publication of *Srpski Mužicki Glasnik* in 1901. Popović, who wanted to inform the reading public of the literary development in Europe, stated: "The foreign literature is today the greatest requirement for the Serbian literature; the foreign literature is today most important for the Serbian literature."[20]

In a similar way Milojević charges that the attitude of Mokranjac accounts for neglecting to enrich the musical life and reach the contemporary develop-

ment. The reasons for this attitude Milojević finds in Mokranjac's devotion to the tradition and lack of interest for the events that took place far away from his homeland. The artistic ideal of Mokranjac was contained in the patriotic ideology of "The United Serbian Youth." Mokranjac had the instinct of "a man with a folk soul" supported by the tradition rather than by the influence of musical currents abroad.[21]

In the given context it follows that Milojević understood tradition, that he otherwise revered as an obstacle for further development of music and of inclusion in the contemporary European musical development.

Further on Milojević stated that it was until recently customary to believe that Mokranjac's contribution was of first rank in the field of composition, and his role as composer was stressed. Milojević is convinced that the most important contribution of Mokranjac was as organizer and founder of the Serbian Music School. Mokranjac became active as a music builder since he was not satisfied with the level of the cultural life: "That is how the power of organizer surpasses the power of the composer in importance and in results. Many will think that my belief is strange and unjust. Many will perhaps reproach me. But someone who truly loves the personality of Stevan Mokranjac must speak out of conviction."[22]

Milojević further pointed out that Mokranjac as organizer was not content with static conditions into which musical life had settled. Already at the beginning of his career, in the course of the 1880's Milojević foresaw the best direction for the development of Serbian music. In the founding of the Serbian Music School he saw the necessary guarantee for a radical betterment of the musical life.

In the analysis of human and artistic traits of Mokranjac, Milojević stated, that although Mokranjac did not accept the situation of the cultural life, he was not a revolutionary. Even his patriotic devotion was not militant or aggressive. In the context Milojević regretted that the "nature of Stevan Mokranjac was not revolutionary," by trying to justify this statement:

"One should give credit to the persistent ambition of a foresighted man inspite of all prejudices, and pettiness and sentimentality of the environment in which he lived, he alone directed himself to the goal known only to him—at the time when he appeared in the arena of our cultural life during the eighties of the last century— and to advance toward this goal with energy permeated perhaps even with vanity and conceit, but also undoubtedly with enthusiasm and ardour."[23]

The conclusion that Mokranjac's role was primarily of an organizing nature points to Milojević's inconsistency in the evaluation of the compositional output of Mokranjac. Milojević contended that because Mokranjac's nature

was not essentially revolutionary he could not depart sufficiently from the national tradition. On the other hand, in a series of articles about the new generation of composers—*progressives* that comprized also some of his former disciples, Milojević bemoaned the lack of continuity in their growth and their refusal to accept "values from the past."

In judging the artistic and human profile of his former teacher Mokranjac, Milojević displayed a contradictory evaluation; while Mokranjac's work presents a gradual continuation of earlier achievement, valuable in itself, and while Mokranjac by nature was not a bold revolutionary, his achievements, his convictions and his artistic credo do not respond to the requirements of his time: he did not demonstrate the necessary contemporaneity.

In order to reinforce his interpretation Milojević pointed out similarities that existed between the artistic ideology of Mokranjac and the development of romanticism in arts. The followers of the romantic school of music justly strove for a new and individual expression. They felt that classicism cannot be surpassed. While admiring the Olympic heights reached by the composers of the classical era they descended to the valleys, and the folk songs of people became their inspiration.[24]

In another article entitled *About the Musical Nationalism,* Milojević expressed a similar view, stating that the composers of the romantic movement were endowed with a lesser musical talent. In the search for the enrichment of their expression they were not ashamed to find support, outside their own individuality, in the simple and naive folk art.[25] Milojević further articulated this thought:

> "If we apply artistic criteria that give right of existence even to the works of talented artists, that are not geniuses, then national music schools if not of primary importance, receive a high artistic value . . . The music compositions of composers of national schools are interesting documents . . . although we do not want to grant them an universal human value."[26]

The criticism of the followers of romanticism points to another parallel with the opinions of Bogdan Popović. Popović although accepting the artists that belonged to the romantic movement, did not have the true understanding of their contributions.[27] At the same time this negative unfavorable evaluation of the achievements of the composers belonging to the romantic movement resembles the postulates of the German musicologist Hugo Riemann concerning the national schools of music. Riemann attested in his book *Geschichte der Musik seit Beethoven* that the national music presents to a certain extent a refuge to the native place for all who could not surpass the gigantic personality of Ludwig van Beethoven.[28]

Milojević came to the conclusion that classical art works present universal expression while compositions of romanticism are limited by an individual and group character. In order to strengthen their musical invention the works of romantic composers based on folk songs reflect a group character and therefore are of less value.

This apparent analogy with Riemann's thesis supports the assumption that Milojević accepted this opinion in order to corroborate his explanation of Mokranjac's compositional heritage. Milojević thought that the compositions of Mokranjac, as compared with the achievements of European composers were anachronous and mistimed.

Since Mokranjac's works are based on folks songs, his compositions cannot have a "universal human value." Mokranjac's choral compositions present mainly a harmonization of folk melodies. These compositions are truly only arrangements of "folk motives." Milojević pointed out that the compositional technique in Mokranjac's choral compositions is of a serious and competent nature, since Mokranjac had a command of the principles of musical harmony. As a student of Josef Reinberger he was fluent in the harmonic thought as "presented by the music pedagogues that belonged to the traditional school."[29]

However, Mokranjac succeeded in depicting the underlying emotions in every choral song: "In this circumstance lies the whole uniqueness of Mokranjac's harmonic work."[30]

By pointing to the capability of Mokranjac to present in music various emotional states, Milojević was in fact perpetuating the findings of Kosta P. Manojlović, who was the first to point to this fact. Manojlović wrote in 1923 about Mokranjac's ability to portray the underlying emotional tenor in his analyses of Mokranjac compositions in his monograph *Spomenica St. St. Mokranjcu.*[31] In the last chapter of this book Manojlović stressed that the composers before Mokranjac, even his contemporaries, understood the folk songs only in the tonal idiom applying literally the rules of harmonic progressions. Due to such a mannerism the free flow of the voices was hampered and there was no deeper interchange between the text and the melody. The typical intervals and rhythmical movement of the folk music were neglected.[32] However, Mokranjac managed to discover in every song the real, although hidden tonality and in this process to develop his compositional approach.[33]

Mokranjac worked incessantly. Milojević noted that Mokranjac created works in the spirit of a cultural action, instead of being guided by genial intuition. Mokranjac possessed intuition, although not the intuition that moves towards creation of original artistic works, with a rich and all encompassing content. The compositions of Mokranjac are not characterized by free motivic

work, although the harmonization is interesting and intricate. Mokranjac's choral compositions called *Rukoveti* comprize several songs and are rhapsodic in form. Due to their form, consisting of a series of songs, Milojević characterized the likeness of *Rukoveti* with potpourri as one of the simplest among musical forms.[34]

Milojević concluded that Mokranjac's compositional heritage presented an important period of Serbian music history. His choral compositions are at the same time a powerful source of live music material. This source will attract future generations of composers, even those that strive to create works of lasting value and surpass the boundaries of temporal ephemerality.[35] With this statement Milojević in part anticipated the influence that would be exerted by Mokranjac's work. In the course of time a number of composers and musicologists turned to Mokranjac's compositions as an important heritage and not only as the source of music material. Milojević's interpretation of Mokranjac's role as composer and organizer was the subject of discussions, disagreements in a number of articles and essays that followed.[36]

Among the writings that discuss the value and role of Mokranjac's compositions, one by Vojislav Vučković should be singled out. Vučković, writing towards the end of the 1930's, stated that the basis for the realistic comprehension of musical art in Serbian music was contained in the compositional method of St. St. Mokranjac.[37] Milojević, as mentioned above, explained the compositional approach of Mokranjac as a belated tribute to the romantic concept of the arts. Since the source of inspiration in Mokranjac's work was the folk song, his compositions are strictly speaking not original, while possessing a group character of an ethnic formation. That is why Milojević thought that the work of Mokranjac as well as the work of other romantic composers did not have a universal importance.

Vučković did not accept this thesis. In order to further articulate his statement about Mokranjac's work as the herald of the realistic movement in Serbian music, Vučković pointed out similarities that existed between the compositional methods of Mokranjac and Musorgskij. Vučković noted Mokranjac's interest in the secular and spiritual folk song which represented also for Musorgskij an area of great interest and research.[38]

The essay that Vučković wrote about Mokranjac denotes a thorough knowledge and a new pertinence reflecting novel thoughts and concepts of writing. Thus in the introductory part of Vučković's essay on Mokranjac, special attention was given to the analyses of historical events after the liberation from the Turkish occupation, as well as to the social and economic conditions that enabled the building of the new bourgeois class. This diachronic articulation in the effort to project a more truthful interpretation indicates the

influence of Vučković's professor Zdeněk Nejedlý and the postulates of Prague Music-Sociological school of thought. Vučković wrote the essay about Mokranjac shortly before the start of the Second World War, at the time when he wanted to review his artistic credo, as composer and music writer. As a composer Vučković strove to simplify and change his current musical language. With this goal in mind he turned to the musical heritage of Stevan Mokranjac. After much deliberation and hesitation Vučković decided that the contemporary realism in music, as an expression of progressive social tendencies, stands closest to the compositional work of Mokranjac, as the true heir of this cultural heritage.[39]

Therefore, Vučković asserted, in opposition to Milojević's view, that the compositions of Mokranjac, and especially the choral songs *Rukoveti* do not represent only a collection or potpourri of folk songs, since there exists a closer interdependence between the songs resulting from the synthesis of the poetic and of the musical content. The compositional method, the rhythmical and metrical structure that Mokranjac used does not represent a mechanical and simplified application of the principles of classical harmony. In the wish to underline the typical elements in Serbian and Macedonian folk songs, Mokranjac achieved an exquisite transformation of the folk music idiom.[40]

In the essay, although the name of Milojević was not actually mentioned, it clearly appears that Vučković wrote this essay as an antithesis and rebuttal to Milojević's conclusions about the compositional output of Mokranjac. Vučković even concluded that Mokranjac was a far greater artist then the ones who disputed this fact.[41] Yet Vučković also pointed out that Mokranjac only created works inspired by the folk songs, and not by the every day life and happenings of the present social conditions. Vučković concluded: "But even what he has left us presents a value as the most healthy, unique and fruitful contribution of the Serbian music before the World War."[42]

The assumption of Vučković that the basis of the realistic direction of the musical art was established by the compositional method of Mokranjac, points to the reevaluation of previous opinions about Mokranjac's work.

Miloje Milojević as one of the most influential critics of the time classified the output of Mokranjac in the stylistic frame of the romantic school of music.

What led Milojević to formulate his judgment of the compositional heritage of Mokranjac was not until now fully explained. His negative interpretation, in its essence, was repeatedly criticized yet not comprehended.

Another music writer, Petar Konjović contended that Milojević being inclined to watchwords, accepted the ideal of the artistic nationalism as a product of romanticism. Konjović writing in retrospection at the beginning of the 1950's did not agree with Milojević's opinion. He thought that Vučković

more correctly appraised the contribution of Mokranjac as the first realist and rationalist in the Serbian music.[43] Konjović also stressed that Milojević's judgement about the choral compositions *Rukoveti* should be severely criticized.[44] The accentuation of Mokranjac's organizing capabilities above his creative and compositional, Konjović considered as exaggeration.[45]

Petar Bingulac thought that Milojević sincerely revered Mokranjac, however, Milojević apriori accepted the prejudice that the *Rukoveti* are of a lesser value, since they are based on folk songs and not on originally composed melodies. Bingulac pointed out that Milojević thought *Rukoveti* should not be judged like "the truly original artistic creations."[46]

In its essence Milojević's interpretation about the compositional work of Stevan Stojanović Mokranjac was derived from his aspirations of approaching the contemporary achievements of the general development of music elsewhere. It was his conviction both as a composer and music writer, actively engaged in changing the accepted inactive values.

Already as a student in Munich in 1907, Milojević wanted to compose the music that would fill the old concert hall *Kolarac* with a powerful sound of a large symphony orchestra.

But even in imagining this future music of his invention, Milojević predicted with a heavy heart that this music was not going to be accepted. The musical environment and especially the older musicians in Belgrade, the *veterans* as Milojević called them, will most likely shrug their shoulders and "declare that we need more mixed choral works than this kind of music."[47] Therefore, Milojević asked in despair: ". . . how could I write choral music when my soul is full of fanfares and devouring harmonies."[48] That is why the tradition of choral singing and the repertoire of singing societies present almost symbolically, in Milojević's mind, an obstacle to the development of music. Therefore the impatience that Milojević felt as a young composer toward the music *veterans* that still demand choral music, was extended also to the *Rukoveti* of Stevan Mokranjac. Milojević wanted with his interpretation to determine Mokranjac's position and the tradition of the choral singing in the historical perspective of romanticism and national schools.

Since Riemann's thesis about the contributions of composers of national schools were close to Milojević's concepts about this period in Serbian music, the inclusion of Riemann's deliberations about the relatively lesser value of composers belonging to national schools reinforced Milojević's exposition.[49] It should be kept in mind that Riemann's thesis did not influence only Milojević. Similar views were shared by the well known musicologists Einstein and Handschin.[50]

However, it is possible to draw a parallel between Milojević's concepts about romanticism and the opinions of Bogdan Popović about Serbian writers, primarily poets, followers of the romantic movement. Popović although acknowledging the presence of romantic writers, with the exception of Laza Kostić, did not have a true understanding of their literary contribution.[51]

In a considerable number of articles and essays Milojević stressed the importance of musical art, since he believed that music did not enjoy the same rights as other art disciplines in present society. Thus in 1932 Milojević wrote about the importance of music: "In the cultural life in our midst music is gaining in importance . . . Mankind is experiencing difficult intellectual and spiritual crises and instinctively tries to free itself from the pressure that has fallen on it. Many seek the liberation in the arts."[52]

Milojević purported that music exudes a more powerful influence then other arts since it moves the human soul, although it is not always correctly understood; but still appreciated:

"The real pleasure is not possible unless a subject is profoundly known and revealed in all its essence. Therefore one can freely assume that the majority who approach the arts do not have a complete enjoyment, since they are not able to fully comprehend, or the path is not indicated that leads to understanding of art to the hidden but important elements. And therefore we often hear: I like this, and that is enough for me! Or: this is not after all such a complicated matter, as usually claimed."[53]

These inferences essentially reflect the opinions of Bogdan Popović. Popović considered the position of music as being the highest among the arts, since music achieves with a minimum of means the maximum of effects on the human soul.[54]

Another similarity with the thesis of Popović is expressed in the statement that the true understanding of the arts is possible only if even the most oblique but important elements are discovered and understood. Milojević is referring to the line-by-line method that insisted on the study of details that constitute an art work. Furthermore Milojević thought that there is still a great number of people who approach music blindly, as if "driven by instinct," and there is still a small number of those who can evaluate the beauty of music.[55]

Milojević concluded that artistic beauty presents a synthesis of different elements, and it should be not explained only as a sensual experience. That is why Milojević accepted the thesis of Grillparzer, that the art is a complete agreement of sensuality and spirituality.[56] It should be remembered that Popović considered beauty as an esthetic value, as in the area of arts so in the

nature itself. In the experience of beauty Popović included next to the emo-
tional, the sensual as well as the intellectual aspect. In these definitions
Popović was influenced by the English art theoretician Grant Allen and his
thesis as postulated in his *Psychological Aesthetics*. Thus besides the influence
that Bain's line-by-line method exerted on Popović's opinions, Grant's theo-
ries about the formulations of artistic beauty, and about the civilization of taste
found him receptive.[57]

Unfortunately the evaluation of an art work is sometimes attempted even
by those who are not aware of its richness and complexity. Milojević calls for
an organized struggle against the "professional superficiality." The compre-
hension of an art work is only possible if its diverse elements that constitute
its essence are analyzed. In order to comprehend the esthetic and stylistic
values of an art work it is necessary to learn the historical development of the
musical art. The knowledge of techniques involved in the shaping of a musical
work, Milojević considers as an important and necessary condition. In the
evaluation of an art work it is most important to know the composer: the man
and his person who created the art work. Only then an art work could be
understood. In conclusion Milojević quoted the well known thought of
Beethoven that music is a higher revelation than all the wisdom and
philosophy.[58]

Milojević asserted that a musical work, as the reflection of the musical
genius, must be respected. The artist who wants to perform the work, as the
ones who wish to explain and evaluate it, should be aware of this responsibil-
ity. One should approach the musical work with respect, since it presents an
honest, sincere and exalted expression of the musical genius, attained in an art
work. Further cultivation of the ethical moment would indicate the divine
origin of arts, since music is alone a divinity.[59]

The supposition that the musical art is of divine origin, to be observed
with respect was criticized and explained as backwardness. Nikola Her-
cigonja explained this statement, as well as some others similar to it, written
by other authors, as the reflection of spiritual idleness of the current musical
milieu.[60]

Another statement of Milojević claiming that the origin of music comes
from "the unreachable depth, from the mystical source," was criticized and
labeled as a "'mistified statement.'"[61]

As a teacher, lecturer and music writer Milojević truly tried to facilitate the
understanding of music. Obviously the "mistification" of music was not his
intention. Milojević believed that the concert public is one of most important
collaborators in building the musical culture. He incessantly tried: ". . . to do
everything possible, to sacrifice the best he had in himself" in order to lay the

foundation of the musical culture.[62] Milojević often repeated his conviction that a music work can only be fully comprehended if there is a thorough knowledge of the historical and general development, as well as of technical knowledge and craftsmanship necessary for the creation of a musical work.

Since Milojević believed that music still did not enjoy an equal position among the arts, he tried, following Schelling's assertion, to attribute to music metaphysical value. In this manner the importance of "technical" knowledge and necessary craftsmanship in the composition process could be lifted and to a higher level, especially since it was believed that the technique of composing and the efforts that were required should not be discussed. The work itself as the "opus perfectum et absolutum" was believed to be created complete and accomplished without hard work and the technique, as a tool, was considered as something that should be hidden from the public.[63]

Milojević himself considered a musical composition as a complex body that can be best understood if besides a general and musical knowledge one develops an ethical approach: "Let us prepare the public to accept this manifestation with delight and not blindly approaching the musical arts . . . since the public is a collaborator of the artists in the development of the musical culture, one of the most important and noble ones."[64]

Milojević's assertion that a musical work should be approached with respect stemmed possibly also from the wish to enhance a truthful interpretation of the musical text, suppressing the arbitrariness in the performance and interpretation. Since he believed that the composer has expressed his intention by writing down even single accents Milojević wanted to establish the sovereignty of the art work that should be interpreted with appreciation and respect for every detail.

All these efforts resulted from the fact that Milojević knew well the performing and artistic capabilities of the artists of his time. Milojević participated in the cultural life as a performer. As a pianist he often accompanied his wife, concert singer Ivanka Milojević, on the piano. Among his best compositions the solo songs with piano accompaniment are an important contribution to musical literature.

However with all these efforts Milojević addressed himself to a small segment of the public: the educated individuals of a particular social standing. Thus in his speech on the occasion of the founding of the *Association of the Friends of Music Cvijeta Zuzorić* Milojević contended:

> "The goal of this society is to attract among its rows all educated ladies from the whole kingdom. They should gather around themselves all public figures, very much like the beautiful, spirited, noble and delightful Cvijeta Zuzorić, a noble

woman from the sixteenth century. As an organized group the ladies should support the works of our national culture as expressed in literature, music, sculpture and painting."[65]

Milojević argued that the works of art are realizations of impressions experienced by the artists. In this process the artist expresses himself as well as his internal reactions toward these impressions. The art works that result possess refinement and delicacy, and therefore are not intended for masses, nor could the masses understand such works. Milojević further quotes the opinion of Popović contending that such a creative process is of a high order: "a truthful expression of an interesting impression." Popović understood under *impression* all that represents the content of a work and under *expression* all that expresses and communicates the content. Popović had a similar opinion about the art works that depict reality in an objective fashion. Such art works are very rare and represent the highest achievements of "distinguished realism." These art works are not for the masses but for educated people with a refined taste since the public is inclined to applaud the works of lesser value.[70] Analogous statements can be found in Popović's writing and consequently in Milojević's critiques and articles. However these contentions have their source in the thesis formulated by Allen in his previously mentioned book *Physiological Aesthetics.*[66]

A remarkable correspondence with Popović's view is noticeable in the poetry of Jovan Dučić, a poet whom Popović held in high esteem. In the *Anthology of Newer Serbian Lyrics* Popović devoted much attention to Dučić's poems thereby enhancing his leading position among the poets of his time. In the total of 167 poems comprising the Anthology, 33 poems were selected from Dučić's poetic collections. *Ars poetica* according to Popović was at best represented in the lyrical poems of Dučić: refined taste, vivid imagination, pure lyrical emotions, serene and descriptive character of his motives in distinguished versification and style. Even the introductory poem in the *Anthology* was Dučić's: *Let us go, oh Muse!.* Another poem of Dučić, included in the *Anthology: My Poetry* stands closest to Popović's concepts of beauty.[67]

In an article, devoted to the young artists, Milojević posed the question whether the new achievements are worthy of attention especially if they are attained by the destruction of the old accomplishments. Milojević understood the development of music as an evolutionary process, as a gradual and organic growth. To show progress in music one should not merely search for something new, in something that was not written before, since progress represents the continuation of pure and unique artistic properties. The artistic spirit is in its essence evolutionary, although it seems revolutionary. Milojević stressed

that it was his opinion that the arts should be directed to a forward motion, without hesitation and stalling. Novelty at any price is a concept that requires reflection.[68]

In the same article addressed to the young composers Milojević pointed out the importance of the diatonic system and the enduring values of the compositions of great composers. The works of these composers will last as long as the diatonic system, which was built thanks to the efforts of many generations. Milojević strongly believed that the deliberations about the poverty of the diatonic system testified to the weakness of spirit of all those wishing to be artists at any cost.[69]

Although Milojević often expressed a critical attitude towards new advancements in music, including the quarter-tone system, one of his best studies was devoted to the inventor of this system—Alois Hába. The study was published in 1926 in Belgrade, in the first book of collected articles on music. Hába himself acknowledged the study with gratitude in a paper written several years later. Hába stated that at a time when critics were constantly casting doubts on the validity of quarter-tone music and even claiming the absurdity of such a system, Milojević was the only one to devote a lengthy, objective report to this topic. In the same article Hába mentioned the support of Josip Slavenski, another well-known Yugoslav composer. In 1923 Hába received from Slavenski two folk songs from Yugoslavia encompassing in their melodic line quartertone intervals. Slavenski himself collected and recorded these melodies.[70]

Miloje Milojević wrote his study of Alois Hába upon his return from Prague in 1925. Milojević had gone to Prague as a mature person in order to accomplish his musicological studies at Charles University under the tutelage of Zdeněk Nejedlý.[71] He stayed in Prague during the academic year 1924–1925, enrolling in three consecutive semesters. In his dissertation, "Smetana's Harmonic Style," Milojević was to establish the typical traits of Smetana's musical language by analyzing harmonic progressions formulated in Smetana's compositions. In view of the existence of an extensive body of musicological research devoted to the study of Smetana's life and compositional output, it is worth noting the favorable reception that Milojević's dissertation was accorded as an original contribution in the country of Smetana's birth.

While in Prague, Milojević keenly observed the musical scene as well as the cultural life of Prague as one of the liveliest cultural capitals of Europe of the day. Milojević was especially attracted to the personality of Alois Hába and the novelties of his theoretical and compositional approach. Although sufficiently open to new ideas, Milojević himself, as an already formed composer, never composed in this vein. Milojević remarked in his study that due atten-

tion should be given to Hába's work even if one did not agree with his ideas and concepts or with the necessity of dissemination of the quartertone system. Hába's contribution, he wrote, was a pioneering effort by a well-trained musician with profound respect for the rich heritage of the musical past. Milojević was also aware that to be vital, cultural development must not stagnate, and as evidence offered the diversity of numerous artistic movements of the period. Therefore, the contribution of the "cultural revolutionaries of music" deserved examination as a source of elements of a future musical language.[72]

In addition, Milojević warned of the dangers of passing an unjust and hasty judgment, as had often been done in the past. It would suffice to mention the unfavorable receptions of some compositions of Rameau, Gluck, Beethoven, or Wagner. Milojević also pointed to the fact that there was insufficient historical distance to allow an accurate evaluation of recent and contemporary trends.[73]

Hába's belief in the importance of a thorough knowledge of the musical heritage as a point for departure on any new path was repeatedly praised by Milojević. In many studies and articles Milojević persistently advocated the necessity of perpetuating the knowledge of the past as a means of preserving the continuity of artistic development. Similarly, Hába insisted that the future recognition of new and still undiscovered sound possibilities would continue. Hába even anticipated the occurrence of new tonal resources. Thus the limits that the quarter- and sixth-tone system might impose would be surpassed by further efforts. The present diatonic system Hába understood "only as a part of a wider tonal range."[74]

Since the quarter-tone system was also a response to the existing crisis in music, Hába did not limit his presentation to the acoustical properties of the new system alone. Therefore he stated: "It should be understood that the new intervals and the new sound are not the essence of the new musical system." The new musical forms that would correspond to the new musical sound would also reflect the "basically different way of thinking and feeling," reflecting the spirit of the time. Hába believed that old musical forms such as the sonata, rondo, and fugue, and the stylistic characteristics inherent in the periodocity of the melody, thematic structure, and transpositions of motives and sequences, should be abandoned. Instead Hába favored the development of asymmetrical melodies in a continuous and spontaneous flow. The new polyphony should make use of contrary and parallel motions in a free style which would avoid certain schematic forms of counterpoint originating in past periods.[75]

Milojević considered Hába's efforts especially valuable since he stressed that music is not a play of sounds and rhythmical patterns, but an element of truth expressing the spiritual concepts of an individual. In conclusion, Milojević did not believe that the subdivision of a diatonic scale would bring practical and positive results to the musical art. Nevertheless, he agreed with the aesthetic and artistic credo of Hába and his novel aspirations. Milojević dedicated his study to his students, as if predicting that in the course of time some of them would become Hába's disciples.

Among the Yugoslav musicians who went to Prague to study with Hába at the State Conservatory were Slavko Osterc, Dragutin Čolić, Vojislav Vučković, Ljubica Marić, Pavel Šivic, Marijan Lipovšek, and Milan Ristić. Hába himself gave a valuable account about his students in an article entitled "Young Yugoslav Composers and Quarter-Tone Music," published in 1933 in the music review *Zvuk*. Hába stated that Slavko Osterc was the first Yugoslav composer to graduate from the Division for Quarter-Tone Music at the Conservatory. Hába singled out the achievement of Dragutin Čolić who graduated in 1932. Čolić had composed a Concerto for a Quarter-Tone Piano and String Sextet. Hába praised Čolić's compositional abilities, stressing that his Concerto represented a remarkable contribution to quarter-tone music. Čolić created an original work in a free athematic style. Furthermore Hába wrote that Čolić was a well-educated musician with a profound knowledge of the contemporary developments in music. Thus Čolić was very much aware of the compositional and theoretical work of Arnold Schoenberg in the field of twelve-tone music. It was Hába's opinion that Čolić was a valuable collaborator in the free athematic style and quarter-tone music. Summing up his evaluation. Hába expressed the opinion that Čolić was well-suited to educate the Yugoslav public about the new compositional principles. It would be his duty to explain the mutual goals that would contribute to the renewed development of European music.[76]

Another student of Hába, Vojislav Vučković, presented the microtonal theory of his teacher in 1935 in Belgrade at the Public University Kolarac. Since its foundation in 1932 a series of lectures on music had been incorporated in its cultural program, engaging prominent personalities from the musical sphere. Vučković was invited to lecture as a promising young musician after the completion of his studies at the State Conservatory, and shortly after earning a doctorate of musical sciences at Charles University in Prague in 1934.[77]

Vučković's lecture, "On Quarter-Tone Music," was later published, and incorporated in several different editions of his collected works.[78] Vučković aimed to establish that the occurrence of quarter-tone music should not be

associated only by name with its founder Alois Hába, but rather with the general development of modern music during the two first decades of the twentieth century. However, the experience gained in this process influenced the consequent evolution of musical thought. Vučković pointed out that the occurrence of quarter-tone music had parallels in other areas of human endeavor, especially with the advent of Cubism in pictorial art. Hába's attempts, he wrote, were very much dictated by the wish to solve the widespread feeling of a crisis in music. Hába wanted to ensure further development of providing a theoretical explanation of new possibilities, presenting the quarter-tone system as a logical consequence and continuation of diatonic music. Hába, he continued, wanted to free composers from imposed restrictions in order to open a new creative flow of artistic imagination. Pointing to the futility of the dogmatic classification of functional tonality as the only *natural* system, Hába argued that any different comprehension of tonal resources was unjustly labeled as destructive.[79]

In his lecture Vučković tried to stress the advantages of the quarter-tone system, although he was aware that Hába's innovative efforts were not widely accepted. Part of this failure Vučković attributed to the scarcity of specially constructed instruments. Several quarter-tone instruments had been manufactured on Hába's initiative, but remained commercially unavailable. However, Vučković came to believe as a musicologist and practicing composer that the subdivision of intervals alone could not provide a solution to the crisis in music. Thus Vučković and other members of the group around Hába's Division for Quarter-Tone Music gradually started to reevaluate their position and outlook.

Of special interest is Milojević's study devoted to Richard Strauss. The artistic personality of Strauss incorporated Milojević's ideal since it showed that a powerful creative spirit is evolutionary, although it only seemed revolutionary.[80]

Milojević became acquainted with the work of Richard Strauss during his studies in Munich between 1907 to 1910. In this period Strauss' fame was constantly rising. Milojević had the opportunity to hear many of Strauss's works that were presented in Munich. He was especially impressed by the performance of the opera *Salome*. After the performance Milojević wrote an enthusiastic letter home describing his fascination with the new creative concepts and new sound.[81]

Many years later, on the occasion of the seventieth birthday of Richard Strauss, Milojević wrote a study that was published in the music journal *Zvuk* in 1934. In the introductory sentence Milojević places the opera *Salome* in first place among the works that made Strauss a celebrity: "Richard

Strauss, author of *Salome* and "Der Rosencavalier" and the poet of the symphonic poem Death and Transfiguration" . . . Richard Strauss is seventy."[82] Although the study was written twenty seven years after the performance of the opera in Munich, Milojević was still convinced that *Salome* is the best work composed by Strauss. Many think, Milojević argued, that the time has come to stop writing about Strauss, since he turned seventy. Instead, Strauss should receive deserving place in musical history. In the busy life of the present, attention is given only to those who wish to destroy everything, praising themselves alone and few others that have the same opinion. This egoistic love changed the concept of judgment of true value and consciousness, therefore it is not judged anymore on the basis of real facts, contained in the art work.[83]

Milojević contended that the intransigent strength is not contained only in "the young spirit." Very much like an old oak tree, he said, with the roots deeply implanted in the soil, standing equally among the young trees in full bloom, a similar relationship should be among people. Milojević concluded that unfortunately this is not the case.[84]

This statement raised in defense of the position of Richard Strauss, expressed with conviction, had very likely a connotation of personal justification. At the time when this study was written, Milojević had become aware of the existing confrontation with the new generation of composers. At the beginning of the 1930's the young generation of composers started returning after the completion of their studies in Prague. Among them were former students of Miloje Milojević.

Among the articles that indicated Milojević's critical attitude toward the young generation, mention should be made of the article published in the leading daily paper *Politika* in December of 1935. The article, under the title "A Music Lecture at the Public University Kolarac," could be interpreted as a public criticism of the lecture on quarter-tone music delivered by Vučković at the Public University Kolarac. Vučković, a member of the generation of musicians that studied in Prague, became actively involved in the cultural life of Belgrade upon the completion of his studies. In the article Milojević reminded the reading public that some ten years ago he had written a study about Alois Hába, the inventor of the quarter-tone system. Milojević stated that Vučković had all the rights to speak and write about the work of Alois Hába, in the framework of the series of popular lectures on music at the Public University. However, Vučković talked without any justification about the end of the diatonic system, regardless of the fact that exceptional works had been written safeguarding this system. Therefore Milojević concluded that Vučković's view presented an imprudent gesture of youthful negation. While the musical art

is experiencing a deep crisis. Milojević considered that the solution lies not in the division of intervals. The public, he felt, should have been informed about this.[85]

In another article under the title: "Two Young Conductors in Front of *Stanković* Orchestra," Milojević wrote: "Dr. Vučković lately made himself known as a music writer of radical tendencies and his position as a revolutionary is visible. And Miss Marić follows him. On the second day of Easter, Marić and Vučković completed their physiognomies as conductors and composers."[86]

Milojević, as the authoritative critic of the reputable daily paper *Politika* felt impelled to judge and comment on the first public concert of the young artists in Belgrade. Milojević's critique of this concert imposed the impression that the performers of this concert are beginners, since they were: "agitated, disheveled, militant, as it behooves the youth." This superficial description resembles a stereotype that depicts the confrontation of the older and younger generation. In addition Milojević did not mention their compositional output, under the pretext that it would be cruel to dissect in detail their artistic personalities. Still Milojević stressed that in general, young artists of real value are the assurance for further development of musical culture.[87]

In fact the compositions of Ljubica Marić and Vojislav Vučković were already performed in well known music centers like Prague, Strasbourg and Amsterdam. Ljubica Marić accomplished her studies in Prague at the Music Conservatory in the masterclass of Josef Suk, as well as at the Division for quarter-tone music of Alois Hába. She also studied conducting in the class of Nikolaj Malko. Her composition *Music for Orchestra* performed at the concert in Belgrade, had been presented to the public during the courses for the New Music held in connection with the Music-Dramatic days in Strasbourg, organized by Hermann Scherchen.

Vojislav Vučković, besides the completion of his studies at the Music Conservatory in the master class of Josef Suk, received his doctorate at Charles University in Prague under the tutelage of Zdeněk Nejedlý. Vučković's *First Symphony* was performed on June 28, 1933 by the Prague Symphony conducted by Otokar Jeremiaš in the studio of the Prague radio-station, and was transmitted live.

The First Symphony was composed as a fulfillment of the requirements for the master's degree that was awarded to Vučković on the same day. It was only after six years in February of 1939 that this composition was featured on the concert of the Belgrade Philharmony conducted by Lovro Matačić.

Vučković participated also at the performances during the Music-Dramatic Days in Strasbourg. As conductor he led the orchestra in the performance

of the *Seranade* opus 24 of A. Schoenberg and *Jewish Songs* by M. Brand. As composer he was represented by the performance of the *Chamber Overture*. During the Music-Dramatic Days Vučković distinguished himself as a concerned music historian and presented his views in the form of a manifest about the solutions of the crises in music, advocating new creative concepts.[88] Thus, four years later, in March of 1938, on the occasion of the performance of the compositions of Vojislav Vučković and Mihovil Logar, he wrote, "The modern music is here. It exists. Not because somebody wants it out of capricious reasons, but because it is a consequence of the contemporary conditions of our times.[89]

As in the study about Strauss, where the old master was compared to an old yet majestic oak, Milojević endeavored to interpret the rising number of the works of *"Modern music,"* as a parallel, coinciding development. Taking the position of a historiographer, Milojević contended that in the historical development of music numerous currents, often existed simultaneously. The old and the new developed in a parallel fashion. Sometimes two, three or even more stylistic trends coincided. The reception of these works was in accordance with the different characteristics of particular movements, and therefore very different.[90]

It is regrettable that Milojević did not develop further in a separate and more extensive study this interesting concept of the historical development of music.

A VARIANT OF THE MATERIALISTIC
AESTHETICS OF MUSIC

The multifaceted achievements of Vojislav Vučković in the fields of musicology, composition, pedagogy and conducting influenced to a great extent the new concepts about the role of music and music tradition throughout Yugoslavia. However Vučković's activities drew attention in a much more developed musical and cultural environment such as Prague. According to the opinion of Czech musicologists, Vučković's endeavors presented an important contribution to the musical culture of Prague at the beginning of the 1930's.[1]

The numerous musicological and journalistic works of Vojislav Vučković have exerted and are still exerting influence and attracting considerable interest. Thus Jiři Fukač pointed out that Vučković already as a student at Charles University, studying under Zdeněk Nejedlý took an active part in the musical life of Prague. The numerous lectures that he held, as well as his less numerous yet important musicological articles, played a decisive role in the founding of a new direction in musicology by establishing the Prague School of Music Sociology.

During the 1940's and 1950's, under the influence of the theory of socialist realism, some music theoreticians criticized the writings of Vojislav Vučković. Among these were the assessments of the Czech musicologist Zdeněk Novaček who expressed eloquently his opposition. Novaček stated in his book *Introduction to Music Esthetics* that Vučković's theses can cause "confusion in the heads of honest and trust-worthy composers."[2]

In Yugoslavia Radovan Zogović and Oskar Danon criticized Vučković's choice of bibliographical material, as well as the fact that Vučković based his research on works of "bourgeois positivists like Guyau, Taine, Hausenstein

and the vulgar sociologists and decadents like Wittvogel and Teige." Zogović believed that Vučković did not know sufficiently well the works of Marx, Engels, Lenin and Stalin as founders of scientific esthetics.[3]

In fact, Vučković had pointed out in this works, especially in "The Review of Theory and History of Esthetics," inconsistencies and weaknesses in the works of Hausenstein, Taine and Guyau. Vučković especially criticized the views of Hausenstein because of his inability to comprehend the advantages of the materialistic concept and sociological observations.[4]

It is interesting to note that during the 1920's Anatolij Vasiljević Lunačarskij often wrote about the important contribution and significance of the works by Hausenstein and Taine. However, Lunačarskij stressed, much as Vučković did some time later, that the arguments and conclusions of Hausenstein should be scrutinized.[5]

It would seem that the claims of Zogović and Danon—that Vučković's writing and selection of bibliography resulted from insufficient knowledge of this area of esthetics—should not be accepted. It is apparent that Vučković's writing and selection of bibliography refers to the influence of the theses contained in the works of Lunačarskij.

As an important cultural heritage Vučković's works continue to be published. In 1968 the sum of his collected musicological and journalistic writings, as well as articles and studies written about Vučković, were edited and published. However, the works of Novaček and Fukač were not included in that edition.

The contrasting viewpoints presented by Fukač and Novaček are of great importance for Yugoslav musicology as another proof of Vučković's lasting contribution to the musical and cultural history.

Novaček approached the musicological work of Vučković from the dogmatic positions of social realism, and therefore refuted Vučković's interpretations. Jiři Fukač, writing about Vučković's contribution eleven years later, asserted that Vučković studies and articles had an exceptional influence on the social and artistic environment at that time. Fukač considered Vučković as a founder of the Prague School of Music Sociology.[6]

Until the present study the influence on Vučković of thoughts and idealogies in the cultural and artistic life after the October revolution was not discussed. This influence is noticeable already in the title and in the essential concept of his dissertation: *Music as a Vehicle of Propaganda* as well as in the category of the social, moral and political reality of the arts contained in the theses of Lunačarskij.

On the other hand, it should be remembered that these viewpoints of Lunačarskij were formed under the influence of the Russian literary and

critical tradition of the nineteenth century. This literary heritage preserved in the works of Naždin, Černiševskij and Belinskij, among others, pointed to the social, political and pedagogical role of the arts. It was the opinion of Černiševskij, that due to the lack of political freedom, literature and poetry attained in this period an exceptional social and political value.[7] The influence of this literary tradition is reflected in the writing of Lunačarskij, Majakovskij and others.

Thus Lunačarskij, in the *Dialogue About Art* published 1905 in *Pravda*, rejected the postulates of the classless art. He stated that by presenting a defined ideal, the arts could become powerful or weak, the victorious or defeated instrument of a certain class. The essence of this dialogue, that had a programmatic character, is contained in the statement: "Every agitator should be an artist, as every artist should be an agitator."[8]

As composer and musicologist Vučković believed in the social importance and benefit of a music work. Vučković believed that the musical art contained useful values that should become the property of all people. As a musicologist Vučković wanted to point to the social role of music in the general development, in order to refute the principle of autonomous and esthetic integrity of the arts. Vučković believed, like Lunačarskij, that "just the *social* importance of the arts, from the point of view of its roots as well as its fruits is what is the domineering aspect. It might be disputable to the people that do not feel close to our social work, but to the public, that we care most, this is clear as the day."[9]

Majakovskij expressed a similar thought in criticizing the poets that proudly said: "A poet does not create useful things, a poet creates unprofitable things." Majakovskij contended very much as Lunačarskij that poetry should contain values of general importance, in order to become part of the life experience of the whole social community.[10]

The interdependence of music and specific social functions demonstrated, according to Vučković, the dichotomy of ethical effect and ethical intention. In this context Vučković understood the social applicability and appurtenance as the ethical and moral reality of the music work. Therefore Vučković asserted in the *"Review of the Theory and History of Esthetics"* that esthetics as a science about the beauty as expressed in the arts, and as a science about the arts, due to its inability to solve these problems was replaced with sociology of arts. The subject of sociology comprized the reciprocity of social factors and the development of arts, as well as the influence of artistic creation on the development of the society. The goal that Vučković formulated for the sociology of arts was the formulation of the directions of further growth.[11]

As a practicing composer and a member of the jury of the renowned International Society for Contemporary Music, Vučković considered the achievements of the athematic, quarter-tone music as a valuable and progressive result of the social development. At the beginning of the 1930's Vučković believed that the avantgarde music would enable the wide and varied public to attain an understanding of the musical arts. The progressive arts should walk in step, he believed, with the progressive society.

Vučković's understanding of the Russian artistic tradition was enriched during his studies in Prague, in the conducting class of the well known Russian conductor Nikolaj Malko. Malko, a conductor of world wide reputation, became from 1927 the main conductor of the Leningrad's Philharmony and often was invited on artistic tours for guest appearances abroad. In 1929 Malko was invited to be a guest conductor in Czechoslovakia, eventually to receive an appointment as professor at the State Conservatory in Prague.[12]

So in Vučković's first article written in Prague, for the Yugoslav journal *Muzički glasnik,* dedicated to the art of Nikolaj Malko, Vučković wrote that he had "the good luck" to attend Malko's interpretation of *Boris Godunov* by Musorgskij as well as Skrjabin's composition *The Poem of Ecstasy.* Malko's performance of the works of Dimitri Šostakovič, according to Vučković, has impressed the public around the world.[13] Since Malko often conducted the compositions of Russian composers, Vučković had the opportunity to hear the most remarkable achievements of the Russian music. Malko, a student of Rimskij-Korsakov, Glazunov and Ljadov, in return, appreciated the talent of his student. The words that he wrote on Vučković's diploma after the completion of the requirements for the examination of conducting, testify to his belief in Vučković's abilities: ". . . (Vučković) without doubt successfully conducted from memory the First Movement of the Italian Symphony by Mendelssohn with the orchestra of the Czech Philharmony, July 3, 1931, a composition of a complicated structure that required a decisive mastery of the elements of conducting technique."[14]

In addition, Vučković attended the meetings of the Society of the Friends of the New Russia. Among the lectures that the Society had arranged, Vučković had the chance to witness the poetic recital of Vladimir Majakovskij. Majakovskij himself read his poems. Vučković was impressed by this meeting as well as by a number of varied cultural events that took place in Prague. At that time, at the beginning of the 1930's, Prague was one of the liveliest social, political and cultural centers of Europe.[15]

There is an interesting parallel that existed between the theses of Majakovskij and Vučković. Vučković believed that the arts should take an active part in the social life of the people. The acceptance of the autonomous

esthetic principle and the emotional subjectivity separate the artists from the social obligations. A similar thought is expressed in the following verses of Majakovskij:

Hark
 Comrade of the future times,
the boisterous leader
 agitator
overcoming
 the murmuring poetry wave
I will pass by the lyrical pages
 for the living
 the living orator.

In this context Majakovskij understood the art as a propaganda determined by the social class. A similar viewpoint was expressed by Vučković, in his dissertation: *Music as a Vehicle of Propaganda* being the proof of the ideological kinship.[16]

The prestige which the cultural policy of Soviet Russia enjoyed abroad was to a great extent attributable to Anatolij Vasiljevič Lunačarskij. Lunačarskij, as the first commissary of education in the period between 1917 and 1919 was responsible for the future planning of growth in the fields of culture and arts.[17]

The position and viewpoints of Lunačarskij on many issues of the cultural and artistic policy are expressed in many articles, essays and speeches. Shortly before the October revolution, Lunačarskij advocated non-intervention concerning the questions of artistic freedom. At the same time, he tried to restrain the destructive tendencies towards the past, since he believed in values contained in art works of past epochs: ". . . because only the truly gifted ones among the new know very well, how much valuable and delightful is contained in the old."[18]

In addition to the duty of the commissary of education, Lunačarskij acted as art historian, dramatic writer, translator and author of philosophical treatises on cognition, esthetics and literary criticism. As a journalist and orator, Lunačarskij was well known and in great demand.

Lunačarskij believed that the influence of the October revolution would save the arts from the worst form of decadence—formalism. The revolution should offer to the arts, "the powerful and irresistible expression of great thinking and great adventure."[19] As a contrast, Lunačarskij pointed to the complete lack of content in the bourgeois art, and a general lack of originality. The search for purely formal requirements brought only eclectic elements,

since "the real perfection in form is not a result of purely formal requirements, but it results when the form . . . corresponds to characteristic feelings and thoughts of people of a defined cultural epoch."[20] Lunačarskij contended that the revolution is characterized by ideas of exceptional breadth and width, since the revolution promotes intensive, heroic and complex feelings. In order to promote the revolutionary form of thoughts, feelings and actions, Lunačarskij posed the question whether the arts can be of any help. In turn Lunačarskij provided himself an eloquent answer to this question: "Since the revolution can offer the soul to the arts, then the arts can serve as the mouthpiece of the revolution."[21] Lunačarskij was aware that very seldom the agitation and a truthful artistic content find an ideal union. There is only a small percentage of artistic works that can be accepted as truly satisfactory, although there are numerous new works, as well as the new propaganda theatre and especially the artistic posters that should elucidate the masses.[22]

Lunačarskij repeatedly stressed that the leadership will endeavor to preserve all that is best in the old art, since it is important for the development of the new art.

At the same time the *New* will be supported, but only if it is beneficial for the growth of the people. Lunačarskij contended that the leadership will not obstruct the new development, disregarding how questionable it may seem, in order not to make a mistake and destroy something of real value.[23]

In new art forms, especially in the film art, and partially in the dance Lunačarskij saw a great propaganda and agitating power. Lunačarskij insisted that he could already foresee the popular folk celebrations where all artistic forms would be joined. Such an occasion would unite the songs, choirs, recitations, dance and motion pictures. The artistic expression will be enhanced as a reflection of the thoughts and feelings of the whole people and there will be no simplification or lowering of artistic expectations: "That was what the exceptional people of the most cultured democracy in Attica achieved, and that is what we are now approaching."[24]

Lunačarskij pointed out that the role of literature "the arts of words," as well as the marxist literary criticism is very important. That is why Lunačarskij equated the role of a teacher with the role of a critic. The critic should be a teacher, in the first place the critic is a teacher of the writers. But the critic should facilitate the reading to the readers, since his role is to indicate the right path and give comments for "the enormous . . . valuable, yet inexperienced public."[25]

Furthermore Lunačarskij contended: "There was the opinion that we do not need more critics like Bjelinskij since our writers do not need advice anymore. Perhaps that was true before the revolution, but it is truly ridiculous

after the revolution, where now hundreds and thousands of new writers are springing from the depth of its people. Here a reliable critic is indispensable, since he should lead, and that is why critics like Bjelinskij are very necessary."[26]

With this assertion Lunačarskij continues the tradition of Russian literary critic of the nineteenth century. The critics and writers of this period, tried to educate and lead the masses morally as well as politically. These were the goals that Lunačarskij, as a writer and critic, tried to implement in the cultural policy that he helped to shape.

The theses about the role and function of the arts in propaganda and agitation were reflected to a great extent in the dissertation of the composer, musicologist and conductor Vojislav Vučković, under the title: *Music as a Vehicle of Propaganda.*[27]

The acceptance of Vučković's dissertation marked the completion of his musicological studies in the class of professor Zdeněk Nejedlý. The dissertation depicts the spiritual orientation of the Prague's School of Music Sociology that was founded in some measure through Vučković's efforts.

The musical art, according to Vučković, always served a defined moral objective of a social class. That is why he chose the the theme of his thesis in the spirit of the definition of propaganda as explained and understood by Lunačarskij. The propaganda should act by the objective and methodic exposition of the facts and logical construction. The agitation, as opposed to propaganda should mostly influence the feelings of the readers and listeners.[28]

Vučković's disclosure should exercise influence like propaganda, through an objective and logical execution, excluding the emotional impact. Such an influence Vučković attributed to music.

Vučković believed that the development of music is instigated by the attachment to the social conditions and the needs of the peoples. This belief Vučković practiced as a composer: in his conversations with colleagues he often inquired why a composition was written and for what audience it was intended.[29]

Vučković insisted that the arts until recently were only understood as creation, and only the art work was analyzed. However, a work of art presents a process, where creation is only one part and is completed when the work is performed, through social application and usefulness in specific social conditions.[30] Vučković underlined the ideological vagueness of the nature of music material itself and the impossibility of music to express a concrete ideological content. It is only in defined social relationships, he urged, that music can fulfill its role and necessary function.[31]

The separation of the expressive elements and means of music from the general social development instigated the concept of the triad as natural support of the tonal system. Thus the triad became an eternal and unchangeable form.[32]

In order to establish the necessity of further development of music, Vučković contended that the athematic style of composing and quarter-tone music do not represent a negation of the harmonic system based in the triad, but a reevaluation of existing values. Vučković described the new assessment as "turning from the head to the feet."[33]

At the time when Vučković wrote the essay "Idealism and Materialism in Music," he sincerely believed in the future of the avantgarde music as indispensable to the future social and artistic development.

Vučković's comprehension of arts was closer to the views of Majakovskij than to the position of Lunačarskij who, only cautiously and with various restrictions, supported modern art. Like Majakovskij, Vučković wanted to find new forms for new content. However, Vučković did not always succeed in remaining consistent in this endeavor as a musicologist and practicing composer.

At the same time Vučković's dissertation as well as his studies and articles written in Prague reflect the thoughts and ideologies that prevailed during this period. The most decisive impetus in the formation of Vučković's artistic credo should, however, be attributed to his professor and mentor at Charles University, Zdeněk Nejedlý. The musicological output of Zdeněk Nejedlý (1878–1962) influenced the development of the music-historic method as well as the initial concepts of the Prague School of Music-Sociology. Nejedlý considered the relation between the arts and society as the starting point of scientific research. In his numerous works Nejedlý anticipated the postulates of the sociological historiography of music, and although methodologically his approach was different, Nejedlý paid great attention to the description and research of the historical events that in a resolute manner shaped the artistic personality of a particular artist. Due to this approach, it occurred that music and musical development were neglected to a certain degree.[34]

In 1926 Nejedlý started his lectures in music sociology at the Charles University in Prague. The lectures stimulated to a great extent the founding of the Prague's School of Music Sociology in the 1930's. The formation of the basic postulates and the very founding of the Prague's School of Music Sociology according to Jiři Fukač, was realized by the participation of Vojislav Vučković. Vučković wrote for the journal *Klič* an essay, that in spite of its brevity and conciseness, was understood as an important and basic work that laid the foundation of the new school.[35]

Vučković wrote the following about the inception of the work:

"On the request of Mr. Alois Hába and the editorial board of the journal *Klič*, I wrote for this journal an article on absolute music. In this article I discovered my resolutely negative position about absolute music while observing it from the utilitarian point of view, starting from the consequences that this music has caused nowadays. As the basis for this article served my dissertation which contains the analysis of the medieval music and world history convincing me in the vital functionality and social usefulness of music, *and therefore her ethical foundation, that is, her moral justification,* content and meaning." (Italics, V. V.)[36]

Stressing the important role that Vojislav Vučković played in the founding of the Prague's School of Music Sociology, Jiři Fukač stated: "The writing of the young Yugoslav theoretician and composer Vojislav Vučković may be taken as the true beginning of the Prague's School of Music Sociology. As a student of Suk and Hába and at the same time participant in the seminars of Zdeněk Nejedlý, in a short time he was familiar with the musical life of Prague. Vučković's dissertation: "Hudba jako propagačni prostředek" (Čast kreda mladeho moderniho skladatele)—*Music as the Means of Propaganda* (A Part of the Credo of a Young Modern Composer) does not depict only the intellectual orientation of the recently constituted school of Nejedlý, but at the same time boldly formulates the basic programs of a Marxist concept of the methodology of this area.

The general public became aware of Vučković's viewpoints from a not very extensive study (published in the journal Klič III, 1932/33), but also this work, only a few pages long, essentially developed main arguments. According to Fukač, Vučković has solved in the first place, the question of the semantic interdependence of music terminology in relation to the basic categories of historical materialism, the base (the relation of men in production) and the ideological and artistic suprastructure. The evolutionary forms of musical thinking he observes as relatively independent and emancipated.[37]

Music as a Vehicle of Propaganda

Among the theoretical works that Vučković published during his relatively short life, a special place is accorded his dissertation: *Music as a Vehicle of Propaganda.* Although this work presents Vučković's beliefs, his artistic and ideological credo, it depicts at the same time the prevailing spirit of the time and place where the work was written. Upon his arrival in Prague and enrollment at Charles University Vučković became, in relatively short time,

well informed about the cultural environment.[38] He frequented musical and theatrical performances, visited artistic exhibits. He also became personally acquainted with a number of artists. In Prague, in the autumn of 1929, a significant discussion among the intellectuals with a progressive, leftist orientation was taking place. This discussion became known as the *Generations' Discussion* and took place on the pages of the literary journals *Odeon* and *Revue Devětsil-Red* involving such authors as K. Teige, B. Václavek and others. The debate started with the appearance of an article written by the painter. J. Štyrský in the journal *Odeon*. Štyrský was concerned about the developing conformity among the artists of his generation. The discussion that followed in the course of 1929 and 1930 was concerned mainly with relations between the political and artistic revolutionaries. Later on the discussion focused on the relevance and influence of the Marxist art theory in the Czech society.

Vučković's dissertation reflects, in its basic concept, the views of the association *Devětsil,* a group formed in 1920 in Prague, uniting those artists and writers with an avant garde and progressive, leftist oriented profile. It was the belief of this group that revolutionary ideas should be equally represented in the society as well as in the arts. Symbolically, the subtitle in form of an abbreviation *RED* pertained to their ideological orientation. The *Devětsil* association was identified as the *Svas moderni kultury* (Union for Modern Culture), and its journal *RED* as a periodical dealing with the modern culture.

The members of the Devětsil group participated in the publication of a host of important collective editions, such as *Devětsil* in 1922, *Život II* also published in 1922 and *Fronta* in 1927. The members also contributed to the journals *Disk* (1923–1925) and *Pismo* (1924–1926). The association *Devětsil* and its periodical remained active until 1929. At the end of this year the group merged with the organization *Leva Fronta* that consisted of the leftist oriented intelligentsia.[39]

The writer, art theoretician and book designer Karel Teige was the spiritual leader of the *Devětsil.* He was the initiator as well as the main editor of its journal in Prague. His editorials and articles that appeared at that time were considerd as an authoritative representation of the position of the group as a whole. The writer Bedřich Vaclavek was the editor of the branch office in Brno. *RED* was conceived as a journal of the international avant-garde movement, yet not limited to the fields of esthetics or fine arts. The journal strove to embody the new art of living and artistic experimentations.[40] In the course of the nine years of existence of the journal, the programmatic concepts were repeated at the beginning of each new yearly issue of the series, but remained basically unchanged. Devětsil urged as the first goal the union of

the artistic and social revolution in the manner that seemed to have been accomplished in SSSR. The second goal projected the keeping of the international contacts with the avantgarde, especially with arts movements in France, Germany and Soviet Union. A third aim was to keep a synthetic interest in all art fields like poetry, literature, music, dance, theatre, music hall, painting and plastic arts, film and photography, esthetics, philosophy, psychology, architecture and urbanism. In addition a number of other topics were discussed such as technical education, physical fitness, hygiene, industry and labor organization, sociology, socialism and class struggle, SSSR, journalism and news, agitation and advertising, book printing and graphic art, documentation and news. In retrospect the most significant achievement of the journal *RED* was in the field of theoretical studies and monographs. Besides, the journal had very good reproductions of art objectism, architecture, photography, and material related to various film and theatrical productions.[41]

Vučković incorporated in his dissertation a number of postulates formulated by *Devĕtsil*. Such was his acceptance of the thesis about the interdependence of art and society. Thus, a progressive society should support progressive art. Still Vučković incorporated the second goal of Devĕtsil reaching the development of the artistic and theoretical thought on an international level, providing parallels with the development in Germany in the dramatic field focusing on the contribution of Bertolt Brecht. He supplied information about the Osvobozene Divadlo of Voskovec and Werich, thus presenting the development of theatrical experiments in Czechoslovakia. Vučković also followed the recent development on the field of an emerging and powerful art form:—the film industry in discussing the films by S. M. Eisenstein. Contemplating the answer about the crisis in the art, as a widespread phenomenon, Vučković presented the views of German musicians Eisler and Scherchen and of the Russian theoretician Lebedinskij.

Vučković's dissertation in its essence strove to elucidate, in a new approach, the crisis that had engulfed the musical art. In order to establish the conditions that had caused this situation, Vučković started his research from the very beginning of development of music as an art form. Early in the introduction, Vučković pointed out that his research was not restricted to music as an art form, but that he had researched the social conditions and functions that music fulfilled in the society, stressing the sociological character of his investigations.

Vučković distinguished in an art work the formal elements and the content, as two equal constituents. The art work cannot exist only as form or as content, but presents the synthesis of these two elements. The form alone is not conditioned only by the artistic content, but is also governed by the

autonomous laws of the development of the form itself. The postulates of the autonomy of the art work are limited only, according to Vučković, to the formal component.[42]

The concept of the autonomy of the arts was derived, he noted, from the insufficient knowledge of the social role of music. Music originated as an ethical sanction of an indirect class propaganda that served the interests and morals of a specific social class.[43] In order to confirm these theses Vučković presented in an abbreviated form the historical development of the ancient civilizations, while observing music within the social and economic development. Methodically this approach points to the influence of his professor and mentor Zdeněk Nejedlý, who was among the first who advocated this method of research.

An example of this approach is found in Vučković's description of the development of the social organizations and religions among the Assyrians, Babylonians, Indians, Chinese, Jews and Ancient Greeks. To conclude, he reviewed the development of the Christian religion. The selected examples point to the different functions and different reception of musical works in specific social environments.[44]

Vučković thought that the dichotomy of the ethical action and ethical intention that declares music as an art form, denotes best the function of the musical art. Only on the basis of the neglected component of the ethical action, is it possible to create criteria for the evaluation of the musical work. The ethical intention alone does not exclude the possibility of creation of an autonmous musical work belonging to the absolute music. Such tendencies could lead to subjectivism, while an art work, according to Vučković, may be only what is accepted as general.[45]

The reality of ethical and moral, according to Vučković is parallel to the comprehensibility and social applicability of an art work. These concepts are typical of the adherents of doctrines that aim to influence the general social development, not having a separate criterion for the arts alone. On the other hand the adherents of the art doctrine L'art pour l'art substitute for the moral categories the purely esthetic.[46] This thesis is confirmed by Vučković's attitude, since he strove to reconcile his artistic activities with a progressive, social, political and life concept.

Following further the development of music, Vučković concluded that the polyphony originated as the result of the subordination of the music to the textual basis and to its capacity for propaganda.

As a support for this thesis Vučković quoted the opinion of the Czech musicologist Černušak concerning the polytextuality of motets both secular and sacred. The motet became part of the liturgy in the 13th century and was

most frequently written in three parts. The lowest part, the tenor, was based on a plainsong. The other parts had different words, sacred or secular. Černušak argued that this form originated due to its practical use in the liturgy in transmitting by the addition of words (mot, diminutive motet) a message. Therefore Vučković concluded that the functional use of music and the possibility of propaganda was far more significant than the autonom-artistic requirements. Thus Vučković's explanation of the occurrence of polyphony presented a somewhat simplified point of view, in accordance with the view of Černušak.

In the course of time music acquired a greater independence from the text pointing to the beginning of a new artistic tradition, supported by the theoretical works and new forms of secular music. At the same time these achievements served also for non musical reasons, for a better use of music as a means of propaganda. The dissemination of non musical goals was served well with the court music as well as with the beginning of bourgeois entertainment in the period of renaissance. Vučković contended that the social conditions and circumstances of performance determined the character of a musical work, even when not associated with a text.[47]

Vučković attributed to the creation of the opera the leading place in the further development of music-dramatic works. Opera maintained the central position in the musical development up to the twentieth century. It must be said, however, that Vučković's supposition about the exceptional significance of the opera in the musical development was influenced by a similar opinion of his mentor Nejedlý. It should be noted that Nejedlý delivered lectures about the history of opera in the 19th century at the College of Philosophy of the Charles' University, in the winter semester of 1933. Vučković followed these lectures and successfully passed the examination of this subject.[48]

Nejedlý often pointed to the significance of the opera in his musicological works. In his study published in the Czech journal *Čin* Nejedlý contended: "The history of the European music from the eighteenth century up to the present days, as a whole, is reflected in the evolution of the opera of this epoch."[49] The changes that took place on the operatic field in the middle of the 18th century point to the influence of the bourgeois class. Instead of impressive mythological themes, there appeared satirical or comical presentations of social happenings. These efforts were the beginnings of the comic opera, Singspiel and ballad-opera. In such circumstances music became a propagator of class interests. Vučković thought that in spite of certain naivety and ideological immaturity of these class manifestations, the basic critical thought was rightfully captured.[50]

Even the instrumental music was influenced in its development by the practical needs of a class propaganda. The first instrumental forms and genres were not developed on the basis of the autonomous artistic endeavors, but rather as a part of a specific social activity. These possibilities of social applicability of the musical art led to the further improvement of the form and content. The insufficient understanding of the social role of music accounted for the formation of the concept that occurred in the classical period of the autonomy of an art work. Vučković contended that the insistence on the autonomy of the art work was the product of the decadent class. Therefore it is possible to determine "a great loss if we proceed from the consequences that were brought upon this to music."[51]

The inability of music to fulfill its social functions, the deprivation of outward existing goals, as well as the creation of the autonomous artistic principle, did not in truth implement a radical break with the tradition of functional music, as Vučković projected. Although the outward purpose was eliminated, in its essence it was incorporated into the specific content and form of an art work. The traits once introduced a musical work in concordance with the function the work performed, became immanent characteristics of that work. The function of a polonaise or mazurka, as an aristocratic or earthy folk dance remained in the work, even after its stylization into a concert piece.[52]

The concept of the autonomy of a musical work and the elimination of the superficial functionality were traceable to the evolving comprehension about the uniqueness and originality of an art work. This change started to take place from the 16th century and became fully appreciated around 1800. In the older, functional music, an art work presented primarily the qualities of a certain musical form, and therefore it was conceived in the spirit of the contained tradition. Gradually new criteria were crystallized about the necessity of a unique, individual expression and emphasis on originality, as well as a digression from the established concepts about the formal structure of a musical work.[53]

In the second chapter of the dissertation: *Cosmopolitanism and Utilitarianism as the Ideological Basis of Music,"* Vučković further elaborated the thesis about the necessity of the association of music with the social happenings. He criticized the endeavors directed towards cosmopolitanism and universalism as a deviation from the artistic and ethical contents and comprehension about the social role of music. These suppositions point, according to Vučković, to a degeneration of the arts to the level of a play without greater significance.

The lack of public interest in the contemporary music creations Vučković explained as an isolation of the music from real life. He pointed to the moral

and ethical role that music enjoyed in the eighteenth century. Therefore he comprehended an art work not only as *opus pulchrum,* but also as *opus utile,* fulfilling a special ethical sanction of social interests. His intention was to point out the exceptional position of music in exercising a socially useful role. If music is to regain this exceptional role in the life of the society, it should abandon the principles of absolute art. In these endeavors one should not strive for a simplification of the musical content, since the contemporary music is a product of a historical development. Vučković was convinced, at the time of writing the dissertation, as a musicologist and as a composer, that the achievements of the athematic, quarter-tone and twelve-tone music present an important and progressive result of the social development. A progressive society should encompass progressive music. It is noteworthy that Majakovskij formulated similar views about the form and content of an art work. Majakovskij contended that one should write in a completely new manner, presenting a new content and a new form. Who ever uses old forms should be convicted as a servant of the by-gone times.[54]

Vučković contended that the compositional output of Arnold Schoenberg and Alois Hába presents the ultimate phase of formal differentiation and accomplishment. The athematic style that emerged in the compositions of these two composers, as opposed to the thematic style, renders an impossibility of further development of form alone and therefore points to the reform of the content.[55]

The didactic third chapter of Vučković's dissertation offers possible solutions to the crisis in music. In order to bridge the gap that existed between the public and the contemporary music, Vučković provided examples pointing to compositional forms that could fulfill the goals earlier described.

Vučković stressed that formal suprastructure of the artist's technique— separated from the functions of the daily life—did not correspond to esthetic norms of the present. In order to establish which forms could strengthen music as propaganda, Vučković singled out three conditions: the development of the social means of production—the degree of their technical perfection; the wish for creating concrete themes reflecting the artistic and class constituents; and the knowledge of current compositional and technical development of music.[56]

Vučković contended that certain forms ought to serve well to promote specific direction and therefore secure the position of music in society: the chambre opera, Zeitstück—Revue, and cartoons. He pointed out that many contemporary composers showed interest in the chamber opera.

From a historical perspective the origin of the chamber opera can be found in cantata de camera. Diligently cultivated by Alessandro Grandi it exerted a

considerable influence on Grandi's contemporaries, and became one of the most popular vocal-instrumental forms of the seventeenth century. Chamber opera that consequently developed was written for a smaller cast and orchestra, suitable for performance in a more intimate surrounding. A number of chamber operas were even written as an ideological reaction against the grand opera of the nineteenth century.

In a relatively short paragraph Vučković presented the essence of the Wagnerian ideology. Wagner's romanticism, he explained, presented a characteristic conflict of a romantic artist with the bourgeois society. Wagner's escape into mythology, pure poetry, antiquity and finally to Parsifalian resignation is, in reality, reaction to the bourgeois existence. A revolt against the society although individual and isolated, it is passive and weak.[57]

Thus the chamber opera was comprehended as the formal antipode of the grand opera of the nineteenth century. The large choirs, and orchestras, magical scenes, projecting an illusion of power, in addition to implausible dramatic plots had to be abandoned. For these reasons chamber opera was understood by many as a change towards a new and simplified operatic style. From the utilitarian point of view, the chamber opera enabled a relatively quicker and easier rehearsal of the new material. With the smaller cast and orchestra the composer was not forced to compromise since there was no need for a material subsidy. Therefore there was no obligation for any change of the dramatic plot, as to render a less recognizable current situation, or a reduction of the number of performances that would restrict the influence and the propaganda to a smaller public.

Vučković pointed to the success that Offenbach achieved in his operettas. Offenbach wrote over sixty one-act operettas that in spite of simple sceneography had many performances. If Offenbach ever possessed a political ideology he could have accomplished an important mass propaganda undertaking. However, he was caught in banalities and trivia rather than in satire or revolt. Therefore Vučković contended, the formal skeleton of his operetta ought to be preserved but the content should be changed to become realistic and class oriented. The form of the chamber opera allows the possibility for the application of absolute music, as a laboratory preparation, that may enable the search for the true musical expression in service of propaganda.[58]

Surprisingly this statement contradicts the basic thesis of Vučković's dissertation. In the first and second chapters of this work, Vučković tried to prove that art work consists not only of the form or content, but presents an equal union of both elements. The postulates of the autonomous art are limited, according to Vučković, only to one of these elements, to the form. Music radiates an ethical action that helps the ideological stabilization and class

orientation, discernible only from the viewpoint of a specific class moral. This indirect propaganda had a relative character that corresponded to the specific social milieu, place and conditions where it originated. Thus the role of the sonata performance at the court differs sharply from the one played during the church service. In both instances music executed its purpose in accordance with a specific class ideology and moral concept. Vučković concluded that further cultivation of artistic forms that originated in earlier historical circumstances cannot promote the same ethical action that originally these forms performed.[59]

These theses that Vučković expounded in the first and second chapters of this dissertation are in opposition to the requirements of the renewed introduction of the chamber opera. The suggestion regarding reinstatement of the old forms brought about the annihilation of the theses of the historical, political, social and economic limitations of ethical action, as well as the supposition about the unity of form and content. Thus by applying Vučković's postulates, Offenbach's musical form reflected in its content the time and spirit of the contemporaneous cultural and artistic life.

Reflecting a broader interest in the topical cultural context set forth by the policies of Devětsil, Vučković included in his dissertation the discussion of the popular forms of Zeitstück-Revue, ballet revue and sketch revue as forms of engaged art. Vučković believed that these forms were the contemporary concepts of the revolutionary theatre. After the subjective art of the previous periods, where the theatre was concerned with portraying passive daydreams and emotional moods, modern art points to the optimistic belief in the strength of man. The epical theatre of Bertolt Brecht embraced this attitude. Brecht negated the sentimental *Rührstück* and introduced the *Lehrstück* which portrays facts and stimulates spiritual awareness. The topical themes in these works excluded lyrical details as well as everything that could be explained as sentimental. Vučković contended that lyrical episodes were conceived as false and superfluous, whereas emphasis should be on the dramatic plot. When the musical sequences were introduced in Brecht's theatrical presentations they were noticeably unmelodic. Vučković therefore contended: "Bertolt Brecht pursues utmost unmelodic music in his epic theatre such as Lehrstück that does not portray sentiments, but arguments, and encourages intellectual activity, presenting the pictures and the comprehension of the world."[60]

Bertolt Brecht believed that the role of music in a progressive dramatic piece can be enhanced only if it is regressive. Regressive music for Brecht was expressed in a sentimental and melodious approach. Thus Brecht wanted to reveal that human emotions are only masques that hide selfish interests. That

is why the music in Brecht's plays is conventional with sentimental overtones, like the feelings that are universal and human, yet selfish and not sincere, brought forth in the conditions of human misery and deprivation, fostering the wish for change.[61]

A new enrichment for the *Zeitstück* presented the introduction of revue elements. In this *Zeitstück* variant lyricism was not preceived as an obstacle. The lyrical episodes brought the necessary contrast to the narrative segments. Thus music was conceived as an unifying element, permeating and binding the dramatic flow. The psychological woof of the play was expanded by the addition of stereotyped figures personifying certain traits.

The selected music for *Zeitstück* performances was akin to popular music, which was melodically and harmonically regressive. Vučković denoted this music as jaz. In the context, however, this concept of jaz music included the popular and trivial music. The beginning of this new theatrical form was associated with hetereogeneous musical arrangements. Vučković argued the necessity of changing this concept since it was an eclectic, stringing together popular tune and well known arias like *Carmen, Aida* and *The Queen of Spades,* and instrumental music comprising different compositions of Chopin, Tčajkovskij and Johann Strauss.

Vučković thought that instead of the music used until then in *Zeitstück,* the twelve tone music of Schoenberg and even the quarter tone music of Alois Hába should be introduced. In order to eliminate the costly rehearsing of actors for the performance of musical parts the recitative choirs should be introduced as an alternative for the soloists and singing parts in general. This recitative principle, akin to the latent melody of speech, was at one time used in the antique Greek drama.[62]

With these aspirations Vučković once again was approaching the theses of Lunačarskij. Lunačarskij contended that a similar theatrical form would be able to unite all arts in the manner of the antique drama. Such an artistic form could unite singing, declamation of verses, dance and film. Lunačarskij insisted that film as a new art form contains an influential propaganda and agitation potential.[63]

Vučković reasoned in a similiar manner stating that the cartoons could allow great freedom to the musical component by providing unrestricted avenues of expression. Since the cartoons do not have a scenographic tradition there is a greater freedom and independence possible. The format of the cartoons originated in music and was reinforced by music accompaniment. The problems of the cartoons were in their content. However, the cartoons as well as the film production had become part of an industry subordinated to the managerial policies.

Vučković believed that there existed numerous possibilities for collaborations between the cartoons and contemporary music. The influence of a dynamic caricature having social satire as its goal could be reinforced by the support of music. On the other hand the modern music might become by the help of cartoons known to many and consequently even widely accepted.[64]

Since the two first chapters of the dissertation had been conceived as an historical explanation of the origin of crisis in music, so the third chapter should have provided the possibilities of solution of the given situation. The didactic character of the third chapter presents in itself an educational treatise—Lehrstück—presenting Vučković in his role, as the educator, akin to his true nature.

In order to bridge the gap between the audience and contemporary music, Vučković supplied examples to show which musical forms might fulfill this goal.

However, Vučković failed to see that the conclusions formulated in this chapter contradict the theories expressed in the first and second chapters of his dissertation. The suggested adaptation of the chamber opera form for new musical and dramatic content implicitly contradicts the thesis about the unity of form and content, as well as the historical, cultural and socio-economical limitations of the ethical effects of an art work.

Similarly, the supposition about the introduction of twelve-tone, quarter-tone and athematic music in the theatrical revue forms is contradictory in nature. Vučković expected that the enrichment of the Zeitstück-Revue with contemporary music would promote the acceptance and popularity of the new music language. Vučković did not realize that the formal schemes of the revues were enhanced by the spontaneity of popular and trivial music characteristic of the genre.

Likewise, Vučković did not comprehend that in the selected theatrical forms there existed a unity of form and content. The regressive character of the music language poignantly indicated the moral and material misery of the then subordinate classes of people. For example, the *Beggars' Opera* by Bertolt Brecht and Kurt Weil can serve. Brecht's conception was suitably supplemented with the stereotyped melody that pointed to the helplessness of many and consequently to the necessity of social and political change.

In the *Beggars' Opera* human emotions were comprehended as false since these emotions resulted from imposed social restrictions, as well as from the loss of personal freedom and dignity.

As a practicing composer, Vučković could have verified these theses by the implementation in the compositional process in order to substantiate his

statements. This approach would have supplied a more truthful insight into the suggested solutions of the crisis in music.

In retrospect, the Czech musicologist Jiři Fukač contended that in particular the conclusions reached in the third chapter of Vučković's dissertation can be likened to the social engineering function that Vučković was attributing to music sociology. The lack of suggestions to prove the possibilities of bridging the existing gap between the public and new contemporary music production presented, in Fukač's opinion, the essential weakness of the dissertation.[65]

The Review of Theory and History of Esthetics

The Review of the Theory and History of Esthetics presents a collection of lectures that Vučković delivered as teacher of the Stankovic Music School in Belgrade. From the autumn of 1934, when he joined the faculty there, he regularly held lectures in music history and music esthetics.

This collection of lectures testifies to Vučković's serious approach to teaching, presenting his views about the current musicological research and at the same time depicting the level of scholarship of the curriculum of this well known school of music. Vučković as a lecturer and pedagogue wanted truthfully to elevate the knowledge of his students. Besides presenting the historical overview of esthetics, Vučković wished for his students to partake in the knowledge of the contemporary musical and esthetic thought.

From the present day perspective, the most significant research was contained in the fourth and fifth chapters. The fourth chapter under the title, "The Theory of Progressive Art—Idealism and Matrialism in Music," appeared in an abbreviated version in Czech language under the title: "Idealism and Materialism in the Fine Arts."[66] After its publication in Prague the essay stirred lively discussions. These discussions were mentioned by Jiři Fukač in "Die Tradition des musiksoziologischen Denkens in der Tschechoslovakei."[67]

The fifth chapter, "The Crisis of Contemporary Music and the Conditions for its Overcoming" was published for the first time in 1962, together with other lectures on esthetics in one volume as a whole.[68]

The fourth chapter, "The Theory of Contemporary Music," with a subtitle: "Idealism and Materialism in Music" is in content and manner of exposition close to Vučković's thesis expressed in his dissertation. As in his dissertation Vučković observed the origin of the crisis in music in an historical framework, including the changes in social relations. Thus the postulates of absolute music, that are according to Vučković widespread, comprehend the expressive means of music melody, harmony and rhythm as the goal and not as the

vehicle of artistic creations. The social background of this music ideology as contained in the concept of absolute music, founded on Kant's idealism, is directed against further growth.[69]

Vučković draws a parallel with the literary formalism and the explanation of Gorkij about the formalistic exposition of esthetics. Vučković paraphrased Gorkij contending that in music as well as in esthetics, according to formalistic views, the beauty is expressed in the harmonious union of sounds, colors and lines—independently from the content. The adherents of absolute music are disassociating the melody, harmony, rhythm from the dependence upon a specific social content. Therefore the representatives of absolute music err when believing that the correct relations of the expressive elements of music are proof enough of the capability of music to serve as medium for spiritual and emotional communication.

Furthermore, according to Vučković's reasoning, reality negates this supposition since the musicians and many non-musicians alike are not capable of discerning in music more than the inner and historically comprehended values of music elements such as melody, harmony, rhythm and tone color, and their logical development. Vučković pointed out that there does not exist a specific condition that will enable the comprehension of music material as an expression of a defined concept or a plurality of concepts.[70]

Vučković considered that far more important were the consequences of separation of the elements of music expression from their social determination. This attitude brought forth the comprehension of the triad as the most significant supporter of the tonal musical language. The separation of the triad from its broader context fostered the belief in the triad as center of the tonal and acoustical as well as formal evolution of music. Thus the triad became the foremost support of tonality and at the same time the main obstacle of further musical growth.[71]

Vučković thought that the historical development that produced idealism at the same time caused the lowering of the musical art to the level of entertainment. Thus the role of moral preacher and educator that music until then held was forcefully lessened.[72]

On the other hand the music ideology that did not comprehend or view the elements of expression as having intrinsic value maintained that the development of music is dependent on the social needs and the function that the music can perform in a society. Thus the postulates of applied music relied on historical experiences, stating that every epoch had a specific comprehension about the function and significance of music. Vučković stressed that the profound difference between the absolute and applied music, similar to the contrast between idealism and materialism, is due to the fact that the absolute

94 TRADITION AND AVANT-GARDE

music is hypothetical and dogmatic while applied music is historical and experimental, and therefore scientific. As an example Vučković mentioned the musical forms where the text reflects the ideology such as in religious songs, oratoriums, cantatas, operas among others. In more compound forms of the social performance of music the purpose of the art does not always correspond to the theme of the work but depends on the social use. In such case, music does not exert its influence by its purely musical qualities of its expressive material, but through its social application. The religious connotation of an organ fugue is transmitted not only by the musical properties, but in equal proportions with the awareness of its place in the ritual conducted in solemnity of a church.[73] Thus Vučković believed that the music materialism had abolished the prejudices about the legitimacy and naturalness of the diatonic system and thematic style alone. This concept was opposed to the supposition about the triad as a central musical value. The triad is only one particular level of the music development, necessary as a reflection of a specific progress of culture, yet not eternal, and inviolable. The triad should not become a stronghold of tonal music and at the same time the profound obstacle of the future development of music.[74] With this statement Vučković seemed to predict the basic postulates of socialist realism that to a great extent blocked further artistic development in the countries of Eastern Europe immediately after the end of the Second World War.

The adherents of this doctrine professed that the avantgarde composers would bring about "the liquidation of music." In this spirit wrote the Czech musicologist Zdeněk Novaček at the beginning of the 1950's:

"The clever theses, explanations and excuses of the formalists, which always had a reactionary character, developed a confusing form. These intentions we can mark as the desire that the liquidation of music should be concealed with leftist phrases. The defenders of one of the most extreme factions of formalism, the quarter-tone music, tried to subdivide the tonal material of music even against the psychophysical properties of men if only to seem to be ideologically progressive."[75]

Novaček criticized even further statements made by Vučković in the same work. Thus Vučković presented the athematic style and quarter-tone music not as a negation of the natural athematic style and the harmonic system based on the triad, but as the "turning from head to its feet."[76] If observed chronologically the thematic style presents the higher degree of development as a negation of the primitive athematic style. Thus the contemporary athematic style, as a further development of the thematic style is the negation of the

negation, that is the abolition of the dialectic contrariety in the development of the expressive means of music up till now.[77]

Novaček commented on this statement in the following manner:

"The undermining of the real basis of the music was hidden (by the avantgarde composers—JMDj) with the help of the terminology of the progessive ideology. Since they wanted to justify their athematic style which contested the basis logic of growth, they used to a great degree the terminology of the progressive ideology . . . These direct or indirect fighters against the working class did not hesitate to use for their defense the dialectical principles of the revolutionary theory of the proletariat, and with faulty application they could cause a confusion among the honest composers full of confidence."[78]

In the formulation of these judgments Novaček was guided and at the same time limited by the impositions of the theses of socialist realism. In addition Novaček's further supposition that Vučković was against the struggle for the rights of the working class was inferred on the basis of insufficient knowledge of the life and work of Vojislav Vučković, who was indeed close to the progressive movement among the working class. Thus he actively participated together with the writer Čedomir Minderović in the organization of the strike that took place in 1936. During the strike Vučković composed the song about the *Ten Thousand Strikers*.[79]

Immediately after his return from Prague, Vučković tried to correlate his work as conductor and composer with social work. As conductor he worked with students and worker's choirs. As composer he wanted to introduce choir recitations where the dominant component was the text with a progressive message. In this vein he composed two compositions for *voice-band* and chambre ensemble, on the text written by his brother Mihailo Vučković. Vučković wrote another work for the choir, employing the recitation manner of performance, and based on the verses of Chinese revolutionary poetry. Although Vučković did not indicate the absolute pitch, a relative differentiation was required, reflecting the latent speech melody. His work as composer and conductor enabled not only the dissemination of musical knowledge but also the contact with the youth, sharing progressive ideas.

Vučković's study: "Idealism and Materialism in Fine Arts" attracted the attention of the Czech musicologists Jiři Fukač some twenty-two years after its publication. Fukač thought that Vučković gave a better explanation of the development of music in this work than in his dissertation: *Music as a Vehicle of Propaganda.* Fukač even briefly reviewed the polemic that Vučković's study stirred at the time of its publication in Prague. Fukač mentioned the

article of Josef Stanislav: "Ideology and the Arts," that appeared in the journal *Rhythmus* in 1937. Fukač pointed out that Stanislav's critique was mainly directed towards the incongruity in Vučković's comprehension of music and philosophy as a reflection of the economic and political basis.[80]

A similar view was proposed by Eleonora Mićunović in the critical study published in the journal *Danas (Today)*. Mićunović wrote the review in connection with the publication of the collection of Vučković's musicological works edited by Dušan Plavša. Mićunivić declared as futile and unsuitable the postulated theses about music as an ideological aspect expressed with the terminology of dialectical materialism. This approach, she said, is even more incongruous if used in music analyses. However Mićunović stressed that Vučković's approach had its validity in the given time period not only due to its progressive and revolutionary significance but also due to its intrinsic professional value.[81]

In the course of time search for a solution to the crises in music became Vučković's primary concern. Vučković realized, as did many others, that the contemporary music was not accepted by the public. This problem was challenging composers, performers and critics around the world. To clarify his position, Vučković wrote the essay: "The Crisis of Contemporary Music and the Conditions of its Elimination," presenting his views about the possibility of solving the existing problems. This essay was later included as the fifth Chapter in *The Review of the Theory and History of Esthetics*. This essay points to the fact that Vučković did not ignore the distinction between the spiritual suprastructure and the development of the economic basis.[82]

In presenting the existing crisis in the contemporary music Vučković juxtaposed the opinions of Eisler and Scherchen in a contrasting manner as *punctum contra punctum*. Hanns Eisler purported that the crisis in music was part of the wide spread economic crisis. Therefore the solution of the crisis in music would depend on the extent that music could help resolve this situation. Vučković concluded that Eisler associated not only the origin but also the solution of the crisis with the world wide economic crisis. The crisis in music, he said, is only the reflection of the economic crisis. Until the economic crisis is solved, the crisis in music could not be solved either. From this statement it could be deduced that the solution for the crisis in music does not depend on music and therefore music cannot influence the crisis in the economic field.[83]

On the other hand, only a few years earlier Hermann Scherchen stated that the music had already long ago solved its crisis. In the last twenty years composers had been inventing new possibilities for ending the crisis. Among the new approaches Scherchen mentioned *Gemienschaftmusik*—The Community Music, and *Spielmusik*—Music for Playing.

Scherchen's opinion contradicted the thesis formulated by Eisler. Scherchen observed the crisis in music as independent from the economic crisis. Scherchen thought that the crisis in music was manifested in the paucity of the thematic material of tonal music. After the appearance of Wagner's *Tristan* the compositional methods were changed, often introducing radical innovation of the tonal system. The new tonal relations, according to Scherchen, have solved the crisis in music. However, Vučković concluded Scherchen isolated the music from the spiritual evolution of mankind and arts in the society.[84]

Vučković contended that the crisis in music cannot be equated with the crisis in the economy. In this explanation of music crisis Eisler identified the development of the spiritual suprastructure with the development of the economic basis. Vučković identified this substitution of the economic crisis with the crisis in music as the cause of contradiction in Eisler's argument. But it is also impossible to separate the crisis in music from the economic influence since the very existence of musical art proves that music is not "a thing in itself," but that it exists for all the members of humankind. Therefore music is subject to all the influences that condition the spiritual and intellectual existence and growth. Similar to the theoreticians who explained the harmonic progressions in late works of Wagner only as tonal relations, Scherchen believed likewise that the solution of the crisis is accomplished with the enriched tonal language. Vučković stressed that this separation of music from the social reliance presented the contradiction in Scherchen's explanation.[85]

The pronouncements of these two outstanding musicians did not fully explain the crisis in music, although representing two opposing views. Vučković stressed that both opinions, besides many other yet similar considerations, originated between 1933 and 1936 at the time of the world wide consolidation of economic crisis. This period produced great stress in the structure of the bourgeois society. The empty concert and theatre halls, the firing of musicians and decimation of orchestras created at the time unemployment and famine as widespread happenings in nearly every city. The serious music was replaced by operatic potpourries and Viennese waltzes. The mechanical music, radio and record player, as cheaper than the live performances, were often used. Such disruptions in the musical life were interpreted as analogous to those of the economic trend.[86]

There were also views stating that the crisis in music was not caused by the economic crisis, since it was considered to be only the problems of composers and their creations. Vučković stressed that this was the contention of Lebedinskij as presented in the essay: "On the Crisis in Music." Lebedinskij discussed contradictions, shortcomings and general anarchy in contemporary

music production. As opposed to Scherchen who completely ignored the inter-dependence of music and social reality, Lebedinskij pointed out that these phenomena are the reflections of the nature of the bourgeois class. Vučković contended that Lebedinskij approached the basic problem with greater acuity than Scherchen.

Vučković considered the basic idea of Lebedinskij—that the main cause for the contradictions and anarchy in contemporary music should be searched for in the society—as methodologically correct. However the incomplete explanation of the idealism and materialism in music prevented Lebedinskij from solving the problem. Vučković repeated the thesis presented in his study "Idealism and Materialism in Music" stating that the manner of application of the expressive means of music, that is of melody, rhythm and harmony, determines the character of the musical art. The expressive means in themselves are neither progressive nor backward. Lebedinskij judged atonality, polytonality and other directions of modern music separately from the evolution of the expressive means of music, in spite of the belief in identification of these directions with the ideology of the bourgeois class. Vučković repeated that the development of the expressive means does not justify incentives for their reactionary application. Therefore the expressive elements should not be discarded and their growth should not be discouraged. Vučković thought that the degree of development of absolute music did not cause the decadence of bourgeois music and it did not result in the reactionary desire to constrict the circle of music consumers.[87]

The crisis in music was not confined to the music alone. Vučković pointed out that the crisis in music is the total of any other contradictions that exist in bourgeois music. Vučković stressed that the crisis in music is only the crisis of bourgeois music. While the production of economic goods in the present society was only capitalistic, the music as well as arts in general ought not to be only bourgeois. Vučković's statement is based on the simultaneous existence of the culture of folk masses and bourgeois culture, in compliance with Lenin's thesis about the parallel existence of socialist culture and in its essence reactionary culture of the leading bourgeois class.[88]

In this essay, as well as in some articles, lectures and studies from this period, Vučković as a musicologist and as composer hoped to justify further development of contemporary music, promoting this view.

THE AVENUES OF THE AVANT-GARDE

The influence of Vučković's endeavors, as a progressive and contemporary musicologist and composer, was reflected in the works of some other authors published during the 1930's. The article of Stana Djurić-Klajn "The Paths of Our Modernism" expressed some opinions similar to Vučković's positions formulated in his dissertation, *Music as a Vehicle of Propaganda.* The similarity appears in the discussion about the thesis of the interdependence of music with social needs of people, regarding the utilitarian criterion in this evaluation of an art work. Stana Djurić-Klajn asserted that an art work due to its character and articulation, should be of general interest and not a subjective experience limited in its scope and directed only to a limited number of people.[1]

At the same time Stana Djurić-Klajn showed a reservation in accepting the compositional output of Vojislav Vučković and other former students of the State Conservatory in Prague. In analyzing the existing situation in the musical field—the article was written in 1938—Djurić-Klajn pointed out the existence of three well delineated artistic movements. The nationalist trend, once very influential, presented at the moment a barrier for the further development of music. Expressionism had as a characteristic trait the wish for the expression of individual feelings of the artists. Stana Djurić-Klajn believed that music, in its essence, should be of general service. The composers should be concerned with the accessibility of an art work. Art work as a reflection of individual experiences could be interesting only for a small number of people. These works are also interesting for the composer himself since he composes such works "for the deliverance of his soul" as well as for professionals who have a command of knowledge of compositional technique. Therefore the

expressionistic style presents a negation of the service, meaning and goal that an art work can perform.[2]

Besides these two movements, Stana Djurić-Klajn described the objective style which is even more directed to the professional musicians. Miloje Milojević addressed the same trend as the "intellectual objectivism." These composers, declared as "constructivists" were eluding the folk idiom as something reactionary, or perhaps as a romantic trait. Stana Djurić-Klajn contended that they are mistaken in their judgment, and that their works are equally not accepted by the public as a valuable contribution capable of performing a service. The solution for this situation is in creating art works that can be easily comprehended by a wider public. Such a possibility might be the folk songs enriched with a contemporary musical language. This approach would even facilitate the comprehension of the new compositional technique and might find adherents even in a less educated strata of general public. Stana Djurić-Klajn stressed that this should be the road that the young composers, those who consider themselves as revolutionaries, should take if they truly wish their music to be accepted by a general public.

If these young composers do not change, they will continue to compose for a few professionals and their music will never reach many listeners. This limitation would prove that they are far from a real artistic revolution.[3]

Furthermore, Stana Djurić-Klajn pointed out that the essential problem of contemporary music is in its social application. To this end so-called applied music that combines music with drama, dance, film and choir recitations has its justification. In such a synthesis the true meaning and function of music is reflected at its best. The contemporary music language can become accessible even to those who have not heard about atonality, polytonality or chromaticism. It is by the mediation of other art disciplines that music can surpass the limited reception and become vital and socially justified. That is how the arts will cease to be one sided and unpopular, by becoming a part of life's reality and struggle.

In the analysis of these statements there is an apparent similarity with the postulates formulated in Vučković's dissertation and especially in Vučković's *Review of Theory and History of Esthetics*. Vučković pleaded for the introduction of applied music that would be relevant and understandable to many. With this goal in mind he advocated new dramatic forms uniting all the arts, similar to the artistic concepts in ancient Greece. Indirectly, this essay of Stana Djurić-Klajn refers to a similar thesis of Lunačarskij, which had influenced Vučković's artistic credo.[4]

Although this article intended to rebuke the young composers, members of the so called Prague School, named after the town where they had studied,

the recurrence of the essential thesis is apparent. Some other reviewers expressed sharp criticism in the pages of current music journals. Thus Milenko Živković raised his voice against "the music scatterbrains" while advocating the creation of an indigenous culture of the native land.[5]

The composer Petar Krstić, who acted from 1928 until 1938 as the chief officer of the Department of Arts at the Ministry of Education, expressed a polemical attitude towards the composers of the Prague School. He wrote a sharp critical review of the piano recital of the composer Mihovil Logar, who performed his own compositions, *Sonata for Piano*, the *Piano Suite Pierrot and Colombine*, *Grotesque*, *The Little Serenade* and *Tango*.[6]

Further disappointment awaited the young composer: since it was hard to attract the interest of music publishers. In one case the publisher Jovan Frajt turned down Logar's plea claiming that the suggested compositions were of a complex compositional texture including chromatic harmonies obscuring the tonal centre.[7]

Some music critics had more pronounced objective views. Branko Dragutinović wrote of the aforementioned recital of Mihovil Logar:

> "The young Slovene Mr. Mihovil Logar, a student of the Czech master Suk and a teacher of the Music School in Belgrade, played with a sufficiently expressive pianistic technique his piano miniatures. Mr. Logar is too young to receive a definite judgment. His piano compositions employ the most modern means and in harmonic aspects reach atonality, often are based on the rhythm of jazz band, with a sound pianistic approach, although still in search for the true expression that will without any doubt develop."[8]

Stanojlo Rajičić vividly evoked the dilemma that awaited students after their return from Prague. To continue composing within a contemporary music idiom would necessarily imply the non acceptance and an impossibility of further performances of the newly composed works. The only satisfaction would be an occasional favorable critique or the support of the few adherents of the contemporary musical trends. While the young generation of composers strove to learn the achievements of athematic, atonal and quarter-tone music, the musical environment at that time in Belgrade was not yet ready for this new avantgarde music.[9]

Rajičić remembers the difficulties that sometimes occurred during the performances of his compositions. For example during the live performance of his *First String Quartet* on the Radio-Belgrade the telephone was constantly ringing with protests of the listeners.[10]

There was also a shortage of good performers. The few dependable players were burdened with many requests. Often a serious preparation for solo or chamber music concert was cancelled due to the heavy load on the artist of scheduled work in a symphony or operatic orchestra.

An example of the revision of a completed composition, is still preserved in the original manuscript score of the Second Strong Quartet by Rajičić. In the fourth movement of the Quartet the triplets were substituted by two eighth notes in order to facilitate the execution of this movement.

It oc asionally happened that the performance of the new works failed due to the insufficient practice. This was the case with the performance of the *First Symphony* by Stanojlo Rajičić; it was played twice as slowly as the indicated tempo.

Although the Opera of the Public Theatre and the Belgrade Philharmony, two important professional bodies, steadily enriched the musical life, the artistic policy as well as the repertoire was closer to improvization than to systematic and planned programs. The composer and conductor Predrag Milošević remembers that when he came in 1931 back from his studies in Prague, the program policy lagged in organization, as in comparison with that of other European centers. As a well schooled and prepared conductor Milošević performed in 1934 the *Requiem* by Verdi, with the participation of the Belgrade Singing Society, Philharmony and soloists from the Opera. Milošević prepared the performance of another importance work: the oratorio *Messiah* by Handel. Both performances mark an important date in the musical life of Belgrade at the beginning of the 1930's.[11]

The public and the critics tended to ignore the compositions of the young generation of composers belonging to the Prague School. Stana Djurić-Klajn, many years later, reminiscing about the concerts of these groups of composers, pointed out that their works "were hard to accept."[12]

Such were the attitudes that motivated Vojislav Vučković to start the lectures on contemporary music at the Public University Kolarac. Vučković believed that lectures would promote better understanding of the contemporary music.[13]

Miloje Milojević, as one of the most influential critics in the period between the two world wars, expressed in numerous critical reviews his disbelief in the true value of the compositional work of the young composers. Milojević thought that these works represented "news at any price," since it seemed that such works had been created on the ruins of former achievements. Milojević was not sure of the "vital value" of these works, although the arts should progress in an evolutionary fashion in a forward motion. Milojević concluded that only these artists who have the tenacity to speak about the paucity of

the diatonic system have a paucity of spirit and wish to achieve a different individual profile at any price.[14]

Gradually Milojević modified his opinion as a critic and as a practicing composer. As historiographer Milojević came to believe that several different musical styles should be able to exist simultaneously, as it was the case throughout history. As composer Milojević changed and expanded his musical vocabulary creating the cycle *Rhythmical Grimasses* for piano with the Opus Number 41. The success of this composition is verified by the fact that it was included in the Festival of the International Society for Contemporary Music that took place in Paris, on June 1937. This was also the first performance of this composition with the pianist Lisa Kurc. The contemporaneity of the harmonic language, leading to atonality, a free thematic development and changeable rhythmic scheme attained an expression similar to the compositions of the composers of the *Prague School.*

In the period when Milojević was approaching the avantgarde position of this musical expression the composers of the *Prague School* were approaching a new phase in their creative efforts. The necessary adjustments and testing of the compositional craft brought a gradual slowing down in their creative endeavors. Anton Dobronić wrote the following about the musical life in Belgrade at that time: "I have the impression that today little is done in the field of musical production. Whether this is the result of the feeling of insufficient artistic power, or even a decline in the musical and creative competition between Zagreb-Ljubljana-Belgrade is a question that I do not care to discuss."[15]

This decline was noticed even by Petar Konjović, who sought to justify Milojević's position towards the young composers. Konjović admitted that Milojević wrote sometimes in a critical and sarcastic manner about the younger generation. The reasons, Konjović explained, were the confusion characteristic of the young generation of musicians and the "characteristic barrenness" of the time when he was writing his critical reviews.[16]

The decline of production and the continuing search for new directions were widespread as the music crisis encompassing composers and performers extended around the world. To give some direction Vojislav Vučković was calling attention to the conclusions of Eisler, Scherchen and Lebedinskij, who tried, each of them in a different manner, to solve the difficulties that plagued the contemporary music.[17] The topic attracted the attention of composers, critics and performers as well. In writing about the music festival in Florence, Petar Bingulac pointed out, with regret, that not enough attention was given to answering pivotal questions. Bingulac wrote:

"During the congress many questions of interest for contemporary musicians were discussed. In the presence of Richard Strauss the talk concerned the importance of the modern opera: in front of critics the critic was criticized. Yet the congress gave more impression of professorial lectures . . . than of a discussion of the very vital problems of music. It would have been better, for example, instead of the talks about the pedagogical influence of the radio or philosophical deliberations about the concept of interpretation, to utter a firm word about the crisis, about the confusion of the contemporary music and at least to try instead of stalling, to find a new path forward."[18]

The crisis of the contemporary music was announced as the theme of the discussions held within the framework of the Music-Dramatic Days in Strasbourg, in August of 1933. The organizer, the well known conductor Hermann Scherchen, wanted to offer an opportunity for the exchange of opinions: "about the current problems of contemporary music, about the music crisis and the possibilities of its solution, about the extensive large music reform, that should be a part of the general artistic renewal—about the new music renaissance."[19] These words encouraged Vučković, who was a participant of the summer course as a conductor and composer, to ask for a special discussion. Vučković wanted to present his "views about absolute music, the reform of the opera, applied music and other similar problems of the contemporary music."[20]

When the scheduled discussion failed to materialize, Vučković felt obliged to present his views in the form of a written message—manifesto Vučković read his manifesto to the participants at the closing session of the Music-Dramatic course in Strasbourg. Manifesto was later published, with an appropriate commentary, in the journal *Zvuk*.[21]

In this manifesto Vučković pled for a renewed contact with the public, which would imply the awakening of the interest of the public for the new and real arts with a social and class orientation. It would mean, he said, that the arts would reflect a new content and revolutionary spirit, as it was the case with the past historic epochs. That is how, according to Vučković, music would attain a new popularity and a new relevance reflecting current issues.[22]

It is very significant to note that while the manifesto contained the theses similar to the ones discussed in his dissertation, it also pointed to a changed viewpoint about the quarter-tone music.

Since Alois Hába was invited to the Music-Dramatic Days in Strasbourg, one session was devoted to the subject of quarter-tone music. While mentioning this fact, Vučković commented with a strong skepticism that: "Hába tried on this occasion to convince a little and unwilling auditorium that the future

of contemporary music lies in quarater-tones, promising to all that believe this an eternal life after death, guaranteed by the history of music."[23] Vučković further contended that it is not necessary to save the modern music from disaster. The modern music is a combination of the most different directions, individual and capricious, that do not belong under objective criteria, because of this subjectivity. "That is why," Vučković stated, "when art left the contact with real life it fell into utmost subjectivism—that is a part of the individualistic anarchy characteristic of the whole post-war cultural life."[24]

Essentially Vučković did not think that the contemporary music was neglected because of the popularity of the previously existing music. The reason lies not in the insufficient knowledge of the contemporary music, since: "nowhere exists so much dirt, kitch and charlatanism as in modern music— which in the first place has been proven by the Festivals of the International Society for Contemporary Music and similar performances (Musikalische-Dramatische Arbeistagung)."[25] In spite of a certain amount of exaggeration expressed in this statement it should be remembered the Miloje Milojević had pronounced a similar judgment about quarter-tone music and contemporary trends in music in a number of articles already discussed.[26] In the course of time Vučković did accept some suggestions contained in Milojević's criticism. A similar attitude and willingness to change was equally shared by other young composers, former students of the Prague State Conservatory.

This change in attitude towards musical avantgarde reflected changes that had evolved on a wider scale in the late Twenties and during the Thirties throughout Europe. The economic, social and political crises of the period influenced the aesthetic and artistic postulates as well, introducing a rejection of the innovations in the earlier part of the century. Atonal, athematic, dodecaphonic and quarter-tone composing was abandoned in favor of a simpler and more sensible musical language. There was also the widespread notion that the atonality, as a musical trend, having appeared too early to be assimilated caused many composers to turn away from this compositional manner. According to the testimony of the Italian composer L. Dallapiccola, it seemed that atonality and twelve-tone music were abandoned and forgotten. Remembering the 1930's Dallapiccola, contended that the atonal music was seldom performed before the arrival of fascism as well as after. Neoclassicism, as a musical trend had many more adherents. At the time when it seemed that nobody was interested anymore in atonality or twelve-tone music, Dallapiccola started to compose in this vein. His attitude evoked criticism at the Festival in Venice in 1937. Even the president of the festival Guido M. Gatti proclaimed Dallapiccola's interest as "non realistic."[27]

Dallapiccola's interest in twelve-tone music was exceptional, the influence of the twelve-tone music had diminished. Paul Hindemith, among the first to accept the new method of composing, decided—also among the first—to modify this way of composing.

This change in the artistic position and compositional method attracted the attention of Vojislav Vučković, who responded with the writing of an essay about the creative personality of Paul Hindemith.[28] Vučković who himself experienced similar metamorphosis of his artistic credo during the late 1930's felt a kinship with the personality of Paul Hindemith in spite of all the differences that existed between these two artists.

Vučković thought that Hindemith's creative growth was a reflection of the aspirations of the German intelligentsia towards stability. The neo-classicism of Hindemith was a return to the natural laws of the tonal language. In the arts this desire is reflected in the search of new means of expression as a substitution for the academic conventionalism or the symbolistic mysticism. Hindemith's neoclassicism is the middle road between the late romanticism as an expression of the stabilization of the bourgeoisie and of the decadent expressionistic constructivism as a manifestation of the disoriented lower middle class. In the concept of "the decadent espressionistic constructivism," Vučković surely meant the avantgarde, contemporary compositional trends, that he until recently had declared as a progressive result of the historical development of music. It is characteristic that in this essay about Hindemith, these trends are defined as "manifestation of the disoriented lower middle class."[29]

Vučković stressed that Hindemith was aware of the ideological disorientation of many composers. Therefore he quoted the following words of Hindemith himself:

"The today musician, in so much as he feels called up to preserve and perpetuate the art of composing, visualizes himself in the same defensive position as at one time Fux did. Even to a great degree, since in all fields of art, after a period of great virtuosity of refinement of artistic means and their forms of application, there appeared a great confusion in music even more then in any other art field. We often find such a confusion in the compositional method that binds tones only according to the spirit that in an arbitrary manner imposes upon himself."[30]

Vučković objected most to the fact that Hindemith neglected to maintain the ties with the social sources of the arts, claiming that "Hindemith did not support the belief about the necessity of the realistic attitude towards the art."[31] In his conclusion he points to a changed evaluation of atonality:

"Hindemith often managed to offer a sound musical content, in spite of the formalistic method. That is to the credit of his strong talent, which occasionally managed to break through the formalistic chains of the decadent atonalism, and to anticipate the ties with reality, if not the reality itself." [32]

In the conclusion of this essay, Vučković stressed that the musical arts should serve the interests of man in society as the main moving force in history. [33] Whereas in his dissertation *Music as Means of Propaganda* and in the *Review of Theory and History of Esthetics,* Vučković had contended that the achievements of the athematic, quarter-tone and twelve-tone music were the product of progressive social development, in his essay about Hindemith the atonal and twelve-tone music he described as "expressionistic constructivism," and as a "decadent appearance." [34]

The German musicologist Ludwig Finscher expressed the opinion, in retrospect, that Hindemith changed his opinion about the avantgarde musical language partially because of the feeling of limitless liberties inherent in such music. Finscher thought that Schoenberg's isolation most of all influenced Hindemith's wish to change. Hindemith himself as a practicing performer strove to have his compositions accepted and presented often to the public. These were the reasons for the change and adaptation that led to the creation of music for pedagogical purposes, theoretical works, the opera *Harmony of the World* and other compositions from this period. [35]

The feeling of isolation and a desire for support brought about the decision of the members of the Group of Atonal Composers in Belgrade to address themselves in the course of 1934 to Arnold Schoenberg. The Group decided to write a letter to Schoenberg who at that time already had emigrated to America. To the Group belonged Dimitrije Bivolarević, Petar Stajić, Milan Ristić, Lazar Marjanović and Milorad Marjanovic among others. The Group was founded in 1933 mainly through the efforts of Dimitrije Bivolarević. [36]

Schoenberg answered the letter, according to the former member Petar Stajić, with a lengthy reply of two typed pages. It was a sad and pessimistic letter. Schoenberg felt unaccepted and complained about the conditions in America and rare performances of his works. Materially he fared poorly; there was not enough remuneration since the orchestra and individual artists did not often enough include his compositions in concert programs. Bivolarević saved the letter and even carried it with him at all times. [37]

Bivolarević was very impressed by Schoenberg's compositional output, and he tried to present Schoenberg's compositions to the public. He gave a public lecture on Schoenberg in the Jewish library. He organized two chamber concerts of Schoenberg's works in 1934 with the participation of Aleksej Butakov and Karel Holub. [38]

In a similar vein around the 1920's the Italian composers such as Casella and Malipiero, in particular, as the most forward looking composers, had approached the expressionist chromatic writing of the Viennese school. It came as a surprise when, instead of following the example of Schoenberg and adopting his formal innovations, they accentuated the neoclassic or diatonic, and the nationalistic or modal aspect of their music. A similar tendency is even noticeable in the logical evolution of modern Italian music as a whole."[39]

Aaron Copland left in his autobiographical sketch published in 1938 an interesting description of his change of mind concerning his attitude towards composing. Copland wrote that in the mid thirties he felt an increasing dissatisfaction with the relationship of the public with the living composer. It seemed to him as the composers were working in a vacuum.

> "I felt that it was worth the effort to see if I couldn't say which I had to say in the simplest possible form. My most recent works . . . embody the tendency toward an imposed simplicity. *El Salon Mexico* . . . on Mexican tunes, the *Second Hurricane,* an opera for school children, *Music for Radio, Billy the Kid—Cowboy Songs, The City, Of Mice and Men, Our Town* music for film. The reception accorded . . . encouraged me to believe that the American composer is destined to play a more commanding role."[40]

In the retrospective of some thirty years later Copland commented upon his autobiographical sketch and the criticism that it had spurred. His wish in creating a more accessible musical language was declared as an imposed simplicity and a renouncement of this more difficult music, while turning away from a more cultivated audience, and henceworth writing only for masses. Copland argued that his position be understood in the context of the period of the 1930's. By the end of 1939 the artists had lived through a very special ten years:

> "In all the arts the Depression had aroused a wave of sympathy for and identification with the plight of the common man . . . suddenly feeling that the composers are needed as never before. Previously our works had been largely self-engendered: no one asked for them . . . Now functional music was in demand as never before. Motion-pictures, ballet companies, radio-stations and schools, theatre . . . music had to be simplier, there was a market . . . evocative of the American scene."[41]

This change of mind brought about a wish for the reaffirmation of the past. Many composers and music writers pleaded for the preservation of the indigenous musical language. The discussions in the pages of the Yugoslav music journal *Zvuk* testify to the endeavors of composers to adapt the recent innova-

tions to the traditional musical heritage. Thus Anton Dobronić in the conclusion of his study, "The Crisis of the Morals in our Musical Life" asserted:

> "From these deliberations . . . it follows . . . that there existed above all the problem of continuation—with new means and higher pretensions and broader horizons— of the tradition of Mokranjac in Belgrade, and equally an important problem in Ljubljana about the discovering and building of the genuine Slovenian musical individuality as an important section of the Yugoslav music culture as a whole."[42]

Dobronić noted correctly that the composers in Zagreb, like Širola, Baranović, Konjović, Šafranek-Kavić, Lhotka and Odak, in spite of the differences in the degree of their creative talent, compositional knowledge and even artistic morals, are united in their wish toward the creation "of our musical expression."[43] Dobronić thought that in Belgrade existed a discord concerning the attitude about the value of traditional artistic heritage. Dobronić stressed that Mokranjac, in his time, was truly a regional Serbian composer in the best and most constructive meaning of the word, his accomplishments represent a positive value for the whole national musical culture of Yugoslavia.[44]

Dobronić was surprised with the declaration Miloje Milojević delivered after the concert of the singing society *Lisinski,* and duly published in the daily *Politika.* Milojević declared on this occasion that the nationalism in music has been surpassed.[45] Dobronić noted correctly that Milojević, in spite of this declaration, was not essentially against the achievements of the nationalist movement in music. Dobronić contended that the situation in Belgrade is unclear and that only the future will show whether the Serbian regionalism or the eclecticism will finally prevail.[46]

As a corroboration to the theses postulated by Dobronić, Anton Lajovic wrote that he had the impression that the movements oriented towards Western Europe or with a strong accent on individual characteristics, present only the tribute that had to be paid by a young nation, wanting to reach in a sudden burst the civilized and cultural niveau similar to that of the western people, whose culture was considered without any doubt and criticism as the only desirable ideal for the cultural life.[47] Lajovic thought that opposite currents which stress the organic connection of the music, of producer and consumer, with the folk music culture should get the full supremacy.

A similar opinion in the fine arts was advocated by Vasa Pomorišac. Pomorišac wrote in the article, under the characteristic title: *The Crisis in our Fine Arts,* that the contemporary arts are not a reflection of the time since it

does not have, in the first place, any contacts with the native soil from where it developed. This art doctrine has not achieved positive results in our spiritual physiognomy. The reason for this failure Pomorišac attributed to the great dependence from all that was declared as contemporary and that comes from the West:

> "Since the last three decades we have been taking over, without selection every-thing that the West, that is Paris, acclaimed as contemporary, forgetting that there are delicate plants that can live and bear fruit only in the environment where they grew up . . . and that in other countries they only become undergrown and grow under the glass . . . Because these plants talk to us in a strange language, their harmonies seem to our hearing non harmonic and incomprehensible. . . Let us turn into ourselves and wake up the dormant creative powers whose roots extend deep in the distant past."[48]

It is interesting to note that Pomorišac extended his criticism to music contending that the success in this field is contained in folk songs and melo-dies. In a similar vein the medieval painting and architecture is a document of its kind about the treasures that are not tended and that could become the happiness of the contemporary culture life stricken by paucity.[49]

The situation in literature was similar. As in the fields of music and fine arts there existed the wish for the preservation of the indigenous contribution, in addition to the wish for the contemporaneity of expression, as contained in European arts movements. Thus Anton Barac pointed out that in the Yugoslav literary scholarship from the very beginning there existed the incentive wish to join the European mainstream, which derived from political and cultural conditions. Vatroslav Jagić already in 1867 classified the Croatian, Serbian and Slovene literature within the European framework. Matija Murko stressed even more this connection in his work: "Geschichte der Älteren Südslavischen Literatur," that appeared in 1908.[50]

Barac considered that while the Croatian, Serbian or Slovenian writers adhered longer to the romantic style, up to the second half of the nineteenth century, this fact in itself is not a sign of backwardness. As an example of this statement Barac quoted the case of Victor Hugo, who was active even in the period after Flaubert, when Zola was starting his literary career. Therefore Barac suggested that next to the term "influence," the literary science should include the term "incentive." The term "influence" denotes to a certain extent a passive reception, while "incentive" projects a motivation for action that is waiting for an opportunity to be fully developed.[51] Barac further explained that the notion of being autochthon that occurred in descriptions of various cultural and national movements, referred to the understanding that all impor-

tant movements on the native soil did not happen because of similar coincidences somewhere else, but have sprung from the land itself.[52]

The music creation of that time, in its essence, was marked by a variety of musical sytles that existed and developed in a parallel fashion. Thus Kosta P. Manojlović further enriched the Serbian vocal musical tradition with new and valuable works. On the other hand composers such as Konjović, Milojević and Hristić created works that represented an advancement of musical technique and expression as well as presenting a link with the immediate past.

According to Milenko Živković it was precisely this generation of composers comprising Petar Konjović, Miloje Milojević, Stevan Hristić, Milenko Paunović and Kosta P. Manojlović that brought the Serbian music to the artistic niveau already attained by the fine arts and literature: ". . . these composers with the strength of their talents and a high degree of taste and literacy, theoretical and technical knowledge introduced in our midst the European reasoning and judgments about music as a social and cultural factor . . . the mission of this generation of composers has obtained a reform like significance in our midst."[53]

Their contribution in the compositional field was matched by their relentless efforts in building different aspects of the musical life. This generation of composers took part in the foundation of all major musical bodies and institutions: in the formation of the Belgrade Opera, Philharmonic, Music Academy, the music section of the Radio-Station. Furthermore they acted as teachers, conductors, members of governing boards, editors and collaborators of different musical and professional journals and as music performers.

In the course of the 1930's a new generation of composers started their professional career, the *Prague Generation,* so named after the town where they did their musical studies. The contribution of this generation brought the long awaited contemporaneity to the mainstream of European development. The majority of the compositions that they wrote aroused at the beginning negative comments in the musical milieu of Belgrade, eventually to be included in the concerts and festivals of the renowned artistic centers.

Thus the *String Quartet* of Ljubica Marić composed during the second year of studies at the Master's School of the State Conservatory in Prague was performed at the festive concert marking the end of the school year, consisting of the compositions of the candidates for the Master's degree. In the daily paper *Československa Republika* from May 25, 1931, the following review was published: "A developed sense for a solid form, purified harmonies and significant independence of a sound invention, singled out the *String Quartet* of Lejubica Marić, in a lively performance."[54] Another review in *Listy hudebni Matice, Tempo,* wrote: "the compositional class was presented espe-

cially well with the Masters School and Ljubica Marić, whose *String Quartet* has a highly cultivated expression and a well composed material."[55]

The *Wind Quintet* of Ljubica Marić, composed in 1931, won an exceptionally favorable reception. The *Quintet* was composed in the last year of her studies at the Master's School in Prague. Ljubica Marić recounted the origin of her work stating that after she finished composing the *String Quartet* she felt drawn to the sound of the woodwind instruments. She wished to explore the possibilities of these instruments out of an inner need.[56] Ljubica Marić praised the first performers of this composition, The Prague Wood Quintet. The members of this quintet felt an affinity towards contemporary music. Prague was at that time one of the significant centers of contemporary music, and both the composers as well as the performers were strongly oriented towards the new and avantgarde music idiom. The *Quintet* was performed for the first time at a concert of the Czech section of the International Society for Contemporary Music in the hall of Úmělecká Besede in Prague.

The critic of the daily paper *Československa Republica* wrote the following about the first performance of the quintet:

> "The fourth regularly scheduled concert of the Society for Contemporary music took place on the 11th of this month in the hall of the Úmělecká Besede. From the works on the program, the *Woodwind Quintet* has attracted attention by a maturity of expression, concentration of invention supported by a logic of harmonic thought and a clear perception of the sound. The artistic sensibility of the talented authoress is apparent in the subconscious respect of the expression of single movements . . . the performance of the Prague Woodquintet was careful and accomplished therefore the success was heartily deserved."[57]

In December of the same year of 1931, the Prague Woodwind Quintet gave a concert in Belgrade, in the hall of the music school *Stanković*. The program included the Woodwind Quintet of Ljubica Marić. The critic Jovan Dimitrijević wrote: "For our public the work of Miss Ljubica Marić was of great interest, since she is our first female composer." Further Dimitrijević said:

> "Marić is inclined even more to the modern vein (as compared to the previous composition the *Quintet* op. 34 by Jirak—J.M.Dj). She showed a great sense for developing the melody through atonal harmonies. After such a work, not at all as of a beginner, we have great expectation from her, since she is so young and, undeveloped in her aesthetic principles."[58]

The *Woodwind Quintet* of Ljubica Marić was later performed at the Festival of the International Society for Contemporary Music in Amsterdam,

in June of 1933. Again the critics acclaimed this work. Thus the critic from
the daily paper from Utrecht wrote: "Finally a woodwind quartet. A work full
of talent by Ljubica Marić, who found excellent interpreters from the
capital: artists that could more than please every composer."[59]

Even the *Daily Telegraph* from London briefed its readers about the Festi-
val and praised the composition of Ljubica Marić: "One Yugoslav girl,
Ljubica Marić, showed in her *Woodwind Quintet* much more spontaneity
and musical talent."[60]

One paper clipping, in the English language, points to the fact that the
musical language of the *Woodwind Quintet* was for some more conservative
critics too bold and new, although the gift of the young composer was not
denied. This critique under the title: *The Festival in Amsterdam* expressed the
following opinion: "The *Woodwind Quintet* of Ljubica Marić, a young
woman that possesses, very likely, a real talent, but who directed that talent in
a wrong direction, and produced sounds similar to cackling. She is sufficiently
young to correct herself, unless she becomes persuaded with praise, that this
cackling is a musical composition."[61] From the last sentence it follows that
the critique was aware of the oral and written praising and positive reception
that the work received.

During the Festival in Amsterdam Ljubica Marić received personally the
invitation of Hermann Scherchen for the participation at the Music-Dramatic
Days in Strasbourg. Scherchen even arranged a stipend to cover the costs of
the travel. In Strasbourg Ljubica Marić was presented to the public in the
dual role of a composer and conductor. As a composer she chose her *Music
for Orchestra* to be performed on this occasion. This work confirmed her
abilities as a promising and able artist. The critic Albert van Dorn mentioned
in his review the performance of the *Wood Quintet* in Amsterdam, confirming
the previously positive impression that the work had projected. Van Dorn
described the Music for Orchestra "as a dazzling talented work."[62]

On the other hand, the commentary of Ljubica Marić about this musical
manifestation appeared two months later in the music review *Zvuk*. Ljubica
Marić thought that Scherchen as the ideological initiator of the summer
courses in Strasbourg did not realize his anticipated goal.

Scherchen had wanted to offer a retrospective review of the musical produc-
tion for the past fifteen years. His aim was to achieve the contact between the
public and contemporary music by the help of musically perfect performers.
This contact is now missing and that is why the contemporary music is in a
crisis. Scherchen believed that in such a manner it is possible to reach a new
musical renaissance.[63]

Ljubica Marić believed that the music works performed in Strasbourg had lost their link with reality and a broader public. Therefore followed the conclusion that even the most perfect performance cannot promote the arts if it is not compatible with the moral and class aspirations. The art works which do not meet such requirements have a limited scope and can exercise influence only on a small number of professionals.[64]

Ljubica Marić pointed out that this is her opinion and that it is shared also by Vojislav Vučković. These were the reasons for writing the Strasbourg manifesto, where the role of music was shown throughout the historical development and thus the true reasons for the crisis of music were established.[65]

In this review of the Music-Dramatic Days in Strasbourg Ljubica Marić was pleading for the arts that should be close to a broader circle of people. Such an art should not be subjective and intellectual and therefore limited in its influence to only professional ranks. The crisis in music originated primarily due to the lack of understanding of reality and social life.

These theses were close to the viewpoints of Vojislav Vučković, as Ljubica Marić pointed out, explaining their collaboration in writing of the Strasbourg manifesto, addressed originally to the participants of the Music-Dramatic Days in Strasbourg. In the manifesto Vučković advocated the necessity of closer links with the public. This goal is only feasible if the arts reflect a new content and revolutionary spirit . . . Thus the arts will be again accepted and relevant since they will correspond to the social and class aspirations.

However, these theses are similar to the ones postulated by M. Ristić somewhat later, at the beginning of 1934's, in the essay: "The Moral and Social Meaning of Poetry." The common trait in the comprehension of these artists is the recognition of the social value of the arts. Ristić realized that the contemporary philosopher as well as the scientist is irrevocably included in the life of the human community. In this context Marko Ristić equated the idea of revolutionary attitude with the social usefulness of "the real poetry." According to Ristić the true poetry, as a moral activity, was always by its latent content and consequences revolutionary, that is, useful.[66]

Besides the similarities between the thesis of Marko Ristić and the opinions of Vojislav Vučković, there existed important theoretical differences. In the aforementioned essay that was published in the journal *Danas,* Ristić stressed that all who want to participate, even to a slight degree, in spiritual life of the current time, feel that they cannot avoid the questions imposed by the existing social chaos. Ristić wrote: "The contemporary poet, like the contemporary philosopher or scientist irrevocably . . . comprehends that he is not alone in the

world, that as long as he lives he is unavoidably connected with the life of the human community, that his personal life exists only within the bonds of the general life."[67]

Thereafter followed the assumption that the contemporary poet must approach the revolutionary, progressive ranks.

"The contemporary poet cannot avoid being a revolutionary: if his inner life, if the poetic source of his inspiration and his thought is authentic and if it does not betray him, he must arrive at revolutionary conclusions . . . The real poetry, the subjective poetry, regardless of its manifested content, *is always with its latent content and consequences revolutionary, that is useful.*"[68] (italics by J.M.Dj.)

As Vučković pointed out in his study: *The Materialistic Philosophy of Arts,* the social value of human quest was already realized by Breton. Thus Breton contended in 1930, in answer to a survey by the journal *L'Esprit Francaise,* in a somewhat broader context: "We can suppose with certainty that every honest quest and every true invention will obtain, in the course of time, a social value."[69] Furthermore Vučković explained this thesis of Breton contending that under the notion *social value* Breton understood all that is found in the framework of a society, and that can serve within this framework the individual, and consequently the society as such. Breton had forgotten, however, that within a society are also harbored antisocial notions that can deter the progress. Vučković concluded that Breton's explanation was irrelevant to class barriers, and in reference to the arts this concept is doctrinaire and not valid.

The supposition that the arts must always serve to define a class morality is presented in Vučković's doctoral dissertation: *Music as Vehicle of Propaganda.* It is through the interdependence of the needs of a social community that music can develop further as an art form. Vučković did not comprehend the arts as being a direct reflection of the material production, since an art work is interwoven with a multiplicity of ideological fragments, as a heritage of the previous cultures. Yet as a socially applied art, music is an agent and propagator of a certain social ideology. In this context music exerts its influence as an applied art form within a specific social function, and not through its purely musical qualities. It should be remembered that Vučković stressed the vagueness of the ideological influence as projected by the expressive material of music, as well as the impossibility of depicting a concrete ideological content. Vučković remained consistent in his comprehension of these basic postulates in the course of his musicological and journalistic career. However, his attitude towards contemporary musical idiom expe-

rienced a gradual metamorphosis, which was also reflected in his compositional output.

At the time Vučković was writing his doctoral dissertation, a lively discussion took place in Prague between the followers of avantgarde movements and the artists with different artistic philosophies. The discussion encompassed all artistic fields. The most prominent group was comprised of adherents of surrealism, led by the poet Vitězslav Nezval. The social and political standing of this group was close to the ideology of the Communist Party of Czechoslovakia.

Vučković followed the discussion with great interest: he frequented the performances and lectures and read the literature devoted to this topic. In the course of time he became personally acquainted with some of the prominent artists, Ljubica Marić later reflected about the friendship of herself and Vučkovic with the poet Nezval.[70]

Almost parallel to this development, that took place in Czechoslovakia, the surrealists in Belgrade gained recognition. The followers of this art movement rallied around the journal *Nemoguće-Impossible*. In the first issue, May 1930, the journal published a joint declaration signed by twelve poets and one painter:

> "Since it was determined, that among them there existed a spiritual kinship in spite of individual differences, and since they were permanently excluded from what the spiritual life was thought to be, the twelve considered that they were forced, under the circumstances, to emphasize what they shared as well as a more disciplined collective activity, for which everyone of them is willing to sacrifice the psychological part of one's ego."[71]

The artists who signed the declaration were: Aleksandar Vučo, Oskar Davičo, Milan Dedinac, Mladen Dimitrijević, Vane Živadinović-Bor, Radojica Živanović-Noe, Djordje Jovanović, Djordje Kostić, Dušan Matić, Branko Milovanović, Koča Popović, Petar Popović and Marko Ristić.

It is important to stress that this journal was not only the mouthpiece of the surrealists gathered in Belgrade, but served as the voice of the French surrealists also. Therefore the title of the journal was bilingually conceived. The contributions of the French writers were published in French language. Among the contributors the names of Breton, Peret, Aragon, Char and Thirion appear often. The journal was well illustrated with graphs, collages and drawings, thereby supplying valuable iconographic material pertaining to this period.

In the consequent formulation of the surrealistic doctrine Vane Živadinović-Bor and Marko Ristić jointly published in 1931 *Anti-Zid.* Starting from the Second Manifesto of Surrealism written by André Breton, Živandinovic-Bor and Ristić emphasized that the criticism and revolt of the progressive artists should not only be confined to the arts, but should encompass the general social developments: ". . . the rebellion of the modernism was contained within the boundaries of the artists. It was proved that such a confinement of the revolt, that implies an opportunistic neutrality in crucial areas of life, that such a shallow and harmless revolt remains barren and condemned to a quick capitulation."[72]

The same year of 1931, marks the publication of one of the most important theoretical works of the Belgrade surrealistic school: the joint work of Koča Popović and Marko Ristić: *The Outline for a Phenomenology of the Irrational.* The postulates explained in this book point to a convergence of the moral and political opinions close to the marxist positions. This modification of opinions as well as other changes that took place at that time were influenced by the social and political events occurring world wide.

At that time Vučković extended his interest in the work of progressive French writers notably so in the activities of Louis Aragon. Aragon had started his literary career in the surrealistic ranks. However, in the course of time he felt a strong affinity towards social literature and became a member of the Association of Revolutionary Writers and Artists. Vučković wanted to gain a closer contact with this group of outspoken artists. An opportunity occurred after the conclusion of the Music-Dramatic Days in Strasbourg, in August of 1933. Vučković mentioned in his article: "The Strasbourg Experiment in the Light of Materialistic Critic," that upon his arrival in Paris, together with Ljubica Marić, he found in the Association support and understanding. Vučković wrote the following about this meeting:

"From there we went to Paris (Vučković refers to Strasbourg as the starting point of his trip) and found support from the people that worked along this line. Louis Aragon in the name of the Association of revolutionary writers and artists, offered his collaboration and membership in this cultural institution, which we accepted with pleasure, and the publication of our manifesto in some of their reviews. Thus next to our ties with Prague, our collaboration with Paris was strengthened, as with other cultural centers where this institution has its collaborators. Even our work in Belgrade will be enhanced, so what we had learned abroad, we will popularize and make accessible not only to the professionals and scientists but also to all whom the arts address, that is, the broadest strata of people who expect not the tickling of their senses, but a revolt against injustice in the present and a struggle for a better future."[73]

Apparently Vučković's opinion had undergone a change. At the time of writing of his dissertation, as well as his other articles and studies from this period, Vučković advocated the necessity of a closer association of the musical art and the general social life, contending that the progressive society should accept the new and progressive music. Vučković did not accept the view that the contemporary music digressed and lost its public due to the new and acrid musical language. Since the current development is the result of an historic process, the expressive mean of music are not progressive or backward in themselves, their character being determined by their application.[74]

In the course of time Vučković, as well as other members of the Prague School, changed their position, mostly due to the wish to accommodate themselves to the needs of the musical environment, as well as their works to attain a socially useful role.

This change is noticeable in the attitudes of Dragutin Čolić, one of the former advocates of the quarter-tone system. When Čolić wrote an article in 1933 about the quarter-tone music for the journal *Zvuk,* he argued with eloquent conviction that the appearance of quarter-tone music is not an incidental occurrence. To dispute the reason for the existence of quarter-tone music would negate the cultural or economic development, since music like any other social phenomenon is not separable from the economic or cultural growth.[75]

Towards the end of his studies in Prague, Čolić wrote a number of quarter-tone compositions, demonstrating the feasibility of this compositional method and the validity of his theoretical discussions. These compositions favorably impressed his teacher and mentor Alois Hába. Hába even wrote an article about his students of Yugoslav origin and their contribution to the quarter-tone music. Hába hoped that Čolić would, upon his return to his native country, inform the Yugoslav public about the advantages of this method:

"In 1932 the Serbian composer Dragutin Čolić completed his studies of quarter-tone music . . . Čolić has understood the melodic and harmonic principle of twelve-tone music; the compositions of Schoenberg served us as a model. He succeeded, according to my judgment, in creating in the athematic style an original composition of quarter-tone music. Čolić is excellently schooled and a convincing collaborator for the athematic free style and the 24-tone system of quarter-tone music. His assignment will be to explain to the Yugoslav musical public the principles that we are trying together to realize in order to provide a new and strong basis for the development of the European music."[76]

Čolić composed at that time the *Tema con Variationi* and several other twelve-tone pieces.

Of these works Čolić himself singled out the *Tema con Variationi* as his favorite work from the Prague period. It was the result of the request of the pianist Hanuš Suskind who was the first to perform this work.[77]

Among quarter-tone compositions the *Concertino for Quarter-tone Piano and String Sextet,* according to Čolić's recollection, achieved the greatest success. The first performance was in 1934 in Prague with the conductor Karel Ančerl. *Concertino* was afterwards performed in 1937 in Berlin, as a featured work on the Festival of the International Society for Contemporary Music.[78] Organized by Alois Hába, who at that time was in charge of the Czech Society for Contemporary Music *Přitomnost,* a new live performance of *Concertino* was given in 1938, on the Radio-Prague, during a concert dedicated to Yugoslav quarter-tone music. The program included the *Suite for two Pianos* by Vučković, the *Suite for Contra-Bass, Trombone and Quarter-tone Piano* by Ljubica Marić, as well as quarter-tone songs with the string quartet accompaniment by three Slovenian composers: Osterc, Šturm and Žebre, each of whom was selected for this occasion.[79] Slavko Osterc had listened to this broadcast and consequently wrote to Vučković commenting on the performance. Osterc singled out the *Suite for Two Pianos* by Vučković, adding that he was also favorably impressed with other compositions on the program.[80]

After his return to Belgrade, Čolić served as a teacher of the Stanković Musical School, later at the Music Academy and as the conductor of the Workers Choir *Abrašević.* Impressed by the fine vocal quality of the choir, Čolić composed several works for this ensemble. In 1937 he composed the *Songs of the Strikers* on the text of Čedomir Minderović. In this vocal cycle Čolić himself singled out the *Song of the Striking Watchmen* and *The Lullaby.*[81] For the same ensemble Čolić composed the *Cantata for the Male Choir,* with two piano accompaniment. The text for the cantata was by Čedomir Minderović. The Cantata was a tonally conceived composition, written in a somewhat simplified musical language and adapted to the current performing conditions. These works are a proof that Čolić in the course of time had "abandoned certain things," as he himself recounted.[82] But Čolić stressed that he never accepted any stereotyped approach. That was his position from the very beginning: in his early compositions he did not pursue a total serialization, but freely used elements of this compositional method. Čolić always strove to avoid a speculative solution in his compositional method.

Motivated in 1939 by the same reasons, the wish to answer the needs of the milieu and achieve acceptance, Čolić composed for the mixed choir *Abrašević: Three Folk Songs.* The well-known songs were often sung by the

folklorist Vasil Hadži-Manev. The three songs of this cycle present, in Čolić's words, his willingness to compose what was needed and sought after. At the same time while composing these songs, Čolić had in mind the choir that he knew and led, and also the public and the general cultural environment.[83]

Composer Stanojlo Rajičić also felt that the wish for accession and acceptance was the primary motivation in the change of his musical language. The pursuit of the compositional methods developed in the course of studies in Prague would have curtailed the performing possibilities. Rajičić contended that every composer is oriented towards the public; if a single work brings about the much needed acceptance, the developed traits serve as an incentive for the future creation.[84]

Publicly well received, the vocal cycles composed between 1938 and 1940, among them the *Guardians of the World* op. 5, and *Eleven Motoric Songs* op. 12, were often performed, although composed in a new and bold musical language, with an accentuated rhythmic pulsation. The song-cycle *Guardians of the World* was awarded a prize by the *Association of the Friends of Fine Arts Cvijeta Zuzorić*. The *Eleven Motoric Songs* were distinguished by the award of the *Academy of the Seven Arts*.[85]

The *Second String Quartet* brought to the young composers exceptional accolades: during the competition sponsored by the *Association Cvijeta Zuzorić* the quartet was awarded the first prize. Rajičić believed that the earlier vocal cycles and the *Second String Quartet* largely established his name as the composer.[86] The critical reviews spoke favorably about these works. Milojevic considered that Rajičić's *Quartet* presented "a big step forward in the direction of consolidation of his temperament and stylistic orientation."[87] Another reviewer, Milenko Živković, also noticed the stylistic change which created a calmer and more mature musical expression, since: ". . . all these qualities of the New Music that represent the starting point for Rajičić's compositional youth, are not any more the decisive qualities of his style . . . Rajičić in his *String Quartet* clearly aspires towards the honest and logical consequences of the tonal, thematic and classicist compositional method."[88]

The critic, Pavle Stefanović was very impressed with the slow movement of the *Second String Quartet* "This is a wonderful movement, with an ascetic grain (from which one day the composer's wisdom can spring up), with a conscious concentration of harmonic potentials in a concise and visible form."[89]

The *Second String Quartet* of Stanojlo Rajičić presented an early indication of a new stylistic trend that was later developed and defined. This change

was predicted by the slow movement of this quartet, based on the thematic material bearing a kinship with the folk music idiom.

The interest in folk melodies gradually became prevalent in Rajičić's compositional output. Around 1940 Rajičić noted down a number of Macedonian folk melodies, transmitted by Katerina Ilić, a performer of folk tunes, featured often on the programs of Radio Belgrade. Rajičić selected eighteen songs for a v~ ¾ cycle with piano accompaniment.[90]

On the literary field many poets and writers approached the postulates of social literature in the evolution of the surrealistic movement. The progressive social standing and interest in the social themes was in its essence apparent from the very beginning of surrealism as an organized literary movement. In supporting the trend Vane Živadinović-Bor and Marko Ristić declared that:

> ". . . from the surrealistic experience it logically results, next to the deduction of theoretical conclusions a critical activity . . . This critical activity is directed primarily against the total bourgeois ideology and thought, in which surrealism presents, thanks to its practical knowledge of some refined mechanisms and reactionary tricks of that thought, a valuable instrument of Marxism."[91]

A similar interest is noticeable in other arts fields. The painters gathered around the group *Earth* in Zagreb, depicted on their canvases the misery of dwellings in the city outskirts and forsaken villages, in the wish to stimulate the social awareness and consequently the general betterment of living conditions. In Belgrade, the members of the group *Life:* Andrejević-Kun, Živadinović-Noe, Kujačić, Karamatijević, Grdan, Baruh and others, expressed in their visual creations a deeply human content and a protest of the current social circumstances. Thus Djordje Andrejević-Kun, influenced by the difficulties and despair of the miners from the mines in Bor created the collection of wood cuts under the title the *Bloody Gold*.[92]

The writer Petar Petrović-Pecija, influenced by these aspirations, envisaged a work jointly with the composer Stanojlo Rajičić, based on a mishap in the mines of Kakanj. In the course of this collaboration Pecija wrote the scenario for the ballet music *Under the Ground*. Rajičić, feeling a great affinity towards the original concept of this work, composed the music with great ease, finishing the score in a three-months period.[93]

Vlastimir Peričić, the biographer of Rajičić, pointed out that the ballet music *Under the Ground* presented one of the first works in Serbian music with a social intonation.[94]

It was precisely due to its disturbing social overtones that the work was not staged or performed as a ballet.

Negotiation about the possibilities for performance were held with the administrations, choreographer and scenographer of the National Theatre. However the ballet was finally declared as not appropriate since it projected a "too gloomy" picture.[95]

Due to these circumstances the composer decided to rearrange his work in the formal scheme of a symphonic poem in order to insure the concert presentations of his musical score. The first performance of this symphonic poem took place in May 1940, with the conductor Mihailo Vukdragović and the orchestra of the Radio-Belgrade. In March 1941, the conductor Lovro Matačić conducted the performance of the symphonic poem *Under the Ground*, played by the Belgrade Philharmonic. The work was praised by the critic and the public. The composer, Milenko Živković, in the capacity of the critic of the daily paper *Vreme,* reported that Rajičić's composition *Under the Ground* radiates an irresistible appeal to the listeners.[96]

Such approval established the reception of the symphonic poem *Under the Ground.* The composer Vasilije Mokranjac remembered that as a high school student hearing this concert, he decided to become a composer.[97]

Stanojlo Rajičić believed that this symphonic poem *Under the Ground* proved to be his most successful composition. In the retrospective of almost forty years, the composer still ranked this composition as his best liked. Rajičić explained that this work presents an ideal relation of the musical content and form: the work can stand alone by its purely musical qualities, without the programmatic basis. Rajičić especially sets aside the *Children's Round Dance* which features the stylized musical material akin to the folklore idiom. Moreover, this *Dance* provides the necessary contrast for further development of the musical structure of the work.[98]

Rajičić's biographer Vlastimir Peričić agreed in this assessment that the symphonic poem *Under the Ground* presents the high point of Rajičić's career before the outbreak of the Second World War. Peričić pointed out the clarity of form, plasticity of thematic material and a persuasive dramatic expression as outstanding qualities of this work.

It is interesting to note the opinion of the composer Jovan Bandur about Rajičić's *Under the Ground.* Bandur wrote this comment on the occasion of the cultural exchange between Yugoslavia and Bulgaria that took place shortly after the end of the Second World War. Bandur discussed the compositions of Slavenski, Vukdragović, Vučković and Rajičić selected to be performed at the concerts in studios of the radio Belgrade and Radio-Sofia, respectively. Bandur singled out the symphonic poem *Under the Ground,* declaring that Rajičić possessed a masterful compositional technique that enabled him to portray in a spontaneous manner the underlying dramatic

context. Bandur concluded that one can freely assume that: "Rajičić holds the banner of the young generation."[99]

From another source came additional acclaim. It was Mihovil Logar's recollection that Vojislav Vučković was pleased with the success of Rajičić's poem *Under the Ground.* Vučković, who was also favorably impressed with the accomplishment of Logar's opera *Sacrilege in Saint's Florijan's Valley,* proposed that a selection of excerpts should be presented at the Kolarac Public University, where he was in charge of the Music Section. Logar, encouraged by this proposal, pointed out that Vučković liked to discuss with his colleagues the musical projects in process, exchanging ideas about the musical form, literary text and general purpose.[100]

Recalling the beginnings of his compositional activity in Belgrade, after the completion of his studies in Prague, Logar stressed the influence of social environment in the gradual change of his artistic concepts:

> "The first contacts with the public, with the cultural masses, is very important in determining the style of a composer. When we returned after the finished studies from Prague to Belgrade, we started in a very stormy and disheveled manner, under the influence of Stravinsky and Hába and under the influence of all sudden changes that happen in fighting tradition in one of the most progressive environments in Europe. This development was suddenly stopped, since the new environment could not comprehend us: it had other needs. Our generation was the first that tried to be contemporary, to go in step with Europe."[101]

The gradual change of the musical language can be traced in the compositions that Logar later wrote. This change was not abrupt, and never left the impression of being forced simplification. Thus the bold harmonic language leading to atonality, as well as the free and rhapsodic form, was substituted for with an eloquent and varied, but in its essence tonal language, in conjunction with a concise formal scheme and pronounced melodicity.

Logar considered the concertante diptych the *Two Toccatas* for piano and string orchestra, as an example of a free harmonic approach that he often used in the composition of this period. The *First Toccata* of the diptych: *Adagio espressivo assai,* depicts the gloomy premonitions of the composer at the eve of the Second World War. The middle section of the movement portrays eloquently the despair felt by many, associating this feeling with an expressive chord progression in the deep register.[102]

The indication of a gradual change is visible in the children's suite: *Musique a mon Bébé.* The most popular piece in this suite and often performed is *Le Poisson d'Or.* Similar stylistic traits are present in the *Rondo Ouverture* com-

posed in 1936. The title of this composition was later changed to the more descriptive heading; *On the Fair*. The composition points to Logar's highly developed sense of exceptional instrumentation, a lively rhythmical flow and melodious and expressive thematic material. The motto of the composition depicts the freshness of observed impressions. The tumultuous atmosphere of the fair is expressed in the dynamic development of the whole composition. The motto, written by the composer, recounts: "Big wheels, little wheels, multicolored carts, engines, cars, airplanes, dolls as automates, little animals, magic boxes, whistles, trumpets, bells: a lot of parcels, a lot of life. What a pleasant feeling when out of the box appears the gleaming toy, that we wanted so much."

The program commentaries of the music works in the form of a well formulated title or an appropriate motto point to Logar's wish to explicate the realm of composer's imagination. Thus the symphonic poem *Vesna,* composed in 1931, bears the following motto: "The goddess of Spring with her warm breath awakes the nature: the universe quivers while awaiting the new life." The freely conceived scherzo-like movement abounds with melodious musical motives and lively rhythmical pulsation associating the arrival of spring. This work received a prize from the *Association of Friends of Arts Cvijeta Zuzorić.*[103]

As another reconciliation with the current musical environment Logar cited his musical drama *Sacrilege in Saint Florijan's Valley,* composed in 1937. The libretto was written by the composer, having its base in the farce bearing the same name, written by the Slovene writer Ivan Cankar in 1908. Cankar depicted the people and customs in a provincial milieu, satirizing human weaknesses and trespasses augmented by social injustice.

Cankar's *Sacrilege in Saint Florijan's Valley* has previously served as the textual base for the opera composed by Mateja Bravničar in 1931. Thus Logar's effort presented yet another attempt at introducing Cankar's literary work to the music stage. Both operatic works offered the introduction of social themes to the Yugoslav music theatre that were already contained and formulated in literary works.

Logar, a Slovene himself, felt a strong affinity towards Cankar's work. Although the *Sacrilege in Saint Florijan's Valley* was written some forty years ago, it remained contemporary in spirit. Cankar's work ideally fulfilled the current expectations of an art work as a social commentary, thereby inducing a hope for a better life. Most of all, it presented a reaffirmation of the ties with the indigenous heritage and stressed the national entity. It is therefore of special interest that Logar chose this work of Cankar, as the basis for his libretto. Likewise it is important to note that Logar introduced the Slovene

folk song "N' mau če izaro" (By the Lake) in the musical score to depict the presence of his native land. The melody is interwoven in the musical texture often in a fragmented and varied form, corresponding to the given context.

All these efforts affirm the continuous search for the creation of a musical work that would be accepted due to the relevance and comprehensibility of its content and form. Logar's work was entered in the competition sponsored by the *Association of the Friends of Fine Arts Cvijeta Zuzorić* and eventually was awarded a prize as the best work submitted for this occasion.

While reminiscing about his early compositions, Logar stressed that the melodicity was always close to his true artistic and human nature. Talking in retrospect, some fifty years later, Logar contended that his first compositions were written as a spirited and youthful declaration of his acceptance of the current musical innovations. These works had been written to demonstrate in a spiteful way the mastery of the contemporary music vocabulary.[104]

At the eve of the Second World War Logar turned to collecting folk songs. This effort prompted the publication of a collection under the title: *Motives from the South*. Like Čolić, Vučković and Rajičić, Logar chose the Macedonian folk songs. Thus the similarity of intentions was apparent among the members of the Prague School, sharing at that time interest in folklore. Logar himself admitted that his interest was spurred by the example set forth by Vučkovic.[105]

Vučković, on the other hand, pointed out in his study: *Characteristics of the Music Folklore from Tikveš,* that he in turn was motivated in his endeavors of collecting Macedonian folk songs by the example provided by Mokranjac:

"... the cultural and historical value of the music folklore of Macedonia was for the first time emphasized by Mokranjac ... Thanks to him the interest for the research and the artistic transformation of the Macefonian folk melodies has grown in an unbroken fashion, so that many prominent music personalities have continued the work of Mokranjac with delight."[106]

Vučković's evaluation of Mokranjac's role as the founder of music realism in Serbia was supported by his study of the Macedonian folk songs, as well as with the previously mentioned study the "Music Realism of Stevan Mokranjac." At the same time these musicological findings influenced his artistic credo and consequently his compositional output.

Vučković incorporated the change of his compositional method gradually and after a lengthy and painful self examination. The transition was hard to accomplish since Vučković, according to the recollection of Marija Mihailović truly believed in the future of the contemporary music:

"He was tormented mostly about the problem of relations in modern music. He liked very much Modest Musorgskij and especially Boris Godunov . . . however his intellect, influenced by the example of modern Czech composers, suggested to him that the future belongs to abstract music. This inner struggle between sentiment for the folk melodies and intellectual confrontation with modernism lasted a long time. Finally, he resolved the problem to the disadvantage of the second force and approached the folk motives. To what extent this inner turmoil was difficult for him is best known to his friends, since Bane (familiar name of V.V.) was always interested in the opinions of others. As soon as someone would come to visit him, he would sit at the piano and play or analyze a few measures or if there was a theoretical work, he would read it and ask for opinions."[107]

Therefore the year 1938 marks an important date for Vučković as composer and music writer. At the beginning of this year the Collegium musicum of the Belgrade University published his *Two Songs* for Soprano and Woodwind Trio (oboe, clarinet and Fagott). The *Two Songs* were submitted to the jury in charge of the selection for the festival of the *International Society for Contemporary Music* that was at the time being planned in London in 1938. Vučković's composition was accepted and represented successfully the Yugoslav music at the festival concert in London in June of 1938.

The first performance took place earlier in Belgrade, on March 15, 1938, at the concert of the Radio-Belgrade, that was broadcasted live. The program featured next to the *Two Songs* of Vučković, Rajičić's *Trio for Violine, Cello and Piano,* as well as Čolić's *String Quartet.*[108]

Just a few days later on March 19, the *Two Songs* was performed again, this time at the Kolarac Public University, as a featured work on the musical series, the *IX Musical Lecture.* These performances included a commentary of the compositions on the program. Miloje Milojević wrote a laudatory review of the concert for the daily newspaper *Politika.* Milojević wrote that Vučković had created an accomplished work: "Dr. Vučković has reavealed in his *Two Songs* the source of his creative fantasy . . . his clear yet free artistic position. This is not stereotyped music, but real music. And because it is truly music we even do not scrutinize the means that the composer used."[109]

With this statement Milojević truly accepted Vučković's main thesis presented in many theoretical works that Vučković diligently wrote. Vučković stated that the contemporary means of expression should not be discarded, since the elements of this musical language do not possess themselves progressive or backward characteristics. The character of expressive means is determined by their application.[110]

Milojević concluded his review by expressing his pleasure at Vučković's success: "And this joy is even greater since one more man from our midst has

entered the ranks of the world's Moderns. At the Festival of the International Society for Contemporary Music that will take place in London this year, the *Two Songs* of Vučković will be performed."[111]

The *Two Songs* by Vučković were performed in London by the well known Yugoslav singer Zlata Djundjenac and the Czech Nonet and received very fine reviews. Even performers were interested about other possible productions of the work: Vučković received requests even from geographically remote countries such as Argentina.[112] At the same occasion Vučković was elected as a jury member of International Society for Contemporary Music which represented an acknowledgment of his erudition and compositional knowledge.

The *Two Songs* reveal the high light of Vučković's style of composing that he strove to develop. It presented a union of the socially engaged thematic content with a contemporary and bold musical expression. The texts of songs although written hundreds of years apart as well as in different and remote parts of the world bear a spiritual kinship with the themes of social literature. The first song *Contradictions* was written by the Chinese poet Pien-Lo-Tien who lived at the end of the VIIIth and at the beginning of the IXth century. The second song *Two Doves* was written by Radovan Zogović.

In the course of the same year of 1938 Vučković composed his essay; "Music Realism," that marks the change of his artistic views.[113] Another step in advancing his new concepts was the essay on Stevan Mokranjac. Vučković's contribution to the scholarly research established the musical heritage of Mokranjac as the foundation of realism in Serbian music.

Gradually Vučković's interest in the folk music continued to increase. He wrote a number of arrangements of Macedonian folk songs for voice and chamber ensemble, based on the notation of Macedonian folklorist Vasil Hadži-Manev. The same folk songs served later as the research material for the study: "Characteristics of the Music Folklore from Tikveš."[114]

In 1941 Vučković finished his choral composition the *First Rukovet,* based on folk songs from Macedonia. This work very likely was conceived as a confirmation of his beliefs expressed in the conclusion of his study about Mokranjac.

Thus the discussions started by Dobronić on the pages of the journal *Zvuk* were in concordance with the attitudes of young Yugoslav composers. In the same manner there must have been received the opinions and ideas of Stana Djurić-Klajn, Pavao Markovac, Lj. Kiš, A. Lajovic expressed in their respective articles and essays.[115] These authors advocated the creation of an autochthon music language based on indigenous folk melodies, suggesting a variety of approaches leading towards this goal. The composers, members of

the *Prague School,* were responsive to this direction although each composer approached the stylistic change after extensive deliberation, according to individual needs and aspirations.

In these endeavors Vučković became close to a group of writers and painters that were united in their search for a new artistic expression. The members of this circle met in long night session in artists' studios and private residences discussing questions of mutual interest. Discussions were centered about the creation of the most appropriate and new artistic expression, reflecting the postulates of the *New Realism.* The participants were the painters Djordje Andrejevic-Kun, Mirko Kujačić, Vladeta Piperski, Prvoslav Karamatijević-Pivo. The writers Jovan Popović, Radovan Zogović and Dušan Matić participated on a regular basis. Vojislav Vučković was the only musician present.[116]

At the end of the 1930's, the composers of the *Prague School* became even more aware of the need for change of their musical language. This pursuit is reflected in the exchange of opinions in the pages of the journals *Slavenska Muzika, Srpski Glas* and *Radio-Beograd.* Thus Svetomir Nastasijević, whose work belonged to the stylistic trend of music nationalism, wrote in a concert review that "in modern symphonies prevail falsehood and darkness."[117]

Stanojlo Rajičić answered to Nastasijecić's criticism under the symbolical heading: "Mr. Nastasijević or Falsehood and Darkness of our Modern Music." Rajičić contended that composers who are adherents of the contemporary trends "appreciate the old masters more than even Mr. Nastasijević, but do not write in their spirit, since they do not want to be imitators, no matter how much that can appeal to the public." Rajičić pointed out that the young composers: "are learning from the great masters so that they can break the old cast in order to express themselves in the manner that corresponds at the best with their time and their feelings."[118]

In another article under the descriptive heading: "The Beauty and Value of our Folk Singing and our Folk Songs are Neglected in our Musical Production," Nastasijević criticized the music "of the brain and mathematics." Nastasijević advised that "it would be healthy and well done to freshen the face at the clear spring of our folk song, in order to see again with one's own eyes."[119]

Rajičić decisively rejected the notion that he did not feel close to the folk music idiom. As a proof for this statement he mentioned the symphonic poem *Under the Ground* that already had been performed and well received. Furthermore Rajičić pointed out that Vučković, Logar, Živković, and Čolić find often inspiration in the folk music, although they write in a

contemporary vein.[120] This statement is of special importance since it is pointing to a certain attitude and determination of the representatives of the current avantgarde.

The young composers in this period appreciated truly the folk songs, using the melodies as the basis of their new compositions, or collecting and recording the rich abundant oral tradition of folk music. It is interesting to note that Vučković as well as Logar, Rajičić and Čolić turned to Macedonian folk songs. Vučković wanted to turn attention to the beauty of the Macedonian music folklore. Because of the unresolved Macedonian national question at that time he presented his findings under the name of the region Tikveš, omitting the broader denotation "Macedonian" in his study mentioned earlier.[121] Logar followed his example and gave to his collection of songs from Macedonia the title: *Motives from the South.*[122]

Until now in the writings pertaining to Serbian music history the opinion prevailed that the avantgarde methods of composing were abandoned only after the Second World War. It was maintained that the composers, members of the Prague School, completely repudiated the national style, as opposed to those who continued to compose more or less in that traditional vein. It was also pointed out that during the 1930's, under the influence of the decadent art from the West, the concept of progress was identical with extreme modernism: technical innovations, acrid harmonic configurations, lack of melody and thematic work as well as formal schemes of classical music.[123] This school of composers was also the largest. The composers Čolić, Logar, Marić, Rajičić and Vučković, members of this group, allegedly based their compositions on formalistic elements of the Prague and Viennese schools. A radical change in the artistic concepts of these composers took place only after 1945:

"The music of our youngest generation of composers has been built at that time on a futile basis and was easily and naturally pulled down after the end of people's liberation struggle. New forward moving forces entered the musical life with a swing, with new ideas, meanings and goals for the arts. Our young music creators are looking back at their past and recovering their senses, assuming a critical relation towards their previous illusions and have entered a transformational process that lasts till today."[124]

Furthermore Stana Djurić-Klajn contended that the composers were prepared for this change only theoretically, but not at all in the practical sense, since before the war only Vojislav Vučković and Pavao Markovac had treated in a scientific manner the problems of music. However, Djurić-Klajn

thought that Vučković could not have freed himself from the "negative elements of the West-European formalism."[125]

Oscar Danon held a similar opinion pointing out that Vučković as composer diligently persisted "to realize his own musical language and find out the music expression that corresponds to the theoretical and esthetic ideals." Danon considered that Vučković did not always achieve the projected goal in his steady search: "He did not always succeed to realize his wishes in his musical works, and he did not achieve expression through his music about himself, his orientation, the man and the artist-fighter."[126]

In the course of time the opinion of Stana Djurić-Klajn about the importance and value of the composers of the Prague School, was to a certain degree rectified. In 1962, in her historical overview, the *Development of the Musical Art in Serbia,* Djurić-Klajn contended that this group of composers due to their command of compositional technique had finally overcome the backwardness perpetuated in the past by taking an equal position with contemporary European composers.[127] However, Djurić-Klajn still maintained the opinion about the younger generation of composers expressed first in 1938.[128] She presented again this unchanged opinion ten years later in an article assessing the goals of the post-war musical life.[129] It was still her opinion that the representatives of the Prague School disregarded and rejected the national style in the prewar period of the 1930's. The same judgment about the compositional output of Logar, Milošević, Čolić, Ristić, Marić and Vučković was expressed in the English version of her music history, stating that these composers, at that time: "completely denied the national style."[130]

The influence of this periodization is visible in the writing of Marija Bergamo. Bergamo contended, while disussing the contribution of the members of the Prague School, that these composers realized a new synthesis only in the course of the 1950's. Bergamo stressed that the writers and pictorial artists arrived at this point in their professional careers much earlier. Thus the surrealists gathered in Belgrade had achieved already in the 1930's a different attitude by becoming social activists, aware of the plight of common men. Even, in some cases, they became revolutionaries. In the meantime, the composers were still engaged in the discovery of "technique and construction" as well as coming of age in the professional sense, since this was the time of their affirmation and presentation to the world community. Furthermore, Marija Bergamo stated that the composers were, on the whole, denied the contact with the public, since their works were seldom performed. During the Second World War the contact with the public completely ceased to exist. Therefore Bergamo concluded that only Vučković managed to change his artistic

credo before the war: "Only the composer Vojislav Vučković, as an active social worker, esthete of Marxist persuasion, felt the need before the war to try to create a synthesis after few transitory anti-ethical works."[131]

Marija Bergamo commented that from the present perspective, it is hard to comprehend what reasons influenced the "change in Serbian music, as being a very clear and devoid of ambiguity in the post war period." Bergamo correctly included some of the reasons that brought the change. She discussed the general artistic situation, Vučković's theoretical suppositions and the possibly spontaneous wish of some composers for a synthesis of the new and the old. Although in the introductory passage there was a mention of the hypothesis that the cause of the post-war democratization of the music in Serbia should be looked for in the works of the pre-war era, there is no further corroboration of this thesis. The conclusion was that only Vučković, in his works that were created after the *Two Songs,* approached the realistic method, although in the matter of style his works are close to classicism, with elements of romanticism. Still another composition was cited: the *Second String Quartet* by Stanojlo Rajičić, as a work that has "similar traits." The compositions that later followed like the symphonic poems of Rajičić, the miniatures of Milan Ristić, only confirmed the "consequences contained in this step."[132]

Vlastimir Peričić stated correctly, while analyzing the compositional output of Vojislav Vučković, that Vučković was not the only one concerned about the reception of his music. A number of other young composers, mostly former students of the Prague School shared his concern; they equally desired that their music be accepted, not wishing to remain in a social vacuum. To that end they consciously changed their music style, in the wish to facilitate the comprehension and consequently the acceptance of their works. Peričić concluded that some succeeded in accomplishing this change before the war, while some approached this point in the post war period. Vučković followed his artistic metamorphosis consistently to the end.[133]

The style change in Serbian music did not occur suddenly and without any anticipation after the end of the Second World War, as it was until now assumed. The deliberations and discussions about the necessity of such a change were explored in studies and essays written during the 1930's. Even the compositional output of Logar, Čolić, Rajičić and Vučković bear characteristics, in concept and musical language, of style change. Predrag Milošević in this period was not primarily occupied with composing. Milošević was engaged as conductor presenting to the public exceptional works of music literature such as the performance of Handel's *Messiah,* and Verdi's

Requiem. In 1937 with the First Belgrade Singing Society he won the first prize at the choir competition in Budapest.[134]

Ljubica Marić began at the eve of the Second World War the research of the Serbian Chant, after a period of search and inner clarifications. Her discovery of the all imposing imperative of continuity and oneness of the past and present came to fruition only in the 1950's in the cycle *Music of the Octoechos.*[135]

In the wish to create music works that would be accepted and performed, the composers gradually abandoned the avant-garde methods of composing. In Serbia, where the tradition of the music folklore was especially rich and alive, the creation of an acceptable music language based on the folk idiom presented one of the feasible solutions. This possibility was even more desirable due to the persistent wish to create an indigenous music style that did not rely on foreign models. The reviews from this period depict the reception of the new works, encouraging the gradual introduction of a new development. Although not all compositions of the younger generation of composers could have been performed, there had been enough performances to enable interaction with the performers and the public, providing the necessary resonance for the new art works. Another insight into the discrepancy that existed between the music language of the current avant garde and the general level of music education was commonly known to the music educators. Since the young composers soon became part of the teaching staff, in addition to conducting or performing appearances, their comprehension of the existing situation was soon enough attained, contributing to the desire for change in style and content. Such were some of the complex changes caused by the economic, political and social crises in the late 1920's and throughout the 1930's. The avantgarde writers, members of the surrealistic movement as well as painters, sculptors and composers were influenced by these events.

On the literary field, in spite of the wish to support the thesis of the New Realism, doubts have been expressed about the dangers of a stilted and schematic, ideological and methodological application of this artistic movement. Among the most eloquent critics was Marko Ristic who in his "Introduction for a few Unwritten Novels" that appeared in 1953 contended that the New Realism is in its essence tendentious and that its philosophical base is the method of dialectic materialism. This should not imply that the literary work should acquire a distinctly educational or propaganda-like aspect, to the detriment of the basic nature of the arts. The art work should not become a programmatic or pedagogical demonstration of the dialectical materialism. Ristić believed that an art work would even act more as tendentious if it remains true to the requirement of its artistic nature, although this may seem

contrary to expectations. Ristić considered that the rational method of cognition belongs to science, while propaganda may use the simplified forms of persuasion. The arts, on the other hand, cannot abandon their true nature of intuitive cognition and emotional expression. Ristić concluded that the criteria used for the evaluation of an art work have to pertain primarily to the specific requirements of the arts. These criteria cannot be restricted only to the evaluation of the social value of the content, utilitarian and fighting spirit or accessibility to the masses.[136]

The support for these conclusions Ristić found in the poetic creations of writers adhering to the movement of social arts. Ristić contended that these recently written poems presented a dull archaism, or even worse, a regression of conscience. These songs were only superficially socially engaged. The motives reflect most often sentimentality. Such poems do not present "a live and truthful expression of psychological reality and its relations with the outward reality." Therefore these rationalist or impressionist tales in verses are not truly a moral act. Ristić concluded that the social poetry is regressive, and that it presents a step backwards in the evolution of human consciousness.[137]

There was a similar situation on the field of pictorial art, according to the testimony of Branko Popović. Popović wrote in 1936 that the painters belonging to the social art movement "use the pictorial language of other good painters."[138] The sentimental and melodramatic form, as well as the conservative pictorial language, in presenting the scenes from the lives of workers, proletarians or soup kitchens and prisons did not bring about the new art. On the surface there seemed to exist great differences between the endeavors of the artists belonging to the Group *Život* (Life) or *Salon Nezavisnin* (The Salon of the Independent) as opposed to the representatives of the nationalistic and conservative groups *Zograf* and *Lada*, as well as members of the representative movements of the bourgeois art such as *Oblik* (Form), *Desetorica* (The Ten), and *Dvanaestorica* (The Twelve). However these differences were mostly noticeable in the themes, and not in the aspects crucial for the fine art—in its pictorial language and artistic form. Speaking in retrospect, Lazar Trifunović concluded:

"Therefore it can be assumed that the social art of the fourth decade presents a characteristic, devious and stylistically conservative expression of the bourgeois arts. This was confirmed even by its destiny: after quickly exhausting its thematic possibilities . . . caused by the mediocre talents that were leading it, it drowned in the bourgeois art of interiors, assorted *nature morte* and landscape scenes. The vitality of the bourgeois fine arts, that created but also finished the social arts, came to expression once more, after 1945, when it literally drowned in the esthetics of socialist realism."[139]

The Second World War and the events that subsequently followed slowed down the newly started development in the building of a more mature and more appropriate language. The greatest loss for the Serbian music came with the premature and tragic death of Dr. Vojislav Vučković. However his artistic heritage remained to influence and attract attention of composers and musicologists alike. His unfinished compositional works were finished in accordance with the preserved sketches, and even posthumously performed. Aleksandar Obradović finished the instrumentation of the *Heroic Oratorium*. The ballet music the *Man that Stole the Sun* was completed by Petar Bergamo, while the instrumentation of the Second Symphony was furnished by Petar Ozgijan.

The theoretical studies and articles written by Vučković gave incentive to the publication of numerous criticisms, reviews, essays and studies that appeared in Yugoslavia and Czechoslovakia.[140] Therefore it behooves one to reiterate the words of the poet Radovan Zogović, that in truth present a paraphrase of the verses of Puškin: "Vučković's path will never be overgrown by grass."[141]

Nor could the period of 1920's and 1930's be discounted due to the unique artistic contribution of its constellation of writers, composers, sculptors and painters. This exceptional period was marked by a bold search for a more truthful artistic expression. In this quest, in the earlier part, the avant-garde tendencies were introduced as an expansion of the artistic language pointing to new sensibilities. Amid the turbulent time of the economic, political, and social crises of the late 1920's a new strain of social concern for fellow men evolved as well as a reaffirmation with the national heritage pointing to the occurrence of the realistic trend in the arts.

In the broad perspective the rich and varied cultural life of the present has its roots and origin in the endeavors of the artistic aspirations of the period of growth between the two World Wars. At this time the achievements of the Serbian literature, music and fine arts contributed to the enrichment of the general artistic development of Europe.

NOTES

Introduction

1. D. Živković, *Evropski okviri srpske književnosti* (Belgrade: Prosveta, 1960), p. 11.

2. Ibid., p. 4-15.

3. V. Vučković, "Problem vaspitanja našeg kompozitorskog naraštaja", *Politika*, 21. March 1936. Reprinted in V. V., *Studije, eseji, kritike,* (Belgrade: Nolit, 1968), p. 555.

4. M. Živković, "Muzički lik Stavana Hristića", *Eseji o umetnosti,* (Novi Sad: Matica Srpska, 1966), p. 271.

5. L. Dallapiccola, "On the Twelve-Tone Road", *Music Survey,* October 1951, London, Vol. Iv, No. 1, pp. 318-322.

6. E. Salzman, *Twentieth-Century Music: An Introduction,* (Engelwood Cliffs, N.J.: Prentice-Hall, 1967), p. 78.

7. St. Djurić-Klajn, "Putevi naše moderne", *Muzički Glasnik,* 1938, Belgrade, pp. 7-10.

8. Z. Simić-Milovanović, "Beograd i borbeni razvoj srpske umetnosti novijeg doba", *Godišnjak grada Beograda,* knj. VI, 1959, p. 643.

9. V. Vučković, "Muzički realizam Stevana Mokranjca", *Slavenska muzika,* 1940, No. 5, 6, 7. Reprinted in V. V., *Studije . . .* , p. 442.

10. V. Vučković, *Hudba jako propagačni prostředek,* (Prague: Charles University, 1934). Reprinted in *Studije . . .* , p. 48. Compare also, V. V., V. V., "Teorija napredne muzike", *Studije. . .* , p. 158.

11. *Danas,* January-March, 1934, p. 85.

12. "Prva izložba beogradskih slikara-grafičara", *Pravda,* 16, Feb. 1934. Reprinted in M. Protić, *Srpsko slikarstvo XX veka,* (Belgrade: Nolit, 1970), p. 341.

13. Quoted after M. Protić, *Srpsko slikarstvo . . .* , p. 340.

14. V. Peričić, *Stvaralački put Stanojla Rajičića,* (Belgrade: Umetnička akademija), 1970, pp. 32-36.

15. St. Djurić-Klajn, "Putevi . . .", p. 8.

16. St. Djurić-Klajn, "Konture našeg novog muzičkog stvaralaštva", *Muzika,* No. 1, 1948, p. 18.

17. M. Bergamo, *Stvaralački put Milana Ristića od Prve do Šeste simfonije* (Belgrade; Univerzitet umetnosti, 1977), p. 14.

18. O. Danon, "Sjećanje na Vojislava Vučkovića", *Muzika,* No. 1, 1948, p. 52.

19. J. Fukač, "Die Tradition des musiksoziologischen Denkens in der Tschechoslovakei", *Die Musiksoziologie in der Tschechoslovakei* (Prague: Tschechoslovakisches Musikinformationszentrum, 1967), pp. 12-14.

Chapter 1

1. Marko Ristić, "Tri mrtva pesnika," *Rad jugoslovenske akademije znanosti i umjetnosti,* Zagreb 1954, p. 264.

2. Rastko Petrović, "Opšti pogledi i život pesnika," *Svedočanstva* No. 3, 11. XII. 1924, Belgrade. Published again in *Izbor,* Vol. I, Matica Srpska, Novi Sad 1958, p. 400.

3. Miodrag Protić. *Srpsko slikarstvo XX veka* (Belgrade, Nolit 1970), p. 92.

4. Ibid., p. 92.

5. M. Ristić, "Tri mrtva pesnika", p. 264.

6. Ibid., p. 264.

7. V. Živojinović, "Akcija Grupe umetnika", *Misao,* 16, XII. 1919, No. 4, Zivojinović pp. 317-318.

8. Ibid., p. 317.

9. Ibid., p. 320.

10. Ibid., p. 317.

11. Ibid., p. 318.

12. Ibid., p. 317.

13. Ibid., p. 318.

14. Ibid., p. 318.

15. Ibid., p. 319.

16. Stevan Hristić, "Dosadašnji muzički rad", *Misao,* Belgrade, December 1919, pp. 394-397.

17. Ibid., p. 394.

18. Ibid., pp. 394-395.

19. Stevan Hristić, "O nacionalnom repertoaru," *Misao,* No. 1, pp. 76-77.

20. Ibid., p. 76.

21. Ibid., p. 76.

22. Ibid., p. 78.

23. Ibid., pp. 76-78.

24. For further data about Hristić and his work see, M. Milojević, "Suton, muzička drama Stevana Hristića", *Muzičke studije i članci,* Vol. II, Belgrade 1933, pp. 79-84. Stana Djurić-Klajn, "Razvoj muzičke kulture u Srbiji", *Historijski razvoj muzičke*

kulture u Jugoslaviji (Zagreb 1962), pp. 669-679. V. Peričić, *Muzički stvaraoci u Srbiji,* (Belgrade 1967), pp. 123-134.

25. Stana Djurić-Klajn, "Razvoj muzičke umetnosti u Srbiji", p. 665.
26. *Misao,* December 1919, pp. 394-397.
27. Petar Konjović: *Miloje Milojević,* (Belgrade, SAN, 1954) p. 69.
28. Ibid.
29. *Srpski književni glasnik,* 1. V. 1926, No. 1.
30. Kosta P. Manojlović, "Pismo iz Beograda", *Sveta Cecilija,* 1922, Vol. 1, XVI.
31. Ibid.
32. Ibid.
33. Kosta P. Manojlović, *Spomenica St. St. Mokranjcu,* (Belgrade: Državna štamparija, 1923).
34. Ibid., p. 166.
35. Ibid., p. 130
36. Ibid., p. 124.
37. K. P. Manojlović, *Spomenica* . . . , p. 4.
38. Ibid.
39. Miloje Milojević, "U borbi za umetnost", *Muzičke studije i članci,* (Belgrade 1926), p. 157.
40. Ibid., p. 155.
41. Ibid., p. 156.
42. Ibid., p. 151.
43. Ibid., p. 152-153.
44. Sibe Miličić, "Jedan izvod koji bi mogao da bude program", *Srpski književni glasnik,* 16. September 1920, p. 192.
45. Ibid., p. 193.
46. Velibor Gligorić, "Miloš Crnjanski", *Ogledi i Studije,* (Belgrade: Prosveta, 1958). Reprinted in *Književnost izmedju dva rata,* editor Sv. Velmar-Janković (Belgrade: Nolit, 1965) p. 259.
47. Sv. Stefanović: "Širim horizontima", *Putevi,* Marsias, Belgrade 1922, pp. 4-5.
48. Ibid.
49. Rastko Petrović, "Opšti pogledi . . .", p. 401.
50. Ibid.
51. Marko Ristić, *Rastko Petrović: Izbor* (Novi Sad, 1958) p. 27.
52. Rastko Petrović, "Opšti podaci . . .", p. 401.
53. Miloš Crnjanski, "Otkrovenje R. Petrovića", *Srpski književni glasnik,* No. 5, March 1923. Reprinted in *Književnost izmedju dva rata,* p. 285.
54. Isidora Sekulić, "R. Petrović: Otkrovenje", reprinted in *Književnost izmedju dva rata,* p. 283.
55. Milan Dedinac, "Dnevnik o Čarnojeviću", *Putevi,* January 1922. Reprinted in *Marko Ristić: Prisustva* (Belgrade, Nolit 1966) p. 49.
56. Marko Ristić, "Kroz noviju srpsku književnost", in *Književnost izmedju dva rata* (Belgrade, Nolit 1965) p. 20.

57. Ibid.

58. Ibid., pp. 20-21.

59. Lazar Trifunović, "Likovna umetnost", *Eseji o umetnosti* (Belgrade, Srpska književna zadruga 1967) p. 334.

60. Mihailo Petrov, "Slikarstvo Petra Dobrovića", *Letopis Matice Srpske,* Novi Sad 1927, CI, p. 314. Reprinted in *Srpska likovna kritika,* selected and edited by Lazar Trifunović, (Belgrade: Srpska književna zadruga, 1967) p. 391.

61. Todor Manojlović, *"Peta jugoslovenska umetnička izložba",* Misao, IX, No. 5-6, 1922. Reprinted in *Srpska likovna kritika,* p. 314.

62. Ibid., pp. 314-315.

63. Ibid.

64. L. Trifunović, "Skica za istoriju srpske likovne kritike", *Srpska likovna kritika,* p. 23.

65. R. Petrović, "Jedna beogradska izložba", *Kritika,* 1. II. 1921. Reprinted in *Srpska likovna kritika,* p. 297.

66. L. Trifunović: *Sreten Stojanović* (Belgrad, Galerija SANU 1973) p. 22.

67. Ibid., p. 23.

68. Milan Kašanin, "Šesta jugoslovenska umetnička izložba", *Srpski književni glasnik,* XXI, 1927. Reprinted in *Srpska likovna kritika,* p. 364.

69. M. Kašanin, "Milan Konjović", *Srpski književni glasnik,* XXXVII, 1932. Reprinted in *Srpska likovna kritika,* p. 365.

70. M. Crnjanski, "Miloš Golubović," *Dan,* No. 7 and 8, 1928. Reprinted in *Srpska likovna kritika* p. 277.

71. L. Trifunović, "Introduction" in: Moša Pijade, *O umetnosti,* (Belgrade, Srpska književna zajednica, Vol. 378) p. 7.

72. M. Ristić, "Kroz noviju srpsku književnost", *Književnost izmedju dva rata,* pp. 19-20.

73. Ibid.

74. Ljubomir Micić, "Zenit manifest", *Zenit,* No. 11, 1922, p. 1.

75. Lj. Micić, *Zenit,* No. 21, February 1923.

76. Lj. Micić, "Voimja zenitizma", Catalogue of the First International Exhibit, arranged by the editors of *Zenit* in Belgrade, 1924, p. 3.

77. Slavko Batušić, "Tridesetogodišnji dječak u velikom gradu," *Forum,* Jugoslovenska akad. znanosti i umjetnosti, Zagreb, Vol. XXII, No. 12, p. 788.

78. Ibid., p. 794.

79. Josip Andreis, "Razvoj muzičke umjetnosti u Hrvatskoj", *Historijski razvoj muzičke kulture u Jugoslaviji* (Zagreb, Školska knjiga, 1962) p. 243.

80. Vlastimir Peričić, *Muzički stvaraoci u Srbiji* (Belgrade: Prosveta, 1967) p. 494.

Chapter 2

1. Quoted after M. Petrić–Petković: "Objašnjenje Sumatre na poziv Bogdana Popovića", *Zbornik radova nastavnika i studenata,* (Belgrade: Filološki fakultet, 1975) p. 294.

2. Ibid.

3. M. Crnjanski, "Objašnjenje Sumatre", *Srpski književni glasnik,* September-December 1920, pp. 266-267.

4. Ibid.

5. Ibid., p. 262.

6. Petar Konjović, *Miloje Milojević* (Belgrade: Srpska akademija nauka, 1954) p. 137.

7. Bogdan Popvić, *Ogledi iz književnosti i umetnosti* (Belgrade, 1927) p. 336.

8. P. Konjović, *Miloje Milojević,* p. 175.

9. Ibid., p. 175.

10. Ibid., p. 177.

11. Milojević was elected for the position of an assistant in October 30, 1922.

12. The publisher was Geca Kon, Belgrade 1922. The first book had twelve editions, while the second eight, reaffirming the value of these textbooks.

13. Quoted after P. Konjović, *Miloje Miojević,* p. 182.

14. Ibid., p. 182.

15. Ibid., p. 182.

16. Stana Djurić-Klajn, "Razvoj musičke umetnosti u Srbiji", p. 686.

17. Ibid., p. 686.

18. Ibid.

19. Ibid., p. 687.

20. K. P. Manojlović, Prilozi za moju biografiju, manuscript. Compare, J. Milojković-Djurić, "Doprinos i uloga Koste P. Manojlovića u razdoblju izmedju dva svetska rata", *Zvuk,* 1969, No. 100, pp. 568-569.

21. K. P. Manojlović, Prilozi. . . .

22. Ibid.

23. Ibid.

24. Ibid.

25. Ibid.

26. Ibid.

27. Ibid.

28. Vojislav Vučković, "Proslava beogradske filharmonije", *NIN* No. 8, 1935. Reprinted in V. V., *Studije, eseji, kritike* (Belgrade: Nolit 1968) p. 546.

29. Ibid.

30. Compare Chapter 1 of this book.

31. V. Vučković, "Proslava . . .", p. 546.

32. V. Vučković, "Prvi koncert beogradske filharmonije", Život i rad, May-September 1940. Reprinted in V. V., *Studije* . . . , p. 596.

33. Ibid., p. 596.

34. Ibid.

35. Marija Koren, "Gradja za biografiju Vojislava Vučkovića", *V. V. umetnik i borac* (Belgrade, Nolit, 1968) pp. 51-52.

36. Ibid.

37. P. Konjović, *Miloje Milojević,* p. 70.

38. Ibid., pp. 72-73.

39. Ibid., p. 72.

40. Ibid., pp. 72-73.

41. M. Milojević, "Rusi i opersko pitanje u nas", *Politika,* 22. X. 1921.

42. P. Konjović, *"Miloje Milojević",* p. 71.

43. Ibid.

44. K. P. Manojlović, *Istorijski pogled na postanak, rad i ideje Muzičke škole u Beogradu,* (Belgrade 1924).

45. K. P. Manojlović, *Prilozi za moju biografiju,* manuscript.

46. P. Konjović, *Miloje Milojević,* pp. 169-170.

47. M. Pijade, "Kroz jugoslovensku izložbu", *Mali žurnal,* Belgrade 1912. Quoted after M. Protić: *Srpsko slikarstvo XX veka,* (Belgrade: Nolit, 1970) p. 77.

48. S. Stojanović, "Sima Roksandić, vajar.", *O umetnosti i umetnicima,* (Belgrade, 1952). Reprinted in *Srpska likovna kritika,* p. 414.

49. P. Konjović, *Miloje Milojević,* p. 169.

50. Ibid.

51. Ibid., p. 64.

52. Ibid.

53. M. Milojević, "Za državni konzervatorijum", *Srpski književni glasnik,* 16. V. 1923, Vol. IX, No. 2. Reprinted in M. M., *Muzičke studije i članci,* (Belgrade: Geca Kon, 1926) p. 155.

54. Ibid., p. 161.

55. Ibid., p. 166.

56. K. P. Manojlović, *Prilozi za moju biografiju.*

57. Ibid.

58. Ibid.

Chapter 3

1. The first and second volume was published in Belgrade by Geca Kon. The third volume appeared posthumously and was edited by Milojević's daughter Gordana Trajković-Milojević and published in Stari Bečej by the printing company Proleter.

2. Introduction, p. XII.

3. Ibid., p. XII.

4. Ibid., p. XIII.

5. Ibid., p. XIV.

6. Ibid., p. XIV.

7. Dragan Jeremić, "Bogdan Popović", *Srpska književnost u književnoj kritici* (Belgrade: Nolit, 1972) p. 146-148.

8. A. Baine, p. X. Quoted after Jeremić, "Bogdan Popović", p. 149.

9. D. Jeremić, "Bogdan Popović", p. 149.

10. P. Konjović, *Miloje Milojević,* p. 231.

11. L. B. Meyer, *Explaining Music* (Chicago: University of Chicago Press, 1973) pp. 16-17.

12. Ibid., p. 21.
13. M. Milojević, p. 9.
14. Ibid., pp. 9-10.
15. Ibid., p. 10.
16. P. Konjović, *Miloje Milojević,* p. 186.
17. *Muzičke studije i članci,* Vol. I (Belgrade: Geca Kon, 1926) p. 82.
18. Ibid., p. 96.
19. Ibid.
20. B. Popović: *Knjizevni listovi—Ogledi,* p. 88. Quoted after D. Jeremić, "Bogdan Popović", *Srpska književnost u književnoj kritici,* (Belgrade: Nolit, 1972) p. 169.
21. M. Milojević, "Umetnička ličnost Stevana St. Mokranjca", p. 112.
22. Ibid., p. 114.
23. Ibid., pp. 84-85.
24. Ibid., pp. 86-87.
25. M. Milojević; "O muzičkom nacionalizmu", *Muzičke studije i članci,* Vol. II, p. 31.
26. M. Milojević, "Umetnička . . .", pp. 36-37.
27. D. Jeremić, "Bogdan Popović", p. 162.
28. H. Riemann, *Geschichte der Musik seit Beethoven* (Stuttgart 1901). Quoted after Z. Lissa, *Aufsätze Zur Musikästhetik,* (Berlin: Henschel Verlag, 1969) p. 235.
29. M. Milojević, "Umetnička . . .", p. 101.
30. Ibid., p. 100.
31. K. P. Manojlović, (Belgrade; Državna štamparija, 1923).
32. Ibid., pp. 123-124.
33. Ibid., p. 125.
34. M.M., "Umetnička . . .", pp. 99-101.
35. Ibid., pp. 97-98.
36. V. Vučković, "Muzički realizam Stevana Mokranjca", *Slovenska muzika,* No. 5, 6, 7, Belgrade 1940. P. Bingulac, "Stevan Mokranjac i njegove rukoveti", *Godišnjak muzeja grada Beograda,* Vol. 3, 1956, pp. 417-446. P. Konjović, *Stevan Mokranjac* (Belgrade: Nolit, 1956). M. Živković, *Rukoveti St. St. Mokranjca,* (Belgrade: Muzikološki institut, SAN: 1957).
37. V. Vučković, "Muzički realizam Stevana Mokranjca", *Slovenska muzika* No. 5, 6, 7, Belgrade 1940. Reprinted in V. V., *Studije . . . ,*
38. Ibid., p. 440.
39. Ibid., p. 442.
40. Ibid., pp. 440-441.
41. Ibid., p. 441.
42. Ibid., p. 442.
43. P. Konjović, *Miloje Milojević,* p. 157.
44. Ibid., p. 158.
45. Ibid., p. 161.
46. P. Bingulac, "Stevan Mokranjac i njegove rukoveti", p. 419.
47. P. Konjović, *Miloje Milojević,* p. 39.

48. Ibid., p. 43.

49. H. Riemann, *Geschichte der Musik seit Beethoven,* quoted after Z. Lissa, *Aufsätze zur Musikästhetik,* p. 235.

50. Z. Lissa, "Uber den nationalen Stil in der Musik", *Aufsätze zur Musikästhetik* (Henschel Verlag: Berlin 1969) p. 215.

51. D. Jeremić, "Bogdan Popović", *Književna kritika,* p. 162.

52. M. Milojević, "U slavu muzike", *Zvuk* 1932, Reprinted in M. M., *Muzicke studije i člnaci,* p. 7.

53. Ibid., pp. 8-9.

54. D. Jeremić, "Bogdan Popović", p. 156.

55. M. Milojević, "U slavu muzike", p. 7.

56. Ibid., p. 9.

57. D. Jeremić, "Bogdan Popović", pp. 155-156.

58. M. Milojević, "U slavu muzike", p. 11-12.

59. Ibid., p. 11.

60. N. Hercigonja, "Muzikološki opus dr Vojislava Vučkovića", *V. V. umetnik i borac,* pp. 131-132.

61. G. Dimitrijević, "Miloje Milojević kao esejista", *Zvuk* No. 1. 1976, p. 10.

62. M. Milojević, "U slavu muzike", p. 13.

63. C. Dahlhaus, *Musikästhetik* (Köln: Hans Gerig, 1967) p. 24.

64. M. Milojevic, "U slavu Muzike", p. 13.

65. M. Milojević, "U borbi za umetnost", *Muzičke studije i članci* (Belgrade: Geca Kon, 1926), p. 157.

66. D. Jeremić, "Bogdan Popović", p. 132.

67. Ibid., p. 147.

68. M. Milojević, "Naše dužnosti prema najmladjem kompozitorskom naraštaju, *Smena,* No. 5-6, Belgrade 1939, p. 8.

69. Ibid., p. 5.

70. Alois Hába, "Mladi jugoslovenski kompositori i četvrttonska muzika", *Zvuk* No. 3, Belgrade 1933, p. 81.

71. Milojević was born in 1884 in Belgrade and completed his general music education in 1910 at the Music Academy in Munich, Germany.

72. M. Milojević, "Ideje Aloisa Hábe", *Muzičke studije i članci,* (Belgrade: Geca Kon, 1926) p. 41.

73. Ibid., p. 42.

74. Ibid., p. 58.

75. Ibid., p. 58-61.

76. A. Hába, "Mladi jugoslovenski kompozitori i četvrttonska muzika", p. 82-83.

77. Vučković, born in 1910, managed to make a strong impact on the cultural life both of Prague and Belgrade, although he lived only until 1942.

78. *Muzika od kraja XVI do XX veka* (Belgrade 1936); *Izbor eseja* (Belgrade 1955); *Umetnost i umetničko delo* (Belgrade 1962); *Studije, eseji, kritike* (Belgrade 1968).

79. V. Vučković, "O četvrt-tonskoj muzici", *Studije, eseji, kritike*, p. 358.

80. M. Milojević, "Rihard Štraus", reprinted in *Muzičke studije i članci*, Vol. III, (Stari Bečej, 1953), p. 139.

81. P. Konjović, *Miloje Milojević*, pp. 38-39.

82. M. Milojević, "Richard Štraus", p. 127.

83. Ibid.

84. Ibid., pp. 127-128.

85. *Politika*, 17. XII. 1935. Reprinted in *V. V. umetnik i borac*, pp. 261-262.

86. M. Milojević, "Dva mlada dirigenta pred orkestrom", *Politika*, 11. IV. 1934. Reprinted in *V. V. umetnik i borac*, p. 245.

87. Ibid., p. 245.

88. M. Koren, "Gradja....", p. 39-40.

89. M. Milojević, "Povodom jedne manifestacije naše muzičke moderne", *Politika*, 21. III. 1938. Reprinted in *V. V. umetnik i borac*, p. 280.

90. Ibid., p. 280-281.

Chapter 4

1. J. Fukač, L. Mokry, V. Karbuzicky, *Die Musiksoziologie in der Tschechoslovakei* (Prague: Tschechoslovakisches Musikonformations-zentrum, 1967) pp. 12-14.

2. Z. Novaček, Musik Ästhetik (Berlin, Henschel Verlag, 1956) p. 126.

3. R. Zogović, "V. V. umetnik i borac", *V. V. umetnik i borac*, p. 301. O. Danon, "Sjećanje na V. V.", *V. V. umetnik i borac*, p. 318.

4. V. Vučković, "Pregled teorije i istorije estetike", *Studije, eseji, kritike*, pp. 134-146.

5. A. V. Lunačarskij, *Pisma ob iskustve*, Sob. soč., Vol. 8 (Moscow: Akad. nauk SSSR, 1967) p. 214-216.

6. J. Fukač, *Die Tradition* ..., pp. 12-14.

7. H. Raab, H. Schmidt, "Die literaturkritische Polemik 1826-1842", *Geschichte der klassischen russischen Lietratur*, Ed. W. Düwel (Berlin: Aufbau Verlag, 1973) pp. 163-164.

8. Quoted after H. J. Drengenberg, Forschunger zur osteuropäischen Geschichte (Berlin: Osteuropa Institut, 1972) pp. 87-88.

9. A. N. Lunatscharski: "Über die soziologische Methode in der Musiktheorie und Musikgeschichte", *Die Revolution und die Kunst*, (Dresden: VEB Verlag der Kunst, 1974), p. 33.

10. A. W. Lunatscharski, "Der Neuerer Wladimir Majakowski", *Die Revolution und die Kunst*, p. 231.

11. V. V., *Studije, eseji, kritike*, p. 134.

12. N. Malko, *A Certain Art*, (New York: 1966).

13. "Nikolaj Malko", *Muzički glasnik* No. 1-2, 1931. Reprinted in V. V., Studije, eseji, kritike, p. 306.

14. M. Koren, "Gradja . . .", p. 32.
15. V. Begović, "Susreti sa Banetom", *V. V. umetnik i borac,* pp. 181-182.
16. Czech title, *Hudba jako propagačni prostredek* (Prague: Karlova Universita, 1934). Reprinted in V.V., *Studije* . . . , pp. 3-49.
17. K. Tschukowski: Closing remark, *Die Revolution u. die Kunst.*
18. A. W. Lunatscharski, "Ein Löfel Gegengift", *Die Revolution* . . . p. 245.
19. A. W. Lunatscharski, "Die Revolution und die Kunst", *Die Revolution* . . . , p. 27.
20. Ibid., p. 26.
21. Ibid., pp. 26-27.
22. Ibid., p. 29.
23. Ibid., p. 31.
24. Ibid., p. 28.
25. Lunatscharski, *"Thesen über die Aufgaben der marxistischen Kritik", Die Revolution* . . . , pp. 14-15.
26. Ibid.
27. First published in Prague, in 1934, as a publication of the Charl's University. Reprinted in *Savremeni akordi* No. 1, 2, 1959 and in the special issue in 1961. Third edition in *Umetnost i umethničko delo,* Belgrade 1962. Fourth publication in V. V., *Studije, eseji, kritike,* Belgrade 1968.
28. Lunatscharski, "Die Revolution u. die Kunst", *Die Revolution* . . . , p. 27.
29. O. Danon, "Sječanje na Vojislava Vučkovića", p. 317.
30. V. Vučković, *Materijalističa filozofija umetnosti* (Belgrade 1935). Reprinted in V.V., *Studije* . . . , p. 94.
31. V. Vučković, "Idealizam i materijalizam u muzici" *Naša stvarnost* No. 5-6, 1937. Reprinted in V. V., *Studije* . . . , pp. 150. A somewhat shorter version appeared in Czech language, under the title "Idealismus a materialismus v. hudbé", in the journal *Rytmus* No. 4, 5, 6, 1936-37.
32. V. Vučković, "Idealizam . . .", p. 151.
33. Ibid., p. 159.
34. J. Fukač, "Die Tradition des musiksoziologischen Denkens . . . ," pp. 10-12.
35. Ibid., p. 35.
36. Vučković, "Muzika kao sredstvo propagande", *Studije, eseji* . . . , p. 40.
37. Fukač, "Die Tradition . . . ," pp. 12-13.
38. Ibid.
39. G. Bouron, H. Kunstmann, Introduction to RED, *Analecta Slavica,* Vol. 13/1, jal-reprint, Würzburg 1977.
40. Ibid.
41. Ibid.
42. V. Vučković, "Muzika kao sredstvo propagande", in *Studije* . . . , p. 3.
43. Ibid., pp. 3-4.
44. Ibid., pp. 4-11.
45. Ibid., p. 12.
46. C. Dahlhaus, *Analyse und Werturteile,* (Mainz: B. Schott's Söhne 1970) p. 27.

47. Vučkovič, "Muzika . . .", p. 15-16.
48. M. Koren, "Gradja . . .", p. 40.
49. Vučković quoted Nejedly's words in his article "Opera na radiju", *Politika* 7. XII. 1936, as an additional confirmation of his statements.
50. Vučković, "Muzika . . .", pp. 25-26.
51. Ibid., pp. 26-27.
52. C. Dahlhaus, *Musikästhetik,* p. 26.
53. Ibid.
54. Quoted after Lunačarskij, "Der Neuerer Wladimir Majakowski", *Die Revolution* . . . , p. 231.
55. Vučković, "Muzika . . . ," p. 31.
56. Ibid., p. 40.
57. Ibid., p. 41.
58. Ibid., p. 41-43
59. Ibid., p. 25-27.
60. Ibid., p. 44.
61. C. Dahlhaus, "Musikästhetik", p. 103-104.
62. V. V., "Muzika . . .", pp. 45-46.
63. Lunatscharski, "Die Revolution . . .", p. 28.
64. V. V., "Muzika . . .", pp. 46-48.
65. J. Fukač, "Die Tradition des musiksoziologischen Denkens . . ." pp. 13-14.
66. V. V., "Idealismus a materialismus v hudbe", Rytmus 4, 5, 6.
67. J. Fukač, L. Mokry, V. Karbuzucky, "Die Musiksoziologie in der Tschechoslovakei", p. 14.
68. V. Vučković: *Umetnost i umetničko delo,* edited by D. Plavša (Belgrade: Nolit 1962.) Reprinted in V. V., *Studije* . . . , Ed. V. Peričić (Belgrade: Nolit, 1968.)
69. V. V., "Pregled teorije . . .", p. 149.
70. Ibid., p. 150.
71. Ibid., p. 151.
72. Ibid., p. 154.
73. Ibid., pp. 154-155.
74. Ibid., p. 158.
75. Z. Novaček, *"Einführung in die Musikästhetik,"* (Berlin: Henschel Verlag, 1956) pp. 125-126.
76. V. V., "Pregled teorije . . .", p. 159.
77. Ibid.
78. Z. Novaček, *Einführung in die Musikästhetik,* p. 126.
79. M. Koren, "Gradja za biografiju", pp. 49-50.
80. J. Fukač, "Die Tradition . . .", p. 14.
81. E. Mićunović, "Muzika i ideologija", *Danas* 4. VI. 1962. Reprinted in *V. V. umetnik i borac* (Belgrade: Nolit, 1968) pp. 447-448.
82. V. Vučković, *Studije* . . . , pp. 159-164.
83. Ibid., pp. 159-160.
84. Ibid., p. 160.

85. Ibid., pp. 160-161.
86. Ibid., p. 161.
87. Ibid., p. 163.
88. W. I. Lenin, *Werke,* Vol. XX, *Kritische Bemerkungen zur nationalen Frage.* (Berlin 1961) p. 8.

Chapter 5

1. *Muzički glasnik,* January 1938, pp. 7-10.
2. Ibid., p. 8.
3. Ibid.
4. Compare Chapter 4.
5. M. Živković, *Muzički glasnik,* 1933, No. 3. Quoted after A. Dobronić, "Kriza morala u našem muzičkom životu", *Zvuk,* February 1935, p. 71.
6. J. Milojković-Djurić, Conversation with the composer Mihovil Logar, May 25, 1978, manuscript.
7. Ibid.
8. B. Dragutinović, "Iz muzičkog života", *Muzika,* No. 2, 1928, p. 48.
9. J. Milojković-Djurić, Conversation with the composer Stanojlo Rajičić, May 9, 1978, manuscript.
10. Ibid.
11. Conversation with the composer Predrag Milošević, July 20, 1978, manuscript.
12. J. Milojković-Djurić, Conversation with Professor Stana Djurić-Klajn, May 30, 1978, manuscript.
13. Ibid.
14. M. Milojević, "Naše dužnosti prema najmladjem kompozitorskom naraštaju", *Smena,* No. 5-6, Belgrade 1939, p. 8.
15. A. Dobronić, "Kriza i problem morala u našem muzičkom životu," *Zvuk,* February 1935, p. 71.
16. P. Konjović, *Miloje Milojević,* p. 201.
17. V. Vučkpvić, "Kriza savremene muzike i uslovi njenog savladjivanja", V. V. *Studije . . . ,* pp. 159-163.
18. P. Bingulac, "Muzički festival u Firenci", *Zvuk* No. 12, 1933, p. 411.
19. V. Vučković, "Štrazburški eksperiment u svetlosti materijalističke kritike", *Zvuk,* No. 1, 1933. Reprinted in V.V., *Studije . . . ,* p. 649.
20. Ibid., p. 649.
21. Ibid.
22. Ibid., p. 652.
23. Ibid., p. 650.
24. Ibid., p. 652.
25. Ibid., p. 651.
26. Compare Chapter 3.

27. L. Dallapiccola, "On the Twelve-Note Road", *Music Survey,* Vol. V, No. 1, October 1951, pp. 318-322.

28. V. Vučković, "Paul Hindemit i atonalna muzika", *Život i rad,* No. 28-31, 1940. Reprinted in *Studije* . . . , pp. 412-416.

29. Ibid., p. 413.

30. Ibid.

31. Ibid., pp. 413-414.

32. Ibid., pp. 415-416.

33. Ibid., p. 415.

34. V. Vučković, "Muzika kao sredstvo propagande", *Studije* . . . , p. 31. "Teorijanapredne muzike", pp. 158-159.

35. L. Finscher, "Versuch einer Neuorientierung", *Hindemith Jahrbuch,* 1971, p. 23.

36. J. Milojković-Djurić, "Conversation with the composer Petar Stajić", July 26, 1978, manuscript.

37. According to Petar Stajić this letter disappeared during the bombardment of Belgrade in 1944. Bivolarević was killed and the manuscripts and letters that he carried very likely perished in the bomb explosion.

38. Conversation with P. Stajić.

39. R. Vlad, "Italian Music Today", *Twentieth Century Music,* Ed. Rollo H. Mayers, (New York: Orion Press, 1968) p. 185.

40. A. Copland, *The New Music 1900-1960,* (New York: Norton & Co., 1968) p. 160.

41. Ibid., pp. 160-162.

42. A. Dobronić, "Kriza i problem morala u našem muzičkom životu", *Zvuk,* February 1935, p. 73.

43. Ibid., p. 71.

44. Ibid.

45. Ibid.

46. Ibid., p. 72.

47. A. Lajovic, "Nacionalizam ili internacionalizam u muzici" *Zvuk,* May 1935, p. 169.

48. V. Pomorišac, "Kriza naše likovne umetnosti", *Letopis Matice Srpske* CII, 1928. Reprinted in *Srpska Lilovna kritika,* Ed. L. Trifunović, p. 409.

49. Ibid.

50. A. Barac, "Evropski okviri jugoslovenske književnosti", *Izraz,* March 1959, No. 3, str. 246.

51. Ibid., p. 251-254.

52. Ibid., p. 249.

53. M. Živković, "Muzički lik Stevana Hristića", *Eseji o umetnosti,* (Novi Sad: Matica Srpska, SKZ, 1966) p. 271.

54. Lj. Marić, Gradja za biografiju (Collection of material for the biography), manuscript, Muzikološki institut, Belgrade.

55. Ibid.

56. J. Milojković-Djurić, Conversation with the composer Ljubica Marić, June 1978, manuscript.

57. Lj. Marić, Gradja za biografiju.

58. Ibid.

59. Ibid.

60. Ibid.

61. Ibid.

62. Ibid.

63. Lj. Marić, Musikalische-Dramatische Arbeitstagung u Strassburgu, *Zvuk,* October 1933, No. 12, p. 400.

64. Ibid., p. 422.

65. Ibid.

66. M. Ristić, "Moralni i socijalni smisao poezije", *Danas,* January-March 1934, p. 85.

67. Ibid., p. 70.

68. Ibid.

69. V. Vučković, *Materijalistička filozofija umetnosti,* Belgrade 1935. Reprinted in V.V., *Studije . . .* , p. 97.

70. J. Milojković-Djurić, Conversation with Ljubica Marić.

71. May, 1930, Nadrealistička izdanja, Belgrade, p. 1.

72. Nadrealistička izdanja, Belgrade 1931. Quoted after M. Protić, *Srpsko slikarstvo XX veka,* (Belgrade: Nolit, 1970) p. 284.

73. V. Vučković, *Zvuk,* No. 1, 1933, Reprinted in *Studije . . .* , p. 653.

74. Compare Chapter 4.

75. D. Čolić, "Izražajni materijal muzike i njeno delovanje", *Zvuk* No. 6, 1933, p. 214.

76. A. Hába, "Mladi jugoslovenski kompozitori i četvrttonska muzika", *Zvuk,* January 1933, No. 3, 82-83.

77. J. Milojković-Djurić, Conversation with the composer Dragutin Čolić, June 13, 1978.

78. Ibid.

79. M. Koren, "Gradja za biografiju V.V., p. 60.

80. Ibid.

81. According to Čolić the scores of these songs are apparently lost.

82. Conversation with D. Čolić.

83. Ibid.

84. Conversation with the composer St. Rajičić, May 9, 1978.

85. V. Peričić, *Stvaralački put Stanojla Rajičića,* (Belgrade: Umernička Akademija 1971) p. 21-22.

86. Conversation with St. Rajičić.

87. M. Milojević, "Dve večeri slovenske kamerne muzike," *Politika,* 29. II. 1940. Quoted after V. Peričić, *Stvaralački . . .* , p. 25.

88. "Moderna jugoslovenska kamerna muzika u priredbi Cvijete Zuzorić", *Vreme,* 29 February, 1940.

89. "Veče moderne jugoslovenske muzike—tri značajna prva izvodjenja", *Pravda,*
29. February, 1940.

90. V. Peričić, *Stvaralački put* . . . , pp. 30-31.

91. M. Protić, *Srpsko slikarstvo XX veka,* p. 334.

92. Ibid., p. 341.

93. J. Milojković-Djurić, Conversation with Stanojlo Rajičić, May 9, 1978.

94. *Stvaralački put* . . . , p. 35.

95. J. Milojkovic-Djuric, Conversation with St. Rajičić.

96. M. Živković, "Koncert beogradske filharmonije", *Vreme,* 27. March, 1941.

97. J. Milojković-Djurić, Conversation with the composer Vasilije Mokranjac,
May 17, 1978.

98. J. Milojković-Djurić, Conversation with St. Rajičić, May 9, 1978.

99. Manuscript, Bandur archives, Serbian Academy of science and arts.

100. M. Logar, "Sećanja", *V. V. umetnik i borac,* p. 215.

101. M. Logar, Commentary in the discussion "The development of the
contemporary Yugoslav music", 1971, *Zvuk* No. 113-114, p. 137.

102. Conversation with M. Logar, 25. May, 1978.

103. Ibid.

104. Ibid.

105. Ibid.

106. V. Vučković, "Osobenosti tikveškog muzičog folklora", V. V., *Studije* . . . ,
p. 296.

107. M. Mihailović, "Sećanje na V. V.," *V. V., umetnik i borac,* p. 355.

108. M. Koren, "Gradja za biografiju V. V.", p. 58.

109. M. Milojević, *Politika,* 21. March, 1938. Quoted after V. Peričić, "Stvaralački
lik V. V.", *V. V. umetnik i borac,* p. 108.

110. Compare the IV Chapter.

111. "Stvaralački lik . . . ," p. 108.

112. M. Koren, "Gradja za biografiju V.V.", p. 60.

113. *Naša Stvarnost,* No. 13-14, 1938. Reprinted in Studije . . . , p. 99-108.

114. *Studije* . . . , p. 296.

115. P. Markovac, "Uz problem nacionalne muzike", *Zvuk* No. 1, 1932, pp. 9-13.
Lj. Kiš, "O novim pravcima muzike", *Zvuk* No. 2, 1933, pp. 53-60. A. Lajovic,
"Nacionalizam ili internacionalizam u muzici", *Zvuk,* 1935, pp. 165-169.

116. Z. Simić-Milovanović, "Beograd i borbeni razvoj srpske umetnosti novijeg
doba", *Godišnjak grada Beograda,* Vol. VI, (Belgrade, 1959) p. 643.

117. Quoted after V. Peričić, *Stvaralački put Stanojla Rajičića,* p. 31.

118. Ibid.

119. Ibid., p. 32.

120. Ibid.

121. B. Lekić, "Dr. Vojislav Vučković", *V. V. umetnik i borac,* p. 510.

122. Ibid.

123. St. Djurić-Klajn, "Konture našeg novog muzičkog stvaralaštva," *Muzika,*
No. 1, 1948, p. 17.

125. Ibid.

126. O. Danon, "Sjećanje na V. V.," *Muzika,* No. 1, 1948, p. 52.

127. "Putevi naše moderne", *Muzički glasnik,* January 1938, p. 7-10.

128. *Historijski razvoj muzičke kulture u Jugoslaviji* (Zagreb, Školska knjiga, 1962) p. 687.

129. "Konture . . .", *Muzika,* p. 19-23.

130. St. Djurić-Klajn, *Serbian Music through the Ages* (Belgrade, Union of Composers of Serbia, 1972), p. 132.

131. M. Bergamo, *Delo kompozitora;* Stvaralački put Milana Ristića od Prve do Šeste simfonije (Belgrade, Univerzitet umetnosti, 1977) p. 14.

132. Ibid., p. 62-63.

133. "Stvaralački lik Vojislava Vučkovića," *V. V. umetnik i borac,* p. 112-113.

134. V. Peričić, *Muzički stvaraoci u Srbiji* (Belgrade: Prosveta, 1967) p. 302.

135. J. Milojković-Djurić, "Das Byzantinische Konzert für Klavier und Orchestra von Ljubica Marić," *Musicological Annual* XV, Ljubljana 1979, p. 103.

136. M. Ristić, *Istorija i poezija,* Sabrani eseji (Belgrade 1962), pp. 127-128.

137. M. Ristić, Moralni i socijalni smisao poezije, *Danas* No. 2, 1934, p. 214.

138. Quoted after L. Trifunović, *Srpsko slikarstvo 1900-1950* (Belgrade: Nolit, 1973) p. 269.

139. Ibid.

140. V. Peričić as the editor of the book *Vojislav Vučković umetnik i borac* (Belgrade: Nolit, 1968) managed to collect in this volume all major writings about Vučković. For a bibliography of publications in Czech language on Vučković compare the Chapter 4 of this book.

141. R. Zogović, "V.V. umjetnik i borac", *Vojislav Vučković umetnik i borac,* (Belgrade: Nolit, 1968) p. 303. The mentioned verses are taken from Puškin's poem *Monument.*

SELECTED BIOGRAPHIES

Dragutin Čolić

Born in 1907 in Požega, Čolic started his music education in the music school *Stanković* under M. Milojevic. He continued his studies in Prague graduating in the classes of K. B. Jirak and A. Hába. Hába had high esteem for Čolić, hoping that, as an accomplished composer, he could stimulate the public and help promote acceptance of contemporary music. After return to Belgrade, Čolić taught in several music schools before accepting a position as docent at the newly established Music Academy in Belgrade. He acted as conductor of the choral society *Abrašević*. In addition, Čolić wrote essays in music and gave occasional public lectures on diverse music topics.

In his early works Čolić's musical language encompassed atonality, athematism, quarter-tone intervals and, sporadically, dodecaphonic technique. Thus he composed *Concertino for a Quarter-Tone Piano and String Sextet* in 1932, followed by *Two Suites* for the quarter-tone piano. Čolić composed in Prague *Tema con Variatione* for piano, displaying an inventive and distinctively contemporary musical language, its thematic material based on a twelve-tone row. *The String Quartet* from the same period presents three traditionally conceived movements, while the musical flow is expressed in an atonal, linear style.

Čolić approached a change of compositional style in the course of the 1930's becoming aware of the needs of a broader, musically inexperienced public. This new attitude led to the composition of several choral pieces based on folk tunes. The score of his first *Symphony* was lost in the war. However in 1968 Čolić composed his *Symphony in Sol* presenting a synthesis of dodeca-

phonic and tonal musical language. In addition Čolić composed two symphonic poems: *Easter Bells* based on the verses of V. Nazor, with a solo tenor part, and *Nikoletina Bursać* based on the story of B. Čopić, about a young partisan.

Miloš Crnjanski

Born in 1893 in Congrad, Hungary, Crnjanski took part in World War I, on the side of the Austro-Hungarian army. After the end of the war Crnjanski lived briefly in Zagreb publishing there his poetry and critical reviews. Among his early poems a significant influence was exerted by his poem *Sumatra* and the ensuing *Explanation of Sumatra* that Crnjanski wrote on the request of Bogdan Popović acting as editor of the journal *Srpski književni glasnik*. Crnjanski captured the feelings of the young generation who participated in World War I, thereby testifying to the enormous human sacrifices and sufferings.

In 1919 Crnjanski entered the University of Belgrade in order to continue his studies of art history started in Vienna before the outbreak of the war. He graduated in 1922, and worked for a time as history teacher. With the writer Marko Ristić, Crnjanski co-edited the journal Putevi. In 1928 he published his well received novel *Seobe (Migrations)*. Crnjanski entered the diplomatic service and acted as attache for culture and public information in Berlin, Rome, Lisbon and London. The World War II he spent in London where he was assigned on duty. After the end of the War Crnjanski stayed in London until 1965. While living in London among diverse emigrants observing their struggle for livelihood he wrote *Roman o Londonu (A Novel about London)* published in Belgrade in 1971.

The collected works of Miloš Crnjanski have appeared in several editions. The most complete edition in ten volumes was published as a joint venture of the publishing houses Prosveta, Matica Srpska, Mladost, Svjetlost, appeared in Belgrade in 1966.

Mihovil Logar

Born in Rijeka in 1902, Logar although of Slovene descent, lived most of his professional life in Belgrade. After his studies in Prague under K. B. Jirak and at the Master's School with J. Suk, Logar has been living in Belgrade since 1927. He has distinguished himself as a prolific composer, teacher of

piano and theoretical subjects at several music schools. Later he became professor of composition at the Music Academy in Belgrade. He acted also as music critic and concert pianist. He was elected for a term as president of the Union of Composers and Music Writers of Serbia.

Logar's early compositional work is characterized by an advanced harmonic language leading to atonality and a free, often rhapsodic form. A metamorphosis of his compositional style took place in the course of 1930's, projecting his predilection for an expressive melodic flow with a tonal support. A large portion of his works belong to the operatic genre like: *Four Scenes from Shakespeare* (1931), *Sablazan u dolini Šentflorijanskoj (Sacrilege in Saint Florijan's Valley;* 1938), *Pokondirena tikva (The Would-be Lady)* (1954), Nineteen-Hundred-Forty-One (1959), and ballet music *The Little Goldfish* (1950).

Among orchestral compositions mention should be made of: *Sinfonia Italiana* (1964), the symphonic poem *Vesna* (1931), *Rondo-Overture* (1936), Rondo Rustico (1945), the concert overture *Comonauts* (1962), Logar wrote several instrumental concertos: *Two Toccatas for Piano and Strings* (1933), *Concerto for Violin* (1954), Concert for Clarinet (1956), *Doppio Concerto for Clarinet and Horn* (1967). In addition Logar composed a number of cantatas and chamber music.

Ljubica Marič

A remarkable personality of the Serbian contemporary music, Ljubica Marić was born in Kragujevac in 1909. She studied in Belgrade in the class of J. Slavenski and later in Prague under J. Suk and A. Hába. After return to Belgrade from her studies she taught theoretical subjects first in the music school *Stanković* and later was elected professor at the Music Academy in Belgrade. Among her early works composed in Prague, mention should be made of her *Wind Quintet* and *The Music for Orchestra.*

After a period of inner search, a new and mature musical style emerged in compositions of the 1950's and later. The cycle *Muzika oktoiha (The Music of Octoechos)*, based on the melodic formulae from Serbian church music, reveals next to the affinity for cultural heritage a kinship to the contemporary sound. The cycle includes *Music of the Octoechos* No. 1, for orchestra; *Byzantine Concerto* for piano and orchestra; the cantata *Prag sna (The Threshold of Dream)* based on the text of three poems by Marko Ristić: Prenuće, Živi dan, Prag sna *(The Waking Up, The Day Alive, Threshold of Dreams);* and *Osti-*

nato super Thema Octoicha for harp, piano and string orchestra. In addition she wrote the *Passacaglia* based on a folk song from Pomoravlje.

Her most significant work, performed very often in Yugoslavia, is the cantata *Pesme prostora* (Songs of Space). The cantata was written for a mixed choir and orchestra. The textual base of the cantata is presented in seven inscriptions from medieval tombstones-*Stećci*-erected by believers of Bogumilism. Marić is a member of the Serbian Academy of Sciences and Arts.

Miloje Milojević

Born in Belgrade in 1884, Milojević exerted a considerable influence on the musical life of his native city between the two World Wars. Milojević died in Belgrade in 1946. Milojević started his studies at the University of Belgrade under Bogdan Popović and Jovan Skerlić. He pursued musical studies with Stevan St. Mokranjac at the Serbian Music School, completing music education at the Academy of Music in Munich. After graduation he returned to Belgrade and taught at various schools, acting also as the music critic for the literary journal *Srpski književni glasnik.*

In 1925 Milojević graduated from Charles University in Prague, as a student of Zdeněk Nejedlý, with a doctoral dissertation on the compositional work of Bedřih Smetana. Milojević was elected as lecturer for the course on history of music at the University of Belgrade. Jointly with his former professor B. Popović, Milojević formed in 1925 the University Chamber Music Society *Collegium Musicum.* Milojević's collected essays, studies and criticism are to be found collected in three volumes: *Muzičke studije i članci,* Belgrade, 1926 and 1933 respectively. Volume III, was published posthumously, edited by his daughter Gordana Trajković-Milojević, in Stari-Bečej in 1953.

As a composer, Milojević was at his best in lyrical works for voice and piano: *Pred veličanstvom prirode (Before the Majesty of Nature)* based on the verses of French poets; *Tri pesme* (Three Songs) set to German poetry and the cycle *Haikai* with Japanese verses. In a similar mood Milojević composed for a vocal soloist and instrumental ensemble the cycle *Gozba na livadi* (A Feast on the Meadow) using the poetry under the same title of Desanka Maksimović. In addition he wrote numerous piano pieces.

Stevan Stojanović Mokranjac

Mokranjac, born in 1856 in Negotin, enhanced the consequent development of Serbian music. After his studies of music in Munich under J. Rhein-

berger, Mokranjac pursued his further education under A. Parisotti in Rome and S. Jadassohn in Leipzig. After his return to Belgrade, Mokranjac became conductor of the Belgrade Singers' Society, remaining in this position until his death in 1914 in Skopje, during the evacuation following the outbreak of World War I. Under his leadership the Society became an outstanding vocal ensemble, touring concert centers extensively in the Austro-Hungarian Empire, Turkey, Bulgaria, Russia and Germany. It was for this Society that Mokranjac composed his renowned vocal rhapsodies—*Rukoveti*—based on folk melodies. His ingenious selection and stylization of folk tunes, underlined with distinctive although latent harmonies was recognized as the epitome of the national musical expression.

In addition Mokranjac composed church music based on spiritual folk melodies. Best known are *Liturgija* (Liturgy) composed in 1895, with its profound *Cherubim's Song,* and *Opelo (Requiem).* Mokranjac distinguished himself also as collector of secular and spiritual folk songs. He was influential as an organizer of musical life and founder of the first music school in Serbia in 1899. The school bears at present his name. Mokranjac was elected as a member of the Serbian Learned Society that evolved later into the Serbian Academy of Sciences and Arts. The French Academy of Arts elected him as a corresponding member.

Rastko Petrović

Petrović was born in Belgrade in 1898, in a scholarly family: his sister was Nadežda Petrović, the renowned painter. As a high school student he retreated with the Serbian army through Albania during the World War I. With a group of young student-refugees he was evacuated to Nice, France, where he graduated from high school. Later he enrolled at the University in Paris where he finished his law studies. After graduation, Petrović returned to Belgrade in 1922. Petrović had started publishing his literary works and criticism of pictorial exhibits as a student. He continued his literary work and art criticism even after entering upon a career as a diplomatic officer, living abroad in Italy and in United States. He died in Washington in 1949.

Among his literary works, mention should be made of *Burleska Gospodina Peruna Boga Groma (Burlesque of Mister Perun God of Thunder)*, Belgrade, 1921. This book was inspired by Slav mythology that Petrović zealously researched while studying in Paris. It projected his belief in the continuity of the Slav heritage in spite of tremendous losses in World War I. In 1922 his collection of poems and prose appeared in Belgrade under the title: *Otkro-*

venje (Revelation), causing a critical uproar. His art criticism was published in several literary journals as well as in the leading newspaper *Politika*. Both his art criticism and literary contribution have exerted a significant impact on the cultural development of his time.

Bogdan Popović

Popović was born in 1863 in Belgrade where he spent most of his life. He died in 1944. After the completion of his studies in France, Popović acted as professor of literature at the University of Belgrade. During his long tenure of some fifty years, Popović exerted a powerful influence on the forthcoming generations of scholars.

In 1901 he founded the renowned literary journal *Srpski književni glasnik (The Serbian Literary Herald)* and served as the editor of the journal for several terms. After his study about Beaumarchais (1898) he published several books: *Ogledi iz književnosti i umetnosti (Essays in Literature and Fine Arts)* (Vol. I and II, 1914 and 1927); *Jovan Skerlić kao književni kritičar (Jovan Skerlić as Literary Critic)* (1921); *Članci i predavanja o književnosti, umetnosti, jeziku i moralu (Articles and Lectures on Literature, Fine Arts, Language and Morals)* (1932). Posthumously were published: *Essays* (1955); *Estetički spisi (Writings on Esthetics)* (1963).

His *Antologija novije srpske lirike (Anthology of Newer Serbian Poetry)* appeared in many editions perpetuating Popović's esthetic judgment of Serbian poets and their work. Popović was a member of the Serbian Academy of Sciences and Arts.

Stanojlo Rajičić

Born in 1910 in Belgrade, Rajičić received his early music education in his native city. Undergraduate and graduate studies in music composition and piano he accomplished in Prague as a disciple of J. Suk. Rajičić started his professional career first as piano teacher, to become eventually professor of composition at the Music Academy in Belgrade. As a composer, Rajičić showed interest in different musical genres, although he was foremost attracted to instrumental concertos.

He enriched Serbian music literature with several outstanding works such as his three concertos for the violin, two for clarinet, three for the piano and one cello concerto. His early compositions testified to his interest in the

contemporary musical development. However, Rajičić did change his musical credo and approached a subdued and serene expression in his ballet music *Ispod zemlje (Under the Ground,* 1940). A similar attitude is expressed in his *Second String Quartet* (1939). The opera *Simonida* (1956), based on the libretto adapted from the play *Kraljeva jesen (King's Autumn)* by Milutin Bojić, depicts historical events at the court of King Milutin. Rajičić composed two more one-act operas: *Karadjordje* and *Dnevnik ludaka (The Diary of a Madman)*—the latter composed after the novel of the same title by Gogol.

Rajičić chose Serbian romantic poetry for his cycles of songs with orchestral accompaniment creating an emotionally charged musical expression. He selected the poems of Branko Radičević in *Četiri pesme Branka Radičevića (Four Songs of Branko Radičević)* (1950) and the song cycle of Djura Jakšić *Na Liparu (At Lipar,* 1957). Rajičić, a member of the Serbian Academy of Sciences and Arts, is secretary of its Fine Arts Division.

Marko Ristić

Born in Belgrade in 1902, Marko Ristić accomplished his studies at the College of Philosophy of the University of Belgrade in 1925. As a student at the University, Ristić was instrumental in founding the literary journal *Putevi.* In 1924 Ristić became editor of the journal *Svedočanstva.* Ristić played a decisive role in the formation of the surrealistic movement in Belgrade, as well as in starting the bilingual journal *L'Impossible-Nemoguće,* published in Belgrade with contributors both from France and Yugoslavia. Ristić had a successful collaboration with Niroslav Krleža in the journal *Danas* (1934) and *Pečat* (1939). From 1945 until 1951 Ristić served as the Yugoslav ambassador to France. Ristić also has acted as the President of the Yugoslav National Commission at UNESCO.

Together with Koča Popović, Ristić wrote *Nacrt za jednu fenomenologiju-iracionalnog* (Concept of a Phenomenology of the Irrational) (1931); *Anti-Zid* (1932) co-authored with Vane Živadinović-Bor; *Književna politika (Literary Politics* 1952); *Predgovor za nekoliko nenapisanih romana i dnevnik toga predgovora (Introduction to Several Unwritten Novels and the Diary of this Introduction)* (1953); *Krleža* (1954); *Tri mrtva pesnika (Three Dead Writers)* (1954); *Ljudi u nevremenu (People in a Storm,* 1956); *Sonata u sivom - Prolazak Antuna Branka Šimića (Sonata in Grey—The Passage of Antun Branko Šimić,* 1956); *Istorija i poezija (History and Poetry,* 1962); *Hacer tiempo* (1964); *Svedok ili saučesnik (Witness or Accomplice,* 1970).

Vojislav Vučković

During his relatively short life, Vučković contributed to the musical development not only in his native country but also to the establishment of the School of Music Sociology in Prague, Czechoslovakia. Vučković born in Pirot and died in 1942 in Belgrade during World War II. Vučković accomplished his studies of composition and conducting in Prague while receiving in addition a doctorate in musicology. After returning to Belgrade Vučković worked as composer, conductor and musicologist. He gave numerous public lectures on music basing his explanations, as in his published works, on the postulates of materialistic philosophy.

Vučković's early compositions reveal an expressionistic style close to the style of his former teacher A. Hába and the pre-dodecaphonic works of A. Schoenberg. Among his compositional output the most significant are: *First Symphony, String-Quartet,* the quarter-tone *Trio* for two clarinets and piano and Dve pesme (Two Songs) for soprano, oboe, clarinet and bassoon.

In the course of the 1930's Vučković changed his musical language, adopting a simplification of his musical style. These new tendencies are evident in the one-act ballet, *Čovek koji je ukrao sunce (The Man who Stole the Sun)* after the story of J. Wolker, as well as in symphonic compositions *Zaveštanje Modesta Musorgskog (The Inheritance of Modest Musorgsky), Ozaren put (The Sunlit Road),* Vesnik bure (The Herald of the Storm), the latter inspired by the poem of M. Gorkij. From his musicological works mention should be made of his doctoral dissertation: *Hudba jako propagačni pristřredek* (Music as Vehicle of Propaganda), *Materijalistička filozofija umetnosti (The Materialistic Philosophy of the Fine Arts)* and *Muzički portreti* (Musical Portraits).

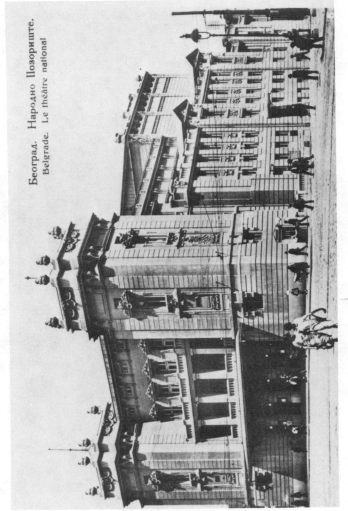

Београд. Народно Позориште.
Belgrade. Le théâtre national

National Theatre, Belgrade

Hotel Moscow, meeting place of the artists during the 1920s.

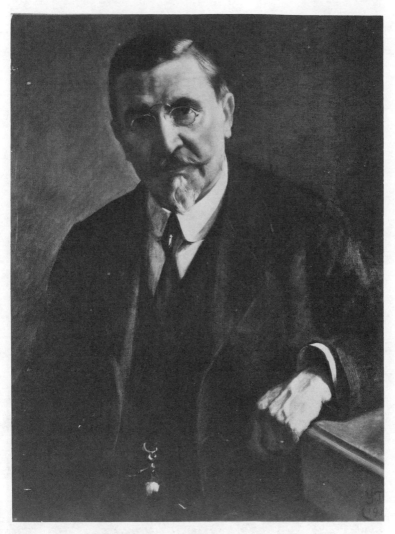

Composer St. St. Mokranjac (oil painting by Uroš Predić).

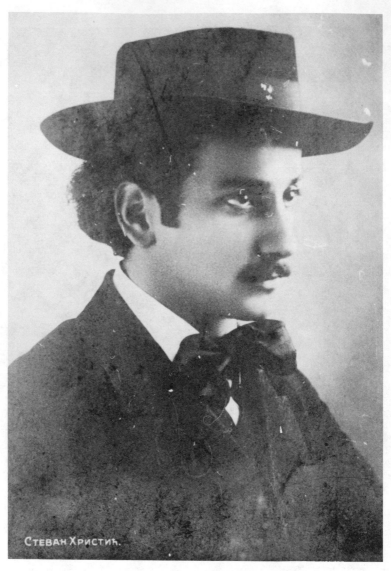

Composer Stevan Hristić

Writer Milan Crnjanski

Composer Miloje Milojević

Composer Kosta P. Manojlović

Composer Petar Konjović (left) and the writer Ivan Vojnović in Prague 1918 with two unidentified ladies.

Composer Mihovil Logar

Composer Mihailo Vukdragović conducting the Belgrade Symphony Orchestra in the concert hall *Kolarac* in 1940.

Composer Ljubica Marić (sketch by Ivan Tabaković 1951).

Composer Stanojlo Rajičić, photographed in 1983.

INDEX